JOHN SELL COTMAN
1782–1842

Edited by Miklos Rajnai

The Herbert Press

First published in Great Britain 1982
by The Herbert Press Ltd, 65 Belsize Lane, London NW3 5AU

Designed by Pauline Harrison

Printed in Great Britain by Westerham Press Ltd.
Bound in Great Britain by The Newdigate Press Ltd.

Jacket illustration: *Hell Cauldron, called Shady Pool on the Greta* (detail), no.68
Frontispiece: Portrait of John Sell Cotman. Etching by Mrs Dawson
Turner after J. P. Davis. Norfolk Museums Service (Norwich Castle
Museum)

British Library Catalogue in Publication Data:

John Sell Cotman 1782–1842.
 1. Cotman, John Sell—History and criticism
 I. Rajnai, Miklos
 759.2 ND1942.C/
ISBN 0–906969–19–0

Contents

Preface

This book is based on the catalogue for the bicentenary exhibition, produced for the Arts Council of Great Britain by The Herbert Press; but, by kind permission of the Norfolk Museums Service, it includes also a twelve-page selection of the most important paintings from the Colman Bequest at Norwich Castle Museum which could not be lent for the exhibition. The exhibition, shown at the Victoria and Albert Museum, London, The Whitworth Art Gallery, Manchester and the City of Bristol Museum and Art Gallery, was devised by Miklos Rajnai and Stephen Somerville.

David Herbert

Acknowledgements

This selection surveys Cotman's art throughout his life, but deliberately concentrates on his early development, and in particular on his greatest period between 1805 and c.1810, from which years of unmatched achievement it presents as many drawings as availability and the condition of individual pieces allowed. Later periods are covered, not in proportion to the volume of work produced, but by a restricted number of pieces, representative of the best and most typical. The catalogue entries do not attempt to be exhaustive (a task left for the forthcoming oeuvre catalogue) but they aim, in the aggregate, to give a rounded presentation of Cotman's work, aspirations and attitudes, as well as some indication of his appraisal by his best critics.

The editor and publisher wish to thank the owners, both private and public, of the works included, for the generosity with which they allowed access to the drawings and paintings in their possession or charge, and also for providing much-needed information from the documentation they have assembled. Anonymity prevents the singling out of those private collectors who have been exceptionally helpful. Among the custodians of public collections, special gratitude is due to Dr Michael Kauffmann and John Murdoch of the Victoria and Albert Museum, Dr Dennis Farr of the Courtauld Institute Galleries, Alexander Robertson of Leeds City Art Gallery, Richard Green of York City Art Gallery, and finally to Lindsay Stainton of the British Museum Print Room, whose readiness to give personal attention to many importunate requests was far above what could reasonably have been expected.

Thanks are also due to the co-organizer of the exhibition, Stephen Somerville, who did much collecting of information for the initial stages of the catalogue and readily responded to cries for help in the panic of the last stages. Norma Watt of the Norwich Castle Museum, without whose anticipated help the cataloguer would not have embarked on his task, has been a greatly valued collaborator from start to finish; apart from reading and commenting on the text, she compiled the sections on *References* and *Exhibitions*. Marjorie Allthorpe-Guyton not only gave invaluable assistance by filling in many gaps in the documentation of the works, but also supplied friendly but exacting scrutiny of the text. For similarly useful and much valued comments on the text, much gratitude is felt to Michael Riviere, a good friend who did not shirk the task of also being a critic. Lastly, the compiler and editor wants to express heartfelt appreciation to David and Brenda Herbert, his publishers, whose gentle firmness and clear-sighted and admirably methodical treatment of problems, as well as their warm hospitality, made the editorial task much less arduous than it would have been otherwise. Gaining their friendship was an unlooked-for bonus.

The editor and his co-authors relied heavily on the Cotman correspondence and would like to acknowledge their indebtedness to the owners or holders of the bulk of this correspondence: Mr Christopher Barker; the British Museum, London; Trinity College Cambridge, and the North Yorkshire County Record Office, Northallerton. The invaluable publications of Isherwood Kay and Adele Holcomb of part of the correspondence are listed among the *References*.

Miklos Rajnai

7

Photographic acknowledgements

Abbot Hall Art Gallery, Kendal 57; Birmingham City Museum and Art Gallery 91,98,106; Bradford City Art Gallery 84; Trustees of the British Museum 11, 13, 18, 31, 37, 40, 42, 48, 49, 51, 52, 58, 63, 69, 78, 80, 103, 107, 111, 112, 113; R. Clive 19, 20; Courtauld Institute of Art 2, 10, 12, 15, 23, 24, 25, 27, 41, 54, 55, 66, 71, 74, 75, 76, 87, 88, 90, 117; Fitzwilliam Museum, Cambridge 22, 108; Hawkley Studio Associates Ltd 7, 8, 17, 53, 62, 65, 104; Laing Art Gallery, Newcastle upon Tyne 92; Manor Photographers, Bolton 26, 81; Michael Marsland 35; John Mills (Photography) Ltd 96; National Gallery of Scotland 116; Sydney W. Newbery 9; Castle Museum, Nottingham 1; The Paul Mellon Centre for Studies in British Art (London) Ltd 5; Philip Armes 45; Tom Scott, Edinburgh 44, 68, 105; Sotheby Parke Bernet & Co. 99; Joseph Szaszfai, Yale Center for British Art 64, 67, 83, 89; Tate Gallery, London 28, 79, 118, 119, 120; University of Oxford, Ashmolean Museum 34, 47, 73, 82, 85, 94, 109; Victoria and Albert Museum 4, 16, 29, 50, 60, 72, 77, 86, 95, 102; Warrington Museum and Art Gallery 100; West Park Studios, Leeds 43; Alan Whitehouse 39; Whitworth Art Gallery, University of Manchester 33; Derrick Witty 3, 6, 14, 21, 30, 36, 46, 56, 61, 93, 101, 110, 115, 122–6; York City Art Gallery 38.

Introduction: Cotman's life and work

At the time of the opening of the Colman Galleries in Norwich, half of which are devoted to Cotman, one of the writers on him asked: 'Is there, in the annals of British art, a much sadder story than that of John Sell Cotman?' That writer's knowledge of the artist must have been based – as everyone's is – on Sydney Kitson's monograph published in 1937. The story told there is unmitigatedly sad; so much so that Paul Oppé, the other recognised authority on Cotman, questioned its validity and chided Kitson for 'deepening the shadows'. Oppé argued that the sky above Cotman was not as consistently black as the artist himself depicted it (Kitson's story was based on Cotman's own testimony preserved in his voluminous correspondence) and most modern scholars would agree. Nonetheless, very black skies and shadows there certainly were.

First of all he had, in Dawson Turner, an almost lifelong patron, who provided the impractical Cotman with much-needed support in managing his affairs, but whose influence at best was not very beneficial to the artist in him and at worst was disastrous. For Turner encouraged the antiquarian, the topographer and the drawing master in Cotman at the expense of the artist; and, even after a lifelong acquaintance with a painter of his brilliance and originality, maintained that it would be by the many architectural etchings – helped along by himself (Turner) – that Cotman's name would survive. Then Cotman's fatal decision to leave London at the height of his artistic power (settling first in Norwich, later in Yarmouth, then in Norwich again) was compounded by his almost total failure to contribute to the London exhibition rooms for two decades, so that most of his major works had no showing in the capital (a situation he made worse by seldom contributing even to Norwich exhibitions during his Yarmouth residence). Next, he almost gave up painting for ten years in order to engage in antiquarian etching, when his painting was at its most original and going well. And, although he was one of the first artists to make extensive tours of the continent, he missed the chance of capturing the ready market for continental landscapes (which a fellow watercolourist, Samuel Prout, then cornered so ably), by himself concentrating on etching and on monochromes for etching or engraved reproduction. Perhaps worst of all, in spite of hating the idea, he allowed himself to take on, and get stuck with for the rest of his life, the role of 'drawing master or pattern drawer for young ladies', eventually becoming the head of a family 'firm' for manufacturing drawings in astonishing numbers for pupils to copy. His inability to escape this role resulted in a flood of often dreary 'Cotmanesque' productions which are by many confused with his own work and so will always hurt his reputation.

Largely because of all this, Cotman, who can be, and has been variously described as, 'one of the world's greatest watercolourists' and 'one of the most original, and, in the light of his happiest moments most exquisitely gifted of English landscape painters' made hardly any mark at all on the contemporary scene, let alone one commensurate with his importance. There is not a single reference to him by name (there is one by inference) in that encyclopaedic compendium on contemporary English art, the Farington Diaries; he is not mentioned once in Constable's correspondence; he is entirely ignored during his life and afterwards by such acquaintances as Elizabeth Rigby, later Lady Eastlake, a highly influential figure in the art scene of the period, and does not appear in the indices to Ruskin's writings, which give full accolade to much lesser men. He was, in fact, ignored to such an extent that when he died not a single obituary was published, even in the papers of the city of his birth.

It all started well. He was born in Norwich 16 May 1782 into the family of a respectable tradesman, a barber

who turned haberdasher before the century was out. The parents, Edmund and Anne Sell, gave him a sound education at the local grammar school, after which – with perhaps an intervening period of work at the shop – he left for London in pursuit of an artistic career. Since he destroyed all his early papers, it is not known whether he took lessons from any of the many drawing masters resident in or visiting the city, nor do we know how and why his interest in painting awakened and grew into an urge to make it his profession. Statements by himself and his son, Miles Edmund, point to 1798 as the date of his arrival in London.

The next seven years can be regarded as plain sailing, even as a success story – if not in financial, then certainly in social and artistic, terms. Cotman seems to have had the good fortune soon after his arrival in London to make the acquaintance of Dr Monro, friend and encourager of many young artists – Turner and Girtin among them. Subjects drawn in 1799 and shown in 1800, when he first sent work to the Royal Academy, suggest a stay at Fetcham, Dr Monro's country house; and the young man from Norwich whom Farington mentions as a protégé the doctor is 'bringing forward', towards the end of 1799, has been generally assumed to be Cotman.

The year 1800 is doubly significant in Cotman's life: he was awarded the great silver palette of the Society of Arts, and his work made its first appearance in a Royal Academy exhibition. His artistic development in the previous two years had been rapid, not to say spectacular. While there is little difference in quality between his first known, juvenile, drawing of 1794 and the drawing of *Devil's Tower* of 1798 in Norwich Castle Museum, and neither gives a hint of what is to come, the development from *Devil's Tower* to, for example, the *Cottage in Guildford Churchyard* of 1800 at Nottingham (no. 1) is great indeed. He was now an artist. Since he had, it seems, no formal training, one is left to assume that copying drawings in Dr Monro's collection and doing some humble work for Ackermann, the printseller, were the activities through which his skills were formulated and his perception sharpened.

In this year, too, Cotman embarked on the 'obligatory' Welsh tour of the self-respecting English landscape artist of the period (confined as he was to his homeland by the Napoleonic wars), in his search for the picturesque and the sublime. This tour, at least the first part of it, is well documented by dated sketches done in a hatching style which resembles sparsely-spaced long stitches. We join him while visiting, in Bristol, the family of his first London friend, Norton, the bookseller, and then, after crossing the mouth of the Severn, we follow him from castle to castle on a slow progress northwards. He seems to have gone as far as Caernarvon and Conway, but the dated sketches come to a halt at Beddgelert which he reached in August. The homeward journey is not documented either, and we can only guess at it from subjects drawn or painted later – presumably from sketches made then. (Kitson suggests, attractively, that for a time he joined Sir George Beaumont's party at Benarth, Conway, and met Girtin there; but unfortunately the timetable of Cotman's tour makes a visit by him to Conway in July extremely unlikely – even if Girtin was indeed with Beaumont, which is far from certain.)

Nonetheless the tour, its impressions possibly strengthened by another, probable visit in 1802, had a momentous effect on him, perhaps even more than the effect Yorkshire and Normandy had later on. The memory store of this highly impressionable young man of eighteen, native of a flat land, was filled with images of mountains, craggy peaks, lakes nestling among hills, and the like – images which were fed into his art all through his working life, even in periods when it might have been expected that fresher experience would have crowded them out. With a little exaggeration, one could say that his visual experience then – and no doubt the emotions they triggered in him – were stacked and preserved in his mind, as well as in his folios, in such a manner that immediate access remained possible to any of them without more recent experiences blocking the way.

He may have visited Devon and stayed again in Bristol the following year, but this is conjecture. Similarly it cannot be proved that he made a second visit to Wales, in 1802, as suggested (and ingeniously reconstructed) by Kitson, whose evidence is some dated sketches – not by Cotman, but by his supposed companion, his fellow artist and landlord at the time, P. S. Munn. The two or three Cotman sketches which fit in with Kitson's theory make a second tour in the year of the Peace of Amiens (when

most artists who could afford it rushed to the continent) a distinct possibility; but if it took place, no new ground was covered, and there are no Welsh drawings by Cotman dated after 1802 which could only have been derived from sketches of a second rather than the first tour.

During 1802, if not before, Cotman became a member of a society of young artists which was either the continuation of one founded by Girtin or a recreation of this, run on similar lines. Apparently he became the leading figure of this Sketching Society, which met weekly to spend a few hours giving pictorial expression to a quotation chosen by the host and president of the occasion, who retained the drawings of his artist guests. Participation in the Society was a good antidote to Cotman's other work which, without exception, had topographical connotations. At the meetings a 'historical landscape' had to be forged in the heat of intense application, mental and technical, necessitated by the short period allowed, and without the aid of something to copy or be guided by. His association with the Society is documented between 1802 and 1804, but in fact it may have extended until the end of his time in London, as certain compositions on what are presumably Sketching Society themes are difficult to date earlier than 1805–6. In the later sketches, the figures tend to be given more and more emphasis, and the uncommonly high skill with which he handled this element, and its expressiveness, make one wonder what other potentials went unexploited in Cotman as a landscape artist. If a figure painter was flexing his muscles in these emotionally charged, romantic compositions, his development was not allowed; he was restricted as a rule to including lively staffage figures – always well placed and sensitively grouped in the landscapes of the earlier period and the townscapes of the later years.

The public face of Cotman's art, as it was revealed in his annual contributions to the Royal Academy, remained constant in the first three years after the turn of the century. He started his artistic life as he was to end it, doing the same thing as his fellow artists were doing, and doing it at a high level of excellence. His landscapes of the period tend to have a monochrome effect and a dark tonality; his materials are so handled as to serve representation rather than a preconceived artistic intent –

revealing at first a Girtinesque use of the pencil (and occasionally the brush as well) but becoming more markedly decorative for a short while from 1803 onwards. His work in this vein reached its culmination in 1804, when he sent as many as seven drawings to the Royal Academy Exhibition, as if to underline an achievement that placed him with undeniable force in the top rank of contemporary watercolourists.

This means that Yorkshire, which he first visited in 1803, did not have an immediate effect on him, or perhaps that it was not Yorkshire in general which suddenly pushed him from good, conventional artistry into unforeseen brilliance and individuality, but Greta – a particular Yorkshire locality – which he did not reach until 1805. His visit to Yorkshire in 1803 was made in the company of P. S. Munn, with an intoduction from one of his first patrons, Sir Henry Englefield, to his sister's family, the Cholmeleys of Brandsby. He repeated the visit in each of the following two years and, embarking on mini-tours, combed the immediate vicinity of Brandsby as well as more distant parts for suitable subjects – the spectacular ruined abbeys among them. There cannot be any doubt that the months he spent at Brandsby were the happiest in Cotman's life, and the friendships contracted with its inhabitants – Mr and Mrs Cholmeley, their daughters and the son and heir of the house, the younger Francis – were among the warmest and most rewarding in his experience. (Although the parents died within a few years of his last visit, the friendship with Francis was to continue right through Cotman's life.) Their unreserved acceptance of him as a member of the family, their genuine affection and touching concern for his well-being and success, Mrs Cholmeley's keenness to introduce her young protégé to the great houses around, homes of their friends, and the whole atmosphere of relaxed and carefree existence in a refined environment and among people superior in class and riches, must have been an unforgettable experience for Cotman. In fact it probably impressed itself more deeply on his mind than was healthy for his future, making him even more unsatisfied with his later lot than he had a right to be.

In 1805, Cotman paid his first and only visit to Greta Bridge, near Barnard Castle, where he stayed for the whole rainy month of August, first as a guest of the

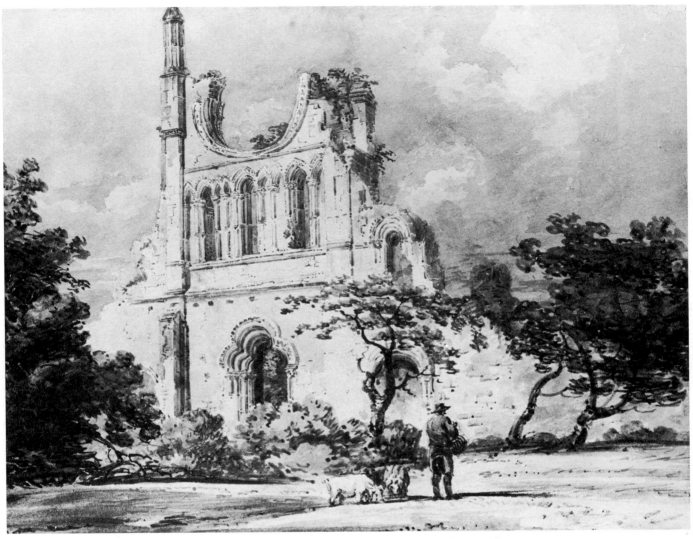

THOMAS GIRTIN, *Byland Abbey*. Watercolour. By courtesy of Birmingham Museum and Art Gallery.

Morritts of Rokeby Park and then, in the last week or so, lodging in the local inn.

The visit to Greta Bridge had an unpromising beginning, an unsettling break in the middle and a precipitated end because of bad weather. At the outset, on Mrs Cholmeley's advice, which she soon came to regret, Cotman left his greatcoat behind, and there was also a delay in the delivery of his colours, which had to be forwarded to him. After three weeks of happy residence at the Hall of Rokeby Park, the Morritts left their home and he had to change over to the inn, leaving the grounds

whose exceptional beauty was captured in verse a few years later by Walter Scott. (In fact, most of his Greta subjects came from the stretch above the bridge and not from the Park proper.) Although on this occasion there exist no over-excited accounts of the subjects he was drawing, such as those he sent to Dawson Turner in 1804 from Castle Acre and Croyland, he was obviously enchanted by his surroundings, by the boulder-strewn river bed and its precipitous banks with dense foliage cascading down from top to water's edge. The immense change that occurred in his art at this point *appears* to have

been immediate – a sudden burgeoning of a new, individual style and approach, very different from that of his earlier picturesque painting; but the truth is a little more complicated, for *Rievaulx Abbey* (no. 14), with its unbelievably early date of 1803, had provided a foretaste of what was to come, and *At Harrow* (no. 33), a most typical 'Greta' drawing, bears a date *earlier* than his arrival at Greta.

The watercolours based on sketches made during these weeks show a balance between a delicate and intimate closeness to nature and an intellect bent on abstraction that is entirely Cotman's own. Although these paintings have often been regarded as outdoor sketches (and one of the artist's own statements would seem to support this belief), it is most unlikely that they were. As Martin Hardie writes: 'Cotman's method demanded a studio table, an even temperature, time for thought and for letting his paper dry evenly or come within an ace of drying, before he applied each additional wash. The work is too formal, the patterns too subtly woven for plein-air painting . . . He was not actually copying the multi-coloured raiment' of nature [Cotman's 'ficle Dame'], 'but colour itself – an emanation or exhalation of colour.'

A fugitive of the weather at Greta Bridge, Cotman first escaped to Durham and then returned to base, i.e. Brandsby, for another long month interrupted only by his week's stay at the nearby Castle Howard. His sojourn at Brandsby extended well into November – as if he were reluctant to leave this happy home of three consecutive summers, to which he was never to return. After the winter of slow progress that followed, he suffered his first cold blast of unsuccess – being, as Mrs Cholmeley put it 'blackballed by the Brook St Society'. The reason for his rejection as a member of the newly-founded Society of Painters in Water-Colours remains a mystery: who 'blackballed' this brilliant young man of twenty-four, who had just finished some of the finest paintings ever made in watercolour, and why? Whatever the truth, Cotman seems to have decided not to take the rebuff as a challenge and, after a visit to Trentham, the Marquis of Stafford's country residence, he returned to Norfolk, where he was to remain for the next twenty-seven years.

The first spell of this long period was spent in Norwich, and its start was propitious. He filled his newly-acquired premises with a one-man show of several hundred drawings, among them loans from patrons such as Dawson Turner, to demonstrate his achievement to date and advertise himself as a drawing master. He joined the Norwich Society of Artists in whose foundation by John Crome and others in 1803 he had taken no part, and to whose first two exhibitions he had not bothered to send any works. He married at the beginning of 1809, and promptly started a family. In the year of his marriage he also embarked on a new venture, a circulating library of drawings to be copied, and undertook to make a twice-weekly delivery to the subscribers himself. All these changes in his way of life affected his art, but they were certainly not detrimental to it. His watercolours became more robust, with an almost archaic simplicity, from which all frills of accident were absent, and often conveying an arcadian calm and peace. But they ill fitted this decade of fast-advancing naturalism in English art, and had to wait nearly a full century for their proper appreciation.

To this period, too, belongs Cotman's strange 'official' appearance as a portrait painter: he advertised himself as such in the 1808 and 1809 Norwich exhibitions, where some portraits were included among a large number of exhibits. Was this to allay the fears of competition among the many landscape painters already active in the city, and later to become well known as the Norwich School?

He was not a stranger to portraiture; indeed, he made portraits right through his life, usually of members of his family, but also of friends and acquaintances. Their style follows his prevalent style in landscape. With few exceptions the scale is small and the medium is pencil. Among the exceptions are some oil portraits painted in the years immediately following his resettlement in Norwich. In 1806, the year of his return, Cotman had taken up painting in oil, soon achieving full mastery over this new medium. It was a medium which he never abandoned, although he probably used it irregularly, in bursts. His oil paintings are almost never dated and seldom is there any external evidence as to when they were painted. In most cases, one can only give them a date by relating their stylistic development to that of the watercolours.

By removing himself from London and abandoning its

exhibitions, Cotman had bowed out of the national scene as a painter, but he soon decided to stage a return, as an etcher, publishing volumes of prints from his Norwich base. With the burning enthusiasm with which he tackled every new venture, he threw himself into the work of the first of his many publication projects, the *Miscellaneous Etchings* which appeared in instalments during 1810 and 1811; and he started on another before the first was finished.

In the midst of this feverish activity he made another move towards increased artistic isolation, changing his residence from Norwich to Yarmouth. This time the blame was not his. Much involved in his printing projects, he was more than reluctant to make such a change, but Dawson Turner, the Yarmouth banker (his patron, confidant and adviser since 1804), wore down his resistance by persuasion and bullying. From now until his return to Norwich in 1823, the painter was to be truly overshadowed by the antiquarian draughtsman – the rare appearance of the former, still in full possession of his earlier powers, emphasising the sadness of the situation.

Not that the etchings are without merit. Many of them belong with the best the period produced, and those that are dry and dreary can no longer be blamed on him; they are now safely ascribed to the helpers he was obliged to employ during and after an exceptionally long and troublesome bout of eye trouble (something that had caused him occasional inconvenience at least since 1803, when we first hear about it). Etchings apart, the main products of this decade or more are monochromes, of great clarity and crispness, of architectural subjects which were made to be etched by himself or engraved by others, and rapid and highly sensitive pencil sketches taken on his frequent trips into the country to collect material for his etchings.

Collecting material for yet another publication project was the reason for his three excursions to Normandy, in 1817, 1818 and 1820. The artistic fruits of the many strenuous months spent there, with ceaseless travel and dawn-to-dusk working, were two sumptuous volumes of etchings, their contents weighted towards the recording of monuments of Norman architecture (the main momentary interests of his two financial and spiritual mentors in this scheme: Dawson Turner and Hudson

Gurney). Other fruits were hundreds of monochromes drawn for etchings, but not every one etched and all dispersed by his sale of 1824; a series of especially fine wash drawings, in pursuit of his pet idea of a volume or volumes of a *Picturesque Tour of Normandy*; and of course the watercolours derived from subjects sketched on these tours, which subjects joined the stock of his growing repertoire. Unfortunately, he concentrated his energies on the etchings first, and his Normandy watercolours did not reach the London exhibition rooms until 1825, eight years later when, becoming an associate of the Old Water-Colour Society, he started exhibiting again regularly in the capital. By that time other artists had stolen the limelight as suppliers of continental scenes to a public starved of them by a long period of isolation caused by the Napoleonic wars.

His *Normandy* finished and the leading figure of the Norwich art scene – Crome – having died, Cotman cut the apron strings that tied him to Dawson Turner's family as a drawing master and topographer, and returned once again to Norwich in 1823.

Meanwhile, Cotman's family had grown: he now had five children. He could look back on a past of exceedingly hard work the results of which were a number of publications, well reviewed in the national press but securing for him neither the reputation he longed for nor the financial ease which they once promised. He could ill afford the imposing house he now took for his residence and teaching establishment, particularly since the teaching was not flourishing sufficiently well to relieve him of worries. The pressures of the previous decade had been considerable but, so far as his peace of mind was concerned, had probably had a salutary effect. Meeting the deadlines of deliveries of etchings to subscribers, or trying to catch up with deadlines long overdue, had kept him busy without allowing him time for reflection, for contemplating his success, or lack of it. This period of constant pressure was now followed by one best characterised by the almost regular return of a debilitating depression, concomitant with months of inaction and spells of black despair.

Sadly, the Cotman who took up the brush again after dropping the etching needle for good was not the same man who produced the Greta drawings and the other

masterpieces of his pre-Yarmouth period. He had been humbled by thwarted expectations, and what he really wanted now was to toe the line, to watch what his more successful contemporaries were doing and how, and to attempt to do likewise. Fortunately, his acute sense of pattern and structure had not entirely atrophied during the years lean in painting, and could still secure an honourable place for his best work among the productions of his leading contemporaries.

To start with, he embarked on a far from successful experiment, presumably encouraged by the licences taken by Turner, that acknowledged wizard of incessant technical experimentation. He began scraping the surfaces of his watercolours excessively with a knife or razor – not merely using this technique to secure accents of highlight (as he had on occasions done before), but scraping the surfaces overall. The rough texture resulting from this treatment is – as a rule – anything but pleasant; it gives the drawings a somewhat vulgar, mechanical impression. Having soon abandoned this practice, he next adopted the winning formula of the period, a beautified – or, in less able hands, prettified – naturalism, used as a vehicle for a generous measure of high-pitched colours. The change attracted patrons for him and purchasers for his never over-abundant exhibits.

With Crome out of the way, Cotman took an increased interest in the Norwich Society of Artists and, in the company of Crome's son, J. B. Crome, and Stark, became one of its leading members. He held office repeatedly, promoted whole-heartedly a series of artist *conversazione*, and hosted and chaired the Society's last, sad meeting in 1833.

A few months after this meeting he changed his residence again, for the last time. Thanks mainly to the caring awareness of his past pupil, Lady Palgrave, one of Dawson Turner's daughters, he succeeded in obtaining the post of drawing master in the school of the recently established King's College in London. The appointment was not a perfect solution for all his problems, as he had hoped. The old troubles, such as inadequate finance, refused to go away and were joined by new ones, one of which was his deepening anxiety about signs of mental instability in two of his sons. The move to London was not accompanied by any appreciable change in his art;

trends already present in Norwich continued their existence unmodified: picturesque continental townscapes, historical costume pieces, interpretation in watercolour of subjects sketched in pencil many years before, and inventions of architectural themes in landscape settings with or without reference to experienced reality.

A typical product of his last years was a largish group of so-called paste medium drawings – that is, watercolours in which body was given to some of the transparent medium used by the admixture of an opaque substance. The drawings are sometimes rich in colour, but more often than not they are restrained, often with an inky dark and/or grey tone predominating so that they have an almost monochrome effect. Their captivating charm is a soothing, sweet, poetic mood. However, most of them bear so much family resemblance to one another that one comes to see them merely as representatives of a group rather than having an individual existence of their own. As in his Norwich years, periods of ill health, real and – one suspects – imaginary as well, held back his output, and certainly the public appearance of his work. It also led to long delays in fulfilling commissions from patrons who coveted his work.

Cotman enjoyed his popularity in the school, which was reflected in the ever-increasing number who opted for drawing, and he took his teaching task – in the limited sense in which he saw it – very seriously. Consequently much of his energy and time, as well as that of his children, was spent in making drawings in vast numbers and as varied in subject as possible, for pupils to copy. His eldest son, Miles Edmund, assisted him in the routine work, first on a voluntary basis but later as a paid assistant.

It was Miles Edmund who stood in for him in periods of depression or incapacitating sickness. He did so in the autumn of 1841 when Cotman returned to Norfolk for an extended stay, which turned out to be his last and farewell visit to the land of his childhood and of more than half his adult years. For two months, Cotman travelled far and wide – sometimes with his old pupil, friend and patron, the Revd James Bulwer – in a grey landscape drenched in rain, swept by high winds and much of it swallowed up by floodwaters. Many of his sketches, and the drawings made from them, survive, and they constitute a telling

testimony of his attachment to the environment which nursed the budding artist in him. Some of these drawings were intended to form the ground plans for paintings in oil, two of which were in fact started at around the turn of the year. The composition of the one which survives, and is his last painting, was worked out through a number of drawings, and it shows a view from his father's house at Thorpe, glorified into a grand residence (which it certainly was not). As had often happened in similar circumstances, the elation he experienced during his Norfolk visit, and the feverishly intense activity afterwards, ended in a deep plunge of spirit; but this time no upturn was to follow. Cotman died on 24th July 1842 – not through some killing disease, but because of a lack of desire to go on living. Outside his family, his death hardly caused a ripple; the deafening silence surrounding it was a better proof than any – if proof were needed – of how justified his dejection was.

It was a good but weak man and a great artist who slipped out of life so quietly in his sixtieth year, after a professional career of four decades. His story is unsatisfactory, because it has neither the cheerful and exhilarating colour of success nor the majesty of tragic failure. He led a mediocre existence and earned a mediocre reputation, when what he longed for was both the more elevated life-style he had tasted in Yorkshire and the success and fame his beginnings had seemed to promise and his achievement certainly merited. After his rejection by the Old Water-Colour Society, and possibly his disappointment at Trentham, he chose retrenchment instead of fight, returning home to tend his wounds and carve out for himself a provincial career of artist-cum-drawing-master. From the time he married and started a family, the duties of a caring husband and good father overrode all other considerations. The worries of Cotman the over-concerned provider influenced and guided the steps of Cotman the artist, to the great detriment of the latter.

The first phase of his art is rooted in the topographical tradition of English landscape painting, which by his time had become moulded by the prevalent ideas of the picturesque and also by that basic attitude of the romantic movement which found the lure of the distant past irresistible. Humble dwellings, with roofs dishevelled and peeling walls tottering, were subjects with as much appeal as the rugged ruins of mediaeval castles, watermills, ancient churches, quaint corners of old towns, and so on. The technique employed was developed from inoffensive tinting, starting with a foundation of neutral washes over a groundwork in pencil which, in Cotman's watercolours, was often so light as to be almost undetectable. The extensive use of the fugitive indigo in the cool half of his palette shows up today as a preponderance of brownish-rusty-reddish tones in many of his early works, never intended by the artist and never experienced by the contemporary viewer of his work.

The Greta drawings are radically different, both in subject and technique. Cotman severely repressed (or forgot about) his interest in the picturesque and in architecture, concentrating for a while on 'nature' as she displayed herself in the plants and trees hugging the precipitous banks of the Greta. The green vegetation merging in screens of curious surface patterns and often invading the entire sheet he was working on did not induce Cotman to analytical studies: rather it made him concentrate on its inherent structure, which found visual expression in the interlocking patches of light and dark areas and contrasting hues. A previously undetectable inclination to abstraction manifested itself in a way seldom seen in painting before: he achieved this without forcing nature into the straitjacket of an idiosyncratic or preconceived style. At the same time the neutral washes disappeared and the usually gentle hues were directly applied to the paper, producing a feeling of closeness with nature and a spring-like freshness.

In his first Norwich period yet another change took place. His genuine love for architecture reinstated it as one of his prime subjects and he gave the representation of interiors more emphasis than it had received before. His colours became dense, organising themselves into inevitable complexes of large, homogeneous blocks where void and matter had equal significance. The abstraction which first appeared in the Greta drawings became more obviously assertive. All things accidental were banished, and what remains appears to be there because of the inner logic (both in colour and form) of the composition, rather than because of the artist's interest in representation. The perfection of these drawings is such

that some admirers of Cotman came to regard it – most unjustly – as a fault. When writing about the large *Byland Abbey* at the Norwich Castle Museum, Kitson wrote: 'The drawing is fine in colour and so admirable in arrangement as almost to defeat its object as a picture, since there is no divine accident here to veil the completeness of its pattern.'

In Cotman's occasional work during the Yarmouth years, the trends of the previous period prevailed, but in the last two decades of his life his art moved in a new direction. He added historical figure pieces and colourful continental scenes to his repertoire and increased his output of seascapes, perhaps collaborating in many of them with his son Miles Edmund. His colour range changed towards a preponderance of blues and yellows, and a sometimes harsh brightness so prevalent in the work of many of his contemporaries. An exception is the large group of the 'paste medium' drawings, which are almost monochromatic with a blackish grey predominating.

Taking his oeuvre as a whole, Cotman is as good as any of the finest watercolourists and landscape artists of his day (only the relative smallness of his output in oil prevents his being considered a leading figure in that medium as well). If, however, one concentrates entirely on the output of his greatest period, that between 1805 and 1812, he stands out as a supreme artist with more marked individuality than any of his contemporaries, not excluding Turner.

Miklos Rajnai

Cotman: romantic classicist

Haydn once said that years of isolation at the court of Eszterháza had forced him to be original. Cotman's isolation was of a different, more desperate kind, and if it did not force him to *be* original it perhaps drove him to remain so. In its inventiveness and range over a career of forty years, Cotman's originality is still one of his most astonishing qualities. Within recognisable traditions, he is like nobody else, and within certain constraints which he could not escape, he rarely stood still. He repeated himself: of course. But Cotman's repetitions are not complacent as those of lesser men can be – he never had enough success to afford that. They are more like a musician's variations on cherished themes; each one a subtly different adventure in feeling, texture, tone, medium, design or colour. For sheer versatility only one contemporary – Turner – could match him, and Turner was operating on a much vaster imaginative scale.

A great Cotman always jolts one with a kind of delighted surprise. It is not just a question of poetic response to a particular subject, though one does feel grateful that such frequent attraction towards the romantic picturesque can be expressed with such taut, spare elegance. The surprise is formal: the refined but vigorous individuality of the handwriting; the clean-cut clarity of vision; above all that indefinable sense of an inspired *mise-en-page* – unexpected, dramatic, graceful, unfussed, unfailingly 'right'. With the hindsight of a later age we tend to say that what excites us is something 'abstract' about Cotman's power of design. It is a dangerous word to use when what we refer to is an ability to convey complex representational information with daring economy of means. But it is true that Cotman's 'new style' was too daring, too self-conscious and private to make much sense to most of the lay audience of his own day (one remembers Francis Cholmeley's kindly-meant advice about the beautiful 1811 etching of trees in Duncombe Park – 'two-thirds of mankind, you know, mind more about *what* is represented than *how* it is done'). It is also possibly significant that appreciation of Cotman begins not merely when the presentation of the Reeve collection to the British Museum in 1902 made his achievement better known, but when the word 'abstract'

itself was just surfacing in the critical vocabulary as a significant term.

This quality in Cotman's style is quite extraordinarily forward-looking – which is what we mean when we flatter ourselves that it can still appear 'modern'. His use of interlocked silhouettes, dark against light, light against dark, creating pattern *across* the flat surface of the page, is something that did not become familiar until the Symbolist Movement in France or the Aestheticism of the 1890s in England. In fact, I would venture to say that there is more in common, in terms of compositional pattern, between Cotman and the *cloisonné* effect of a Beggarstaff Brothers poster or even the landscapes of Klimt and Schiele, than between Cotman and any other nineteenth-century painter. There is even a late picture in the Norwich Castle Museum of dancers by moonlight in front of a classical temple which one might be forgiven for thinking was a Benois design for Diaghilev. But that said, there are the differences – of intention as well as effect. One is a matter of organisation in depth, another of that elusive quality we define as classical instinct informing a romantic vision.

Where Cotman's unmistakable style 'came from' is one of the open questions of art-history and the unexplained wonders of genius. It seems to start beyond the influence of Girtin but during Cotman's involvement with the Sketching Society (whose leadership he took over from Girtin). This was when he had barely turned twenty. The Yorkshire tours of 1803–1805 encouraged it to flower, but they did not begin it. In fact, most attempts to 'explain' it offer suggestions just a year or two too late to do more than support his new direction rather than point out its inspiration. There is evidence of his having owned, perhaps surprisingly at that time, a book of Chinese wash-drawings of figures and landscapes: more than one critic has paused to note the 'oriental' finesse of the Greta drawings. There is also the possibility of his having seen Francis Towne's retrospective exhibition in London in 1805. Towne's distinctive style of outlining thin colour-washes is certainly a striking parallel with Cotman's discovery of thin, 'flat' colour; but it has nothing of Cotman's feeling for depth. Cotman would always find the effective silhouette to convey complicated mass, but he would set off each silhouetted edge, however slender

or ragged, with a clear tonal contrast, which makes some of the earlier monochromes look almost like cut-out theatrical scenery, stepped back sequentially in space. He would let mass register as a flat plane – and this is where his interest in architecture helped him – but encourage the eye to follow through to shadowed openings past or beyond it. It could be an archway, a small window or just a hollow between trees: what Adele Holcomb has imaginatively called his 'poetry of entrances'. Or he would clear the way to a wide horizon, set provocatively high or low on the page: uncluttered horizontal width is another of his compositional 'surprises'.

But if Cotman, suggestively, looks forward, he also, evocatively, looks back. Derived as it is from a topographical tradition, much of that looking back involves a late eighteenth-century taste for the picturesque. But Cotman's Gothic goes hand-in-hand with its opposite. Turner, who was only seven years older and greatly admired by him, is again the only contemporary one can compare him with for quite open resort to eighteenth-century standards of classical landscape – that is to say, the traditions of Claude (in Turner's case) and of Poussin and Gaspard Dughet (in Cotman's). Cotman goes right against the early nineteenth-century bias towards Dutch-inspired naturalism which motivated so much of the landscape of his age – the work of Peter de Wint, David Cox, the whole Norwich School from Crome onwards, and above all, of Constable. The clarity of his design is classical. The sense of antique Arcadia in an English setting is Poussin anglicised via eighteenth-century landscape gardening (the effect on him of a week's stay at Castle Howard when he was twenty-three was probably lifelong). But there is a lightness and grace to Cotman's idiom which should more properly be called neo-classical. Except in architecture and applied decoration, Neo-classicism surfaces in English art rather late and mainly in figure-drawing – in Blake, for example, Fuseli or Flaxman's widely celebrated Homer illustrations. Only in Cotman can one sense its presence in landscape painting. If there is one contemporary who matches Cotman's unique blend of neo-classic elegance with picturesque incident, it is that idiosyncratic architect, Sir John Soane. Soane's famous low, elongated arch has as much to do with what Cotman

made of Greta Bridge as the actual Greta Bridge did.

The role of architecture in Cotman's art has something also to do with the fact that his vision of landscape is not really a countryman's. There is no doubting his love for the Norfolk scenery that bred him: his letters, falling over themselves with enthusiasm and exclamation-marks, bear witness to that. Its skies, heaths and seascapes are frequently made the vehicle for his most charged emotion. But there is not the intimacy in his love that a Crome or a Constable would bring to one treasured locality. Cotman sees Nature through the glass of Art. It is something to be impassioned about but not to convey as 'truth'. 'Enchanted bath-sponges' was a not unsympathetic description of his trees in some of the Greta drawings, and his later notation for massed foliage, superb in its generalised linear rhythm and movement, has been rather more unkindly dubbed his 'bunches of bananas' technique. But architecture of itself alerts and re-inforces Cotman's innate sensitivity to shape, spacing and interval. It conditions his mode of feeling and his attitude to picture-making as in the work of no other English painter. Even in the antiquarian hack-work to which he was often reduced during the entire decade when he virtually gave up painting for etching, he has few equals as an architectural draughtsman. When a particular building sparks his imagination, he has none. From

John Sell Cotman, *Classical Dance*. Watercolour. Norfolk Museums Service (Norwich Castle Museum).

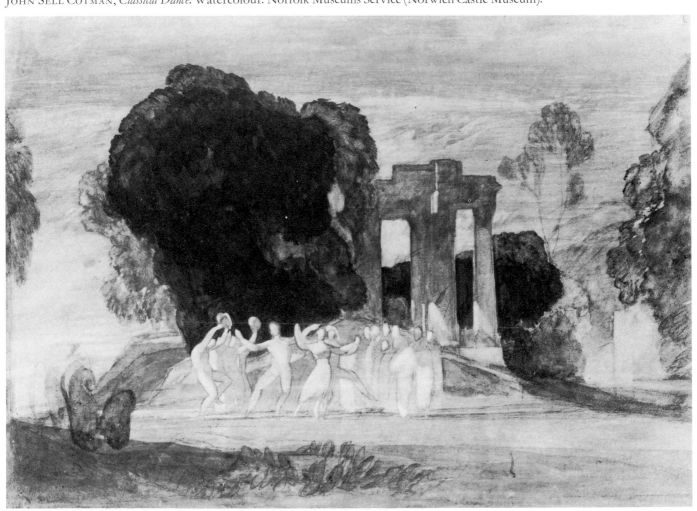

crumbling cottage or Gothic ruin to the majesty of Chirk Aqueduct, architecture informs his design, his detail, and in particular his sense of the ever-present involvement of man in the continuity of time.

Cotman's arresting virtuosity as draughtsman tends to overshadow his subtler power as a colourist. When talking of an artist's colour, one has always to distinguish between the merely 'colourful' and what might be called an organic understanding of colour, colour which grows from a ground-base. Cotman's colour-base can be almost neutral, never more resonant than when he is working in monochrome. But he can reach out from, say, an establishing tone of muted green-brown to a radiant blond-gold or a stabbing blue in the sky, either of which derives organically from the colour-base. The result is a contained strength quite as functional to the way the painting 'works' as the logic of its design. For the period of the 'fancy' pictures in the 1820s and 1830s, when he was straining to catch public attention, Cotman does add bright hue to bright hue for intentionally decorative effect. What usually he avoids, even in his gold and blue paintings, is pitching hot colour against cold – intense red, for example, against intense blue – as Turner never hesitated to do. It is the essential difference between them as colourists. Turner's purpose was dynamism – elemental contrast: fire, air and water. Cotman's was harmonic. His element was earth, given form by shadow and warmed by light. The late and still underrated paintings in his invented 'paste' medium (one has to remember that sheer cost limited his resort to oils, just as it limited the size of his work) are closer in spirit than the landscapes of any other artist to what Constable, at this same time, was striving to define as 'the chiaroscuro of Nature'. Cotman's colour extends that idea in a direction which is peculiarly personal and, over the range of his output as a whole, one of the most consummate achievements of English painting: a vision which embraces romantic grandeur and idyllic calm, but never fails to hold the imagined and the real balanced precisely in the scales of art.

David Thompson

Cotman and his patrons

In his article 'Cotman and his Public' in the *Burlington Magazine*, written on the centenary of Cotman's death, Paul Oppé sought to modify the generally held view of his lack of patronage and critical recognition. 'An extreme instance of the maladjustment of the artist to ordinary life,' Cotman was, wrote Oppé, 'constantly striving to prove, against himself and the outside world, his industry and his integrity.'

Cotman's letters are documents of his 'volatile and weak' nature, from the heights of jubilation (when he was carried along 'hotly and madly', but seldom for long), to the depths of despair (often 'deep and deadly'). They are seldom records of him at his most normal. He joked with his son John about his habit of changing the subject without warning. 'What effect! What contrast!!! from the sublime to the ridiculous, not one space between'. His friends and patrons were outlets for his highly strung nature. He often needed them to boost his flagging spirits or to discuss with them his plans. He worked hard for 'Reputation, and consequently a fair standing amongst my friends'. When he pleased them 'twas an equivalent to Reputation' which he felt he had earned 'for industry if not for talent'. It gave him inordinate pleasure to be told by the principal of King's College School: 'Mr Cotman you have good friends. You have retained them, and you are formed to create them.'

Many letters have survived but Cotman himself destroyed 'all papers relating to occurences before his marriage'. This his son Miles regretted for, although his father had seldom talked 'of his early days or of his early

patrons', some letters 'would have proved how much he was esteemed as an Artist and as a Man by persons to whom it was alike honourable and pleasureable to be known'.

As a young and ambitious artist Cotman had worked for Ackermann and other printsellers. His experiences with Dr Monro and members of the Sketching Society opened up more contacts. His 'first warm friend' was Sir Henry Englefield, an 'enlightened and ardent promoter of topographical and antiquarian works' as Cotman described him on his etching of Walsoken Church (1817). Englefield had proffered advice 'as to price & mode of Execution' and given him etchings by Piranesi as models to follow. Cotman in return dedicated to him in 1811 his first series of etchings. Sir Henry died in 1822 but was long remembered, not least because he had introduced Cotman to Brandsby in Yorkshire, home of Sir Henry's sister Mrs Cholmeley.

The Cholmeleys retained a permanent place in Cotman's affections long years after his three visits to them in 1803, 1804 and 1805. 'We took you in as the friend of Sir H. Englefield but we shall now be ever happy to see you as our own,' Cotman remembered Mr Cholmeley saying after his first visit. It was 'the sweetest piece of flattery'. Cotman was not exaggerating in claiming to have spent his 'happiest and blithesomest hours' there. Mrs Cholmeley promoted him as her protégé, while her son was to become his close friend and confidant. He found patrons in the Worsleys at Hovingham Hall, the Morritts at Rokeby Park, the Smyths at Heath Hall and the Bellasis family at Newburgh Priory. He also went to stay at Castle Howard whence may have originated his invitation in 1806 to Trentham Hall, seat of the Marquis of Stafford. 'The Patronage of ye most rich and powerful is very rarely so advantageous as it ought to be,' cautioned Mrs Cholmeley and sensibly advised him diligently to cultivate the friendship of Dawson Turner and 'never by any indiscretion forfeit it'.

Dawson Turner was perhaps the key figure in Cotman's career and his letters to Turner during nearly forty years of 'constant and steady friendship' must form the core of any study of the artist. The artistic temperament bewildered Turner whom Haydon called 'an immense living Index', his mind 'ever on the look out,

but never on the *look in*'. This methodical, businesslike banker did, however, have a genuine regard for Cotman's talents, and tried hard to understand his weaknesses. 'Without such a friendship,' Cotman admitted, 'I must have sunk under the intolerable load of bodily & mental affliction.' Shortly after Cotman's death Turner wrote: 'His name will always live by his etchings, which I had the great satisfaction of mainly inducing him to execute.' Cotman, he wrote, 'regarded them as a degradation to his talents'. At the outset of his career as an etcher Cotman had told Cholmeley 'it gives me spirits, for I fancy a long line of patrons'. Eight years later he wrote: 'My works have gained me credit in y world & I have been introduced through them to many of the first men in London.'

Above all, however, Cotman wished to be known as 'the Man claiming rank as an Artist, my glory & my Pride'. Here Turner was little help but through him he met others whose help he could call on – Turner's partner Hudson Gurney was one. 'He supplied me with money,' Cotman wrote, 'like a prince', and saved him 'from actual ruin'. He had been a 'noble, noble Gentleman'. When Turner's daughters, who had all been Cotman's pupils, married, they and their husbands John Gunn, John Brightwen and Francis Palgrave all helped and supported him. Cotman was 'most eager to cultivate and to deserve' Palgrave's friendship. Brightwen was a partner in the bank and Cotman was 'very sensible of Mr Brightwen's kind recollections . . . by receiving orders for Drawings from his friends'.

Through Turner Cotman probably met the Revd Charles Parr Burney whose purchases included one of Cotman's own favourite compositions, the *Abbatial House of St Ouen at Rouen* (V & A). Cotman dispatched one 'Kind & friendly order' to Burney in November 1824. He had 'been tried & found sterling', admitted Cotman to Mrs Turner. In the summer of 1826, in an almost suicidal depression, Cotman informed Burney that his situation was 'deplorable'. His state of mind was 'one of chaos of agony'. 'Wonder not then with these horrors upon me that your Drawing is not forthcoming . . . My power of action is gone.' By November he had recovered: 'I will rise, or fall, but to stagnate, whilst the tide is running is death to me.' In November 1827 he wrote again to

Burney, still waiting for his watercolour. 'I fear I bare [*sic*] with apparent justice a tarnished name in your estimation.' The 'wretched and overwhelming' events of 1826 had caused him, he explained, to recoil 'from your Drawing as from a precipice'. He now assured him 'I have gone on with no drawing – (excepting by Lessons) notwithstanding I have longstanding orders'.

Other patrons in the 1820s included J. Eager, a Norwich music master, Charles Turner, a local collector, Joseph Geldart, a pupil, John Bridgman, whose daughter was a pupil, and William Roberts, a Birmingham businessman and amateur artist who exhibited in Norwich.

Cotman's Normandy drawings were auctioned in 1824 and James Christie reported that John Allnutt 'one of the most liberal buyers of modern drawings tried to obtain some of the coloured ones' but was outbidden. Given the very low prices obtained, this seems strange. In 1825 Cotman exhibited at the Water Colour Society for the first time. Of his three exhibits at least two were loans. Orders were placed for all three at the private view and Cotman was 'quite satisfied... with the stand they made... moreover,' he added, 'my purchaser is satisfied too'. He also received orders for two oils at eighteen guineas each. In 1833 the *Norwich Mercury* for 10 August noted that all eight of Cotman's exhibits in London had been sold. The following year he became a resident there.

One patron during this period was a banker from Saffron Walden, Francis Gibson. He also admired and bought some of Cotman's early works. He had literally to wait for years before his first commission was delivered, Cotman having lost it. Not deterred, Gibson wrote to reserve another exhibit but received no reply for almost two months, Cotman's 'misfortunes' during that time having been 'excessively heavy – both bodily & mentally'. Fears that his good character had been marred as usual obsessed him.

Three of the most important people in Cotman's life in the 1830s were James Bulwer, William Henry Harriott and John Hornby Maw. They were all keen amateur artists and Cotman used their sketches for a number of his own works. Bulwer considered that from 1827 to Cotman's death he had seen more of him 'than any individual not of his immediate family'. Cotman wrote of their never having 'had a minute's disagreement'. 'Fortunately for me,' he informed Turner, 'he draws and colors admirably.' Bulwer owned several hundred drawings and watercolours by Cotman, among them masterpieces such as *Greta Bridge* and *A Dismasted Brig*. After being the minister of St James's Chapel in Piccadilly, Bulwer moved to Norfolk in 1839. 'I miss you much,' wrote Cotman, '& I knew I sh^d for you have always been most kind to my failings.' He discussed with Bulwer his hopes of producing a series of prints of foreign views, a plan involving his friend W.H. Harriott, a clerk at the War Office who was a regular traveller abroad. 'Our first few hours acquaintance proved his knowledge of my character,' he told Turner, '& his own noble and unsuspecting nature.' Harriott was ready to allow Cotman to use his sketches which, wrote Cotman, 'are very fine and ought not to be lost to the world'. But Cotman was undecided whether to adopt lithography or mezzotint and the scheme was abandoned.

The third of Cotman's important patrons of the 1830s was J.H. Maw, a manufacturer of surgical instruments. Like Bulwer he possessed a fine collection of watercolours including about fifty by Cotman. Maw also had to wait many months for the dilatory Cotman to fulfil his commissions.

It would be easy to see Cotman's last years as a drawing master as unrewarding, but his friends kept his hopes alive. 'Age,' he lamented 'has overtaken me perhaps prematurely... without having accomplished what I hoped to have done – but this is but the lot of millions.'

At his creative best, his cares forgotten, Cotman wore an old morning gown, a green shade, smoked cigars, ate grapes, and was surrounded by books and prints. For company he had his black cat (he was deeply superstitious) and his dogs Titian and Rubens. Then, but only then, was he in his element.

Michael Pidgley

Note

I have dealt more fully with some of the issues raised in this essay in: 'John Sell Cotman's Patrons and the Romantic Subject Picture in the 1820s and 1830s', unpublished doctoral thesis, University of East Anglia, 1975

Cotman and his publication projects

Between 1810 and 1822, Cotman produced seven antiquarian publications, containing between them 403 prints. Of these the series of greatest aesthetic interest are the *Miscellaneous Etchings* (1810–11), the *Architectural Antiquities of Norfolk* (1812–18), and the *Antiquities of Normandy* (1819–22). Much of the remainder were executed by assistants. To understand why Cotman devoted so much energy to such works it is necessary to see them in historical context.

Since the sixteenth century, travel, antiquarianism, genealogy and heraldry had been common pursuits of the English landed gentry and provincial bourgeoisie. By 1821 a writer in the *Quarterly Review* could claim:

Every nook in our island has now been completely ransacked and described by our tourists and topographers. If we call over the Counties one by one, their historians will be seen marshalling their ranks in quarto or in folio . . . Nor has the pencil been employed with less diligence than the pen. It would be difficult to name any structure of the 'olden time' which has not been transmitted into the portfolio and the library.

Such studies multiplied in the eighteenth and nineteenth centuries, partly, no doubt, because they offered a process of legitimation through which the growing ranks of the rural and provincial bourgeoisie could establish their roots in the respectable tissues of English society and be seen to share the same interests as the gentry. In his *Antiquities of Norfolk* Cotman dedicated many of the plates to subscribers to the work, so that the plates present a sequence of dedications in which Norwich bourgeois and local clergy rub shoulders with the landed gentry in a juxtaposition which clearly expresses the binding role which local history and antiquarianism could play in provincial society.

The widespread enthusiasm for these pursuits among the wealthier social groups had an important influence on British art. By the early nineteenth century, the demand for illustrated local histories and traveller's guides had helped to foster a highly sophisticated school of topographical landscape painters and engravers. The drawings which Turner, Girtin and a host of lesser artists provided for publications such as Hearne and Byrne's *Britannia Depicta* (1806–18), Britton and Brayley's *Beauties of England and Wales* (1801–15), and Whitaker's *History of Richmondshire* (1823) are only the best known of a huge corpus of similar work. In the field of antiquarian topography, the early part of the century was dominated by John Britton (1771–1857), who published a stream of progressively more scientific publications from 1801 onwards. The changing character of the five volumes of his *Architectural Antiquities of Great Britain* (1807–26) is an index to the increasingly serious interest in Gothic and the consequent sophistication of archaeology.

The rising prestige of Gothic is partly explained by developments in British aesthetics in the eighteenth century, but a remark in the preface to a collection of essays on gothic architecture published in 1800 indicates another reason for this:

This style of architecture may be properly called English architecture, for if it had not its origins in this country, it certainly arrived at maturity here . . .[1]

It is hardly surprising that a new pride in British antiquities should develop in the years 1793–1815, a period of more than twenty years of warfare, broken only by the brief Peace of Amiens, in which the dominant groups mobilised nationalist sentiments to an unprecedented degree, partly to divert attention from discontents at home and fix them on an external enemy. The extreme national feeling associated with the claim that the Gothic style had been invented in Britain can be gauged from the controversy provoked by George

Whittington's *Historical Survey of Ecclesiastical Antiquities of France* (1809), which was intended to refute a view supported by many in the powerful Society of Antiquaries. Whittington demonstrated the priority of French gothic architecture, and his book was accused of being 'anti-national', and 'ungracious' or even 'hostile' to 'British genius'.

In a period when a second invasion from Normandy sometimes seemed a possibility, the question of whether the Saxons had a significant architecture of their own before the Conquest also became an issue. The general opinion was that prior to the Conquest the Saxons had fallen into a degenerate state and lived in 'low and mean buildings'. The Normans, by contrast, were 'moderate and abstemious', and had re-introduced 'civility and the liberal arts' and revived architecture.[2] Underlying this view was a political ideology. In the early eighteenth century, several Whig theorists had maintained that the British constitution had its origins in the Anglo-Saxon Witanagemot, and that the Normans had usurped traditional rights. As the century progressed, most Whigs abandoned this appeal to an ancient constitution, and rested the authority of government on the settlement after the Glorious Revolution of 1688, leaving it to the reformers and Jacobins of the 1790s to revive the idea of ancient rights in support of their campaigns for a parliament based on manhood suffrage.[3] So it is not surprising that when James Storer criticised William Burdon's usage of the term 'Norman' in an article in Britton's *Architectural Antiquities*, Burdon should accuse him of being 'a very violent and injudicious friend of liberty', who could not bear to see British architecture as the creation of the Norman oppressors of Saxon liberties.[4] Cotman's antiquarian publications were thus produced in a period of intense and unprecedented interest in Gothic, which had become connected with a variety of political and social values.

Cotman patterned his works partly on those of John Britton, and it is possible that Britton first interested him in antiquarianism as he did several other young artists. Cotman made a few drawings for Britton early in his career and relations between the two men remained friendly. He was also encouraged in such work by Sir Henry Englefield, a leading figure in the Society of

Antiquaries and an amateur etcher himself, to whom he dedicated the *Miscellaneous Etchings* of 1811. After his return to Norwich in 1806, Cotman encountered a number of enthusiastic local scholars: William Stevenson, William Gunn and Dr Sayers, all of whom wrote on the Gothic. However, in sustaining his antiquarian enthusiasm, the Yarmouth banker Dawson Turner, who was the very type of provincial bourgeois antiquarian discussed earlier, undoubtedly played the leading role. Most of Cotman's publications were produced during the years 1812–23, when he was living at Southtown near Yarmouth and teaching drawing to the Turner household, but it needs to be stressed that Cotman did not undertake these works simply at Dawson Turner's bidding and he undoubtedly hankered after the reputation of draftsmen such as Charles Alfred Stothard, whose *Monumental Effigies* had begun to appear in 1811, and whose position with the Society of Antiquaries he hoped vainly to fill after Stothard's death in 1821.

'An artist not ambitious is an anomaly – that I must confess I do not understand – ', Cotman once wrote, and when he was learning to etch he took as his model the acknowledged master of the architectural print, Giovanni Battista Piranesi. The influence of Piranesi is evident in the dramatic viewpoints and lighting which Cotman employed in some of his plates, and also in the atmosphere of crumbling decay which he evoked, particularly in the *Miscellaneous Etchings* and the *Antiquities of Norfolk*. In the first of these Cotman was still feeling his way technically, but despite the increasing sophistication of the *Antiquities of Norfolk* he did not attempt to copy Piranesi's technique. The character of the style he developed must again be seen in context.

In 1814 the first number of George and William Cooke's *Picturesque Views on the Southern Coast* appeared. 'The movement in the practise of engraving here commencing forms an epoch in its history . . .', wrote one of George Cooke's obituarists.[5] Cotman had admired the Cookes' *Thames* etchings, published in 1811, and he was to become a close friend of the Cooke family. The type of topographical engraving produced by the Cookes and others such as Henry Le Keux, which contained a considerable amount of etching anyway, was increasingly to provide the inspiration for Cotman's style. The free

etching style which he had used in the early plates came to look increasingly amateur, partly owing to the standards set by these engravers. In the early nineteenth century, engravers such as John Landseer were campaigning vigorously to have engraving recognised as an art in its own right, and to change the rules of the Royal Academy, which allowed engravers only Associate status. In May 1821, a group of engravers which included the Cookes and Le Keuxs even took the novel step of organising a special exhibition of engravings at 9 Soho Square. Cotman may well have been influenced by these efforts to establish a new status for engraving, and as a result sought for a more engraved effect in his own work.

Other pressures included problems with his eyes, which obliged him to employ assistants from 1814 onwards, and perhaps to develop a more mechanical technique which could be easily imitated by others. He also seems to have been pressed to produce more 'finished' work by his patrons, and particularly by Dawson Turner. As a result, the *Antiquities of Norfolk* became progressively more restrained over the six years of its publication, and his Normandy etchings were still more so.

Until the *Antiquities of Normandy*, Cotman's works had been directed largely at a local market, but in this, his most ambitious publication, he consciously tackled a controversial subject of general antiquarian interest. In 1817 he carried with him to the continent a copy of Whittington's *Ecclesiastical Antiquities of France*, 'decidedly the best written book I have ever read on the subject – '. His exploratory tours to Normandy in 1817, 1818 and 1820 were partly financed by Dawson Turner and Hudson Gurney, Turner's banking partner. Gurney, who was to be Vice-President of the Society of Antiquaries from 1822–46, regarded a proper study of Norman architecture as a 'National desideratum', although his interest in it was certainly enhanced by the idea that his own family was descended from one of those which had accompanied the Conqueror. Dawson Turner, who had

himself examined Norman architecture on tours in 1815, 1818 and 1819, was finally persuaded to write the letterpress to the work late in 1819, thus adding the reputation of an antiquarian to that he had already acquired as a botanist.

Despite the assistance of his patrons, the *Antiquities of Normandy* did not bring Cotman the fame and wealth for which he craved. His business sense was always poor, the book was over-priced, and a considerable number of copies were still unsold in 1830. Perhaps in attempting to combine serious archaeology with picturesque interest he had misjudged his market, or at least so John Britton implied in the introduction to his own *Antiquities of Normandy* of 1828. Whatever the reason for its comparative lack of success, Cotman produced no further antiquarian work. He was later forced to sell his plates of British antiquities for a derisory £100 to Henry Bohn, who threw together a new edition in 1838, after having many of them butchered by rebiting. It is not surprising that Cotman came to look back with bitterness on his antiquarian labours as a 'degradation to his talents'. Yet in a portrait of 1830 he had himself shown clutching a large volume entitled *Normandie*, an indication of his justifiable pride in his achievement.

Andrew Hemingway

Notes

Some issues raised in this essay are discussed more fully in my articles in *The Walpole Society*, Vols. XLVI and XLVIII.

1. Revd T. Warton *et al., Essays on Gothic Architecture*, 3rd edition, London 1808, p.iv.
2. *Ibid.* pp.63–4. Cf. H. G. Knight, *An Architectural Tour of Normandy*, London 1834, p.224.
3. H. T. Dickinson, *Liberty and Property*, London 1977, esp. pp.63–4 and p.204.
4. *Gentleman's Magazine*, Vol.83, July–September, 1813.
5. *Arnold's Magazine*, 1834, pp.553–60.

JOHN SELL COTMAN,
*Cherbourg, c.*1820–22.
Brown wash. Norfolk
Museums Service
(Norwich Castle
Museum).

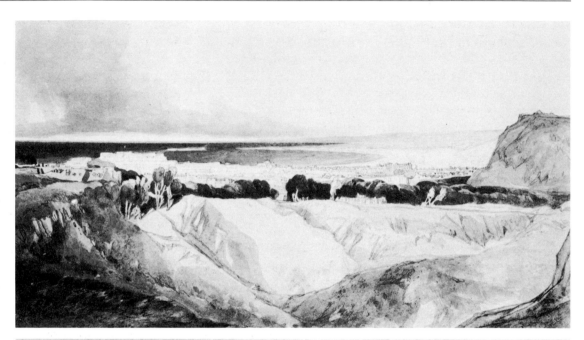

THOMAS GIRTIN,
*A General View of Paris
from Chaillot* (detail).
Etching and water-
colour. Fine Art
Society, London.

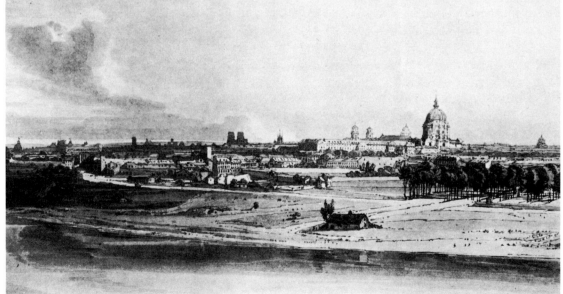

26

Cotman and Normandy

'It is quite certain that in Normandy an Englishman feels himself as much within the pale of English history as if he were in Yorkshire.' This comment in *The Quarterly Review* of April 1821[1] might well have been made about Cotman, for whom Yorkshire and Normandy were the central experiences of his life. During his three tours of Normandy in 1817, 1818 and 1820, Cotman regained briefly the personal and artistic freedom he had felt so intensely at Brandsby and on the banks of the Greta a decade before. Normandy yielded hundreds of pencil, sepia, some watercolour drawings and oils and a set of ninety-seven etchings which form the core of the artist's achievement in the last two decades of his life.

Many British artists and middle-class travellers had visited France during the brief periods of peace in 1802–3 and 1814–15. Among them, the leading artist of the Norwich School, John Crome, made his only trip abroad, to Paris, in 1814, when Dawson Turner, the patron whom he shared with Cotman, also went, recording his tour in a lengthy manuscript journal. For most, Paris (with the Louvre) was the principal place of pilgrimage. Although there had been English communities since the eighteenth century in Normandy, at Dieppe, Caen and Rouen, few went further afield until after 1820.

Cotman was one of the first British artists to go to France after Waterloo. The Norwich painters John Berney Crome, George Vincent and Joseph Clover preceded him by one year, travelling to Normandy in 1816. But of the mere sixty French subjects shown at the Royal Academy between 1815 and 1827 only twenty-four were of Normandy.

Henry Edridge followed Cotman in the autumn of 1817 and made another trip in 1819, but his tours were made more for pleasure than for any serious antiquarian pursuit, for 'the extraordinary things that France produces – Magnificence and Filth – The Formal and the Picturesque'.[2] He found Rouen 'more picturesque than you have any idea of' and of his eleven French subjects shown at the Royal Academy, seven are of Rouen. Edridge set a pattern that was relentlessly exploited by Samuel Prout whose visits to Normandy in 1819, 1820, 1821 and possibly 1828 yielded drawings with which he flooded the exhibitions of the Watercolour Society from 1820 until his death in 1851. Prout's actual itineraries are little known although lithographs dated 1821 show a tour from Rouen to Le Havre in 1820 and in 1821 he took in the area around Mont St Michel. Turner made his first trip to Dieppe, Rouen and Paris in 1821, followed by others in 1824, 1826, 1828 and possibly 1829. Richard Parkes Bonington also travelled in Normandy in 1821 with the French artist Alexander Colin and accompanied Prout in 1822 on a tour of the Normandy coast. It was the exhibited works and publications of Bonington and Prout above all which launched Normandy on the English public, and a host of other English artists, among them William Callow, Peter de Wint, David Cox, Thomas Shotter Boys and William James Muller, followed in their wake in the late 1820s and 1830s.

Cotman's three tours of Normandy, totalling at least twenty-nine weeks in all, are the most extensive undertaken by an English artist between 1815 and 1820. They are also the most fully documented: Cotman's vividly descriptive letters home provide a detailed day-by-day account of his experiences and activities. From Normandy, too, he wrote that his 'Sac d nuit' was 'full of Norman Book' and his 1834 and 1843 sales included some fifty works on French history and architecture. While he was undoubtedly influenced by Norwich friends and patrons who had been to Normandy, the idea of a publication on Normandy architecture was Cotman's own; although Hudson Gurney rightly sensed that the antiquarian in Cotman would always bow to the artist.

By his third tour Cotman was planning a publication which never came about: 'to bring out a Splendid Book (if I can find engravers to join with me) on the picturesque scenery of this most delightful country'. He may have had in mind Girtin whose twenty soft-ground etchings of *The Most Picturesque Views in Paris*, 1803,[3] were exhibited at Spring Gardens at the same time as Girtin's panorama of London, the famous vanished Eidometropolis. A series of outline drawings and related monochromes of Normandy, all similar in size and of assured high quality and verve, were almost certainly made with Cotman's cherished project in mind. Many are distant, wide-angled views with a middle horizon, where the landscape unfolds in a receding succession of horizontal planes. These drawings, of Arques, Mont St Michel, Coutances, Cherbourg, Fécamp, Dieppe and Rouen, where distant buildings are crisply and accurately drawn, owe a debt to the panoramas of London and Paris by the Barkers, father and son, and by Thomas Girtin – which, according to Constable, were 'all the rage' while Cotman was still in London in the early 1800s.[4] Cotman's fellow members of the Sketching Society, Robert Ker Porter and J. S. Hayward, were foremost panoramic view painters and his Norwich friend the Revd E. T. Daniell evidently copied Girtin's panorama of London.[5] Cotman may have also seen, on his return from London, John Serres' *Panoramic Picture of Boulogne* which was exhibited in Norwich around 1808. And his brother-in-law, John Thirtle, was also painting by 1819 atmospheric panoramic watercolours of Norwich, undoubtedly influenced by Girtin, which were a radical departure from the pen and wash townscapes, derived from Canaletto, typical of Farington and his followers Hunt, Edridge and Prout.

Like the panoramists, Cotman took his Normandy views from an actual vantage point, sometimes, as with *Rouen from Mount St Catherine*, from the edge of a perilous sheer drop. However, unlike the hard, unpicturesque views of the Barkers, Cotman's monochromes betray no mechanical verisimilitude; landscape and trees cloak the towns in an orchestration of tones, giving the composition that supreme balance which is Cotman at the height of his power. His response to the Normandy landscape was immediate and passionate. Of Cherbourg he wrote to his wife in 1820, 'You look down upon it as upon a fine

SAMUEL PROUT, *Coutances, Normandy*. Watercolour. Walker Art Gallery, Liverpool.

quarry of dead silver with here and there a tinge of Gold and the light and shadowed sides both comming off from the deep azure of the bay, as one mass of rich glowing pearl olour'. Himself bewitched, Cotman cast his own spell over Normandy, as years before he had spun enchanted visions of Rokeby and Greta.

The Normandy monochromes are nevertheless anchored in the natural world. They have an austerity which transcends the picturesque but does not approach the sublime. Cotman does not attempt the dizzy vistas, the dramatic high viewpoints and contrasting perspectives of land and water which Turner miraculously conveys in his tiny watercolours of Rouen and Dieppe – designs for his *Rivers of Europe*, of which the *Seine* was published in 1834.

But like Turner's compositions, which were worked up for the engraver from sketches made in soft-covered drawing books, Cotman's monochromes are studio drawings made from small summary pencil sketches, such as those of Coutances and Dieppe, or from detailed outline drawings probably drawn with the help of a camera lucida.

Cotman gave up his *Picturesque Views*. Not only were his energies fully stretched in his *Antiquities of Normandy*, but he was also pre-empted by a series of publications which appeared in the 1820s. Notable among these was Sauvan's *Picturesque Tour of the Seine*, with twenty-four engravings after Pugin and Gendall, published by Ackermann in 1821. Jolimont's *Rouen* and *Monumens de la Normandie* both followed in 1822, as well as Captain Batty's *French Scenery*. Osterwald's *Excursions sur les Côtes et dans les ports de Normandie*, with plates after Bonington and Copley Fielding, appeared in 1823–5, and Bonington brought out his *Restes et Fragmens d'Architecture du Moyen age* in 1824. All were overshadowed and outmoded by Baron Taylor's *Voyage Pittoresque et Romantiques dans L'ancienne France* (20 volumes, Paris 1820–78, of which the first two and the last volumes were *Ancienne Normandie*). This massive French undertaking in the new process of lithography included two hundred plates by English artists, among which were outstanding compositions of Rouen and Evreux by Bonington. (Lithography's relative cheapness and scope had surplanted etching, engraving and aquatint, but Cotman only experimented with it once and late: in 1829.)

Cotman's project would probably have failed, not only because of its costly, outdated production process but also, paradoxically, because of its forward-looking naturalism. The *Voyages Pittoresque* was essentially the last great romantic publication on the Gothic ruins of France; in Cotman's series, landscape – trees, rocks and riverplains – dominates, most dramatically in the views of Domfront and Mortain. Nevertheless, some of the drawings found an appreciative buyer in 1824 when Cotman was forced to sell at Christie's *One hundred and fifteen Picturesque and remarkable subjects in Normandy which have never been engraved*; his friend, the antiquary John Britton, bought twenty-two lots which he described as 'tasteful and beautiful picturesque views'[6] in the introductory essay to his own *Series of Engraved Specimens of the Architectural Antiquities of Normandy* published in 1828.

Britton was able to publish because Cotman had also misjudged his market with the *Antiquities of Normandy* which, Britton argued persuasively, 'appeals fairly and forcibly to the amateur and antiquary rather than to the architect and man of science'. Yet the Normandy etchings contain some of the finest plates produced in the period. The church façades of Rouen and Lisieux are sensitive portraits rather than architectural elevations, fully deserving the accolade they received when Cotman exhibited them with the Norwich Society of Artists in 1821. The landscape plates of Chateau Gaillard, 'a most magnificent Castle and as magnificently situated', of Falaise and of Arques are powerfully conceived and executed. They are rhythmic, sinewy compositions, their richly-woven broken lines held in fine control, against which the Piranesian pastiches of contemporaries such as George Cuitt (whom Cotman was advised to follow) look like smeared, theatrical daubs. Likewise, Samuel Prout's Rouen townscapes seem factory confections beside Cotman's taut, boldly structured, late Normandy watercolours: *Alençon* 1828, no.91, *Aumale* 1832 and the remarkable capriccio, *Hilly Landscape*, no.105.

The irony is that Cotman was not known in France. He did not attempt to visit Paris to contact French dealers or to exhibit at the Salon. At the memorable 1824 Salon, French critics found the English watercolours dangerously sketchy and unfinished. They might have found in Cotman a marriage between formal control and freshness of vision which looked forward to new languages – those of Whistler, and Cézanne.

Marjorie Allthorpe-Guyton

Notes

1. Quoted by Hammond Smith in 'British landscape artists working in France 1814–1824' unpub. MS 1975.
2. Hammond Smith *op. cit.*
3. Girtin's publication was in Cotman's 1843 sale lot 363.
4. Constable to Dunthorne 23 May 1803, Scott Barnes Wilcox 'The Panorama and Related Exhibitions in London', unpub. M. Litt. Thesis, Edinburgh 1976 p.62. This is the source for other references to Panoramas.
5. E. T. Daniell Sale, Christies 17 March 1843 lot 39.
6. Andrew Hemingway, *Walpole Society*, vol.XLVI p.178.

Chronology

1782 Born 16 May in the parish of St Mary Coslany, Norwich; christened 7 June in the church where Crome was to get married ten years later. Parents Edmund Cotman, hairdresser (later haberdasher), and Ann Sell.

1793 Entered Norwich Grammar School as a 'freeplacer' on 3 August.

1798 Moved to London. Worked as one of the assistants to Ackermann, publisher of engravings and dealer in the Strand.

1799 Joined Dr Monro's circle. Presumably attended the evening meetings at the Doctor's house in Adelphi Terrace and studied there by copying drawings in his host's collection, as Turner and Girtin had done a few years earlier.

1800 Exhibited for the first time at the Royal Academy (from 28 Gerrard Street, Soho). Awarded the large silver palette by the Society of Arts. Visited Bristol and toured Wales from there.

1801 Elected an honorary member of the Society of United Friars of Norwich 27 January and 'produced for the inspection of the Brethren some very masterly sketches of scenes in Wales'. This year, or at the beginning of the next, became a member of the Sketching Society in London.

1802 Possible second tour of Wales in the company of Paul Sandby Munn, an older fellow-artist and his landlord at 107 New Bond Street from 1802 to 1804.

1803 First tour of Yorkshire, the first part with P.S.Munn. Met the Cholmeley family and stayed with them at Brandsby Hall, the first of three visits.

1804 Second tour of Yorkshire.

1805 Third and last tour of Yorkshire. Stayed with the Morritts of Rokeby Park on the Greta and in the village of Greta Bridge just outside the Park gates. His London address was 20 Woodstock Street, Bond Street.

1806 Failed to be elected to membership of the recently founded Society of Painters in Water-Colours (Old Water-Colour Society). Exhibited for the last time at the Royal Academy (from 71 Charlotte Street, Portland Place). Returned to Norwich and set up a School of Drawing in Wymer (now St Andrew's) Street. Retrospective exhibition of several hundreds of his works in his new premises. First experiments in oil painting.

1807 Exhibited for the first time with the Norwich Society of Artists.

1808 Appeared with 67 works, the largest number ever, in the Norwich exhibition. This year and the following he was listed as portrait painter in the catalogues.

1809 Married Ann Miles of Felbrigg on 6 January. Started circulating collection of drawing copies.

1810 Birth of eldest son, Miles Edmund, on 5 February. Vice-President of the Norwich Society of Artists. Exhibited in London at the Associated Painters in Water Colours and at the British Institution.

1811 Publication of *Miscellaneous Etchings*. President of the Norwich Society of Artists. Exhibited for the second and last time at Associated Painters in Water Colours.

1812 Moved to Yarmouth under the patronage of Dawson Turner. Settled into a house at Southtown, facing the river. Birth of his only daughter, Ann, on 13 July.

1813 Suffered from 'dangerous illness'.

1814 Birth of second son, John Joseph, on 29 May. Eye operation in the spring, his eyes remaining 'very bad through the year'.
Employed apprentices for the execution of his etchings, while he himself 'only finished the works and sketched abroad' for a period of two to three years.

1816 Birth of third son, Francis Walter, on 5 July.

1817 First tour in Normandy.
Publication of volumes of etchings of *Norman and Gothic Architecture* and *Castellated and Ecclesiastical Remains*.

1818 Second tour in Normandy where he was joined by members of Dawson Turner's family.
Publication of volume of etchings of *Architectural Antiquities of Norfolk*. Contributed drawings for engraved illustrations in the two volumes of *Excursions in the County of Norfolk*, one published this year and the other in 1819.

1819 Birth of fourth son, Alfred Henry, on 11 October. Publication of volumes of etchings of *The Sepulchral Brasses of Norfolk*, and *Antiquities of St Mary's Chapel at Stourbridge, near Cambridge &c. &c.*

1820 Third and last tour in Normandy.

1822 Publication of two volumes of etchings of *Architectural Antiquities of Normandy*.

1823 Returned to Norwich. Opened a School of Drawing in his opulent residence at St Martin at Palace Plain. Exhibited at the British Institution, not appearing there again until 1827, his third and last time.

1824 Sale of a large number of his drawings, most of them Normandy subjects, at Christie's, 1 May.

1825 Became an Associate of the Old Water-Colour Society. Exhibited at their exhibition for the first time.

1826 The most alarming of his frequent spells of depression.

1833 After a vice-presidency of two years, President of the Norwich Society of Artists (since 1828 called the Norfolk and Suffolk Institution for the Promotion of the Fine Arts). The Society was disbanded at a meeting in his house.

1834 Moved to London to take up appointment as drawing master at King's College School. Found a house at 42 Hunter Street, Bloomsbury, which remained his residence for the rest of his life.
Sale of paintings, drawings, prints, books, etc. at his St Martin at Palace Plain home in Norwich, Spelman, 10–12 September.

1838 Publication by Henry Bohn of *Liber Studiorum* and *Specimens of Architectural Remains in various Counties in England, but especially in Norfolk . . .*, an omnibus edition of his etchings with the exception of the Normandy ones. Exhibited for the first and only time at the Society of British Artists.

1841 Last visit to Norfolk during the autumn.

1842 Died on 24 July at his Bloomsbury home. Buried in the churchyard of St John's Wood Chapel, Marylebone.

1843 Sale of his oils and drawings, Christie's, 17–18 May. Sale of his library, Christie's, 6 June.

1861 Cotman Collection sale, Spelman, Norwich, 16 May.

1862 Cotman Collection sale, Murrell, Norwich, 26–27 November.

Exhibitions
(bold type indicates abbreviation in text)

RA 1801–6. London, Royal Academy, Annual Exhibitions.

NSA 1807–33. Norwich, the Norwich Society of Artists, Annual Exhibitions.

OWCS 1825–9. The Old Water-Colour Society (The Royal Society of Painters in Water Colours), Annual Exhibitions.

Norwich 1860. Norwich, Government School of Art, Norfolk and Norwich Fine Arts Association, *Exhibition of Works of Deceased Local Artists*.

Norwich IE 1867. Norwich, St Andrew's Hall, *Norwich and Eastern Counties Working Classes Industrial Exhibition*.

Norwich EAA 1873. Norwich, Churchman's Club, *Loan Collection of East Anglian Art*.

Norwich BMA 1874. Norwich, St Andrew's Hall, British Medical Association, *Loan Collection of the Works of Norfolk and Suffolk Artists*.

London IE 1874. London, *International Exhibition*.

King's Lynn 1877. King's Lynn, Athenaeum, *Second Grand Art Loan Exhibition*.

Norwich PM 1878. Norwich, St Andrew's Hall, *Art Loan Exhibition in aid of the Fund for the Restoration of the Church of St Peter Mancroft*.

Norwich 1885. Norwich, St Andrew's Hall, *Art Loan Exhibition in aid of the Fund for the Restoration of St Peter Mancroft Church*.

NAC 1888. Norwich, Old Bank of England Chambers, Queen Street, *Norwich Art Circle Ninth Exhibition. Drawings by the late John Sell Cotman*.

BFAC 1888. London, Burlington Fine Arts Club, *Exhibition of Drawings in Water Colour and in Black and White by John Sell Cotman*.

Great Yarmouth 1889. Great Yarmouth, *Art Loan Exhibition in aid of the Book Fund of the Free Library*.

RA 1891. London, Royal Academy, *Exhibition of Works by the Old Masters*.

RA 1892. London, Royal Academy, *Exhibition of Works by the Old Masters and by deceased masters of the British School including a collection of watercolour drawings, studies and sketches from nature*.

Norwich 1894. Norwich, Agricultural Hall Gallery, *Loan Collection of Pictures and Water-Colour Drawings during the Grand Oriental Bazaar promoted by the CEYMS and YMCA*.

RA 1896. London Royal Academy, *Exhibition of Works by the Old Masters and by deceased masters of the British School*.

Norwich 1903. Norwich, Castle Museum, *Loan Collection of Drawings in the New Picture Gallery*.

Shepherd's Gallery 1903. London, Shepherd Bros., 27 King Street, St James's Square, Winter Exhibition, *Early British Masters and Modern Painters*.

Grafton Galleries 1911. London, Grafton Galleries, *Exhibition of Old Masters in Aid of the National Art-Collections Fund*.

Whitworth 1912. Manchester, Whitworth Institute, *Loan Exhibition of Water Colour Drawings by Deceased British Artists also of a collection of Paintings and Drawings by J. Sell Cotman*.

W. B. Paterson's Gallery 1913. London, Wm B. Paterson, 5 Old Bond Street, *Loan Collection of Pictures and Drawings by R.P.Bonington and J.S. Cotman.*

Norwich 1922. Norwich, Castle Museum, *Crome Centenary Exhibition.*

Tate 1922. London, National Gallery, Millbank, *Exhibition of Works by John Sell Cotman and some related painters of the Norwich School.*

RSBA 1923. London, The Royal Society of British Artists, Suffolk Street, Pall Mall, *Centenary Exhibition.*

Norwich 1925. Norwich, Castle Museum, *Loan collection of Pictures . . . from the XVIIth Century to the present Day.*

Walker's Gallery 1926. London, Walker's Gallery, *John Sell Cotman (The Bulwer Collection).*

Agnew 1927. London, Thomas Agnew & Sons Ltd, *Exhibition of Water Colours.*

Oxford Arts Club 1928. Title and catalogue of exhibition untraced.

Brussels 1929. Brussels, Musée Moderne, *Retrospective Exhibition of British Art, Eighteenth and Nineteenth Centuries.*

V & A 1932–3. Title and catalogue of exhibition untraced.

Ashmolean 1933. Oxford, Ashmolean Museum, Oxford Art Society, *43rd Annual Exhibition of Pictures in the Department of Fine Art.*

RA 1934. London, Royal Academy, *Exhibition of British Art c.1000–1860.*

Amsterdam 1936. Amsterdam, Stedelijk Museum, *Twee Eeuwen Engelse Kunst.*

Bucharest 1936. British Council, Muzēul Torua Steliar *37 Desenul si gravura Engleza (secolele XVIII–XX).*

Barnsley 1937. Barnsley, Cooper Art Gallery, *A Collection of English Drawings.*

Country Life Exh. London 1937. London, 39 Grosvenor Square, Loan Exhibition, *British Country Life throughout the Centuries.*

Leeds 1937. Leeds, City Art Gallery, *Sixty Pictures of Yorkshire Scenery.*

Whitworth 1937. Manchester, Whitworth Art Gallery, *Watercolour drawings by J.R. Cozens and J.S. Cotman.*

Agnew 1938. London, Thomas Agnew & Sons Ltd, *65th Annual Exhibition of Water-Colours and Pencil Drawings.*

Hull 1938. Kingston-upon-Hull, Ferens Art Gallery, *Works by John Sell Cotman, Bacon Collection.*

Paris 1938. Paris, Louvre, *La Peinture Anglaise XVIIIe et XIXe Siècles.*

Birmingham 1938. Birmingham, Museum and Art Gallery, *Early English Watercolours from the Collections of J.Leslie Wright and Walter Turner.*

RIBA 1939. London, Royal Institute of British Architects, *Architectural Drawings and Water-colours by John Sell Cotman, Bequeathed to the RIBA by Sydney Kitson, FSA, FRIBA.*

Palser Gallery 1940. London, Palser Gallery, *Annual Exhibition of Early English Water Colours including collection of Drawings by John Sell Cotman.*

Norwich 1942. Norwich, Castle Museum, *The Seven Cotmans, Loan Exhibition to mark the centenary of the death of John Sell Cotman.*

Agnew 1945. London, Thomas Agnew & Sons Ltd, *72nd Annual Exhibition of Water-colour Drawings.*

Agnew 1946. London, Thomas Agnew & Sons Ltd, *Watercolour Drawings in the Collection of Sir Hickman Bacon Bt.*

Arts Council 1946. Leeds, Hull, Lincoln, Derby, Norwich, *English Watercolours from the Hickman Bacon Collection.*

Arts Council 1947. Leeds, Hull, Harrogate, Derby, Cardiff, Bristol, *English Romantic Art.*

Arts Council 1948. Manchester, Birmingham, Cardiff, Bristol, *English Watercolours from the Hickman Bacon Collection.*

Arts Council (Whitworth) 1948. Harrogate, Wakefield, Brighouse, York, Batley, Scarborough, Hull, *Watercolours and drawings from the Whitworth Art Gallery.*

Boston and Ottawa 1948–9. Title and catalogue of exhibition untraced.

Bournemouth 1949. Bournemouth Arts Club, College of Art, Bournemouth, *Exhibition of Early English Watercolours from Public and Private Collections.*

Arts Council 1949. Newcastle, Swansea, Exeter, Sheffield, Jersey and Guernsey, *British Watercolours from the Gilbert Davis Collection.*

RA 1949. London, Royal Academy, *Masters of British Watercolour (17th–19th Centuries). The J.Leslie Wright Collection.*

British Council 1949–50. Hamburg, Oslo, Stockholm, Copenhagen, *British Painting from Hogarth to Turner.*

Aldeburgh 1950. Aldeburgh, *Third Festival Exhibition, John Sell Cotman*.

Scarborough 1950. Scarborough, Art Gallery, *English Watercolours from Four Yorkshire Houses, 1660–1860*.

Arts Council 1951. *Three Centuries of British Watercolours and Drawings*.

Southport 1951. Southport, Atkinson Art Gallery, Festival of Britain, *Local Art Treasures*.

RA 1951–2. London, Royal Academy, *The First Hundred Years of the Royal Academy 1769–1868*.

Bedford 1952. Bedford, Cecil Higgins Art Gallery, *English Water-Colours from the Hickman Bacon and Other Collections*.

Kettering 1952. Kettering, Alfred East Art Gallery, *Crome, Cotman and the Norwich Artists*.

Delft 1952. Delft, Museum het Prinsenhof, *De Aquarel 1800–1950*.

Sheffield 1952. Sheffield, Graves Art Gallery, *Early English Drawings and Watercolours from the Collection of Paul Oppé*.

Bristol 1953. Bristol, Royal West of England Academy, *British Painters in France*.

Hampstead Artists' Council 1953. London, Studio House, Rosslyn Hill, *Artists at Work from Sketch to Finish*.

Paris 1953. Paris, Orangerie des Tuileries, *Le Paysage Anglais de Gainsborough à Turner*.

Sheffield 1953. Sheffield, Graves Art Gallery, *Early Watercolours from the Collection of Thomas Girtin Jnr*.

Agnew 1954. London, Thomas Agnew & Sons Ltd, *Watercolour Drawings from the Whitworth Art Gallery*.

Colnaghi 1955. P. &D. Colnaghi & Co. Ltd, *Watercolour Drawings of Three Centuries from the Collection of Sir Bruce and Lady Ingram*.

Norwich 1955. Norwich, Castle Museum, *English Watercolours c.1750–c.1820*.

Rotterdam 1955. Rotterdam, Museum Boymans, *Engelse landschapschilders van Gainsborough tot Turner*.

Geneva and Zurich 1955–6. Geneva, Le Musée Rath, and Zurich, Le Cabinet des Estampes, *L'Aquarelle Anglaise 1750–1850*.

New York 1956. New York, Museum of Modern Art, *British Paintings 1800–1950*.

Norwich 1956. Norwich, Castle Museum, *Water-colours by British Landscape Painters c.1820–c.1870*.

Dijon 1957. Dijon, Musée des Beaux Arts, *Peintures Anglaises d'York et du Yorkshire*.

Agnew 1958. London, Thomas Agnew & Sons Ltd, *Crome and Cotman Exhibition in Aid of the Friends of the Norwich Museums*.

Colnaghi 1958. London, P. & D. Colnaghi & Co. Ltd, *Early English Watercolours, Drawings by Old Masters, Etchings and Engravings from the Collection of Alan D.Pilkington*.

Leeds 1958. Leeds, City Art Galley, *Early English Watercolours*.

RA 1958. London, Royal Academy, *The Paul Oppé Collection, English Watercolours and Old Master Drawings*.

Arts Council 1959. Arts Council, Tate Gallery, *The Romantic Movement*.

Agnew 1960. London, Thomas Agnew & Sons Ltd, *Watercolours and Drawings from the City Art Gallery, Leeds*.

Arts Council 1960. *Drawings and Watercolours from the Whitworth Art Gallery*.

Bedford 1960. Bedford, Cecil Higgins Art Gallery, *John Sell Cotman 1782–1842*.

Moscow & Leningrad 1960. British Council. Moscow, Pushkin Museum, and Leningrad, Hermitage Museum, *British Painting 1700–1960*.

Calais 1961. Calais, *L'Aquarelle romantique en France et en Angleterre*.

Ottawa 1961. Ottawa, National Gallery of Canada, *Works from the Paul Oppé Collection; English Watercolours and Old Master Drawings*.

Whitworth 1961. Manchester, Whitworth Art Gallery, *The Norwich School. Loan Exhibition of Works by Crome and Cotman and their Followers*.

Colnaghi 1962. London, P. & D. Colnaghi & Co. Ltd, *Memorial Exhibition of Paintings and Drawings from the Collection of Francis Falconer Madan*.

Minneapolis & New York 1962. Minneapolis, University of Minnesota, and New York, The Guggenheim Museum, *The Nineteenth Century. 125 Master Drawings*.

Washington & New York 1962. Washington, National Gallery, and New York, Metropolitan Museum, *English Drawings and Watercolours from British Collections*.

RA 1962. London, Royal Academy, *The Girtin Collection*.

Colnaghi 1963. London, P. & D. Colnaghi & Co. Ltd, *Loan Exhibition of English Drawings and Watercolours in memory of the late D.C.T. Baskett*.

Swansea 1964. Swansea, Glynn Vivian Art Gallery, *Art in Wales; A Survey of Four Thousand Years to AD 1850*.

Arts Council Galleries 1965. London, *Sixty Years of patronage; drawings, gold, silver and ivories from museums in Great Britain and Northern Ireland bought with the aid of the National Art-Collection Fund.*

O. & P. Johnson, Norwich School 1965. London, Oscar & Peter Johnson Ltd, *Painters of the Norwich School.*

Colnaghi 1966. London, P. & D. Colnaghi & Co. Ltd *Old Master Drawings, a Loan Exhibition from the National Gallery of Scotland.*

Kendal 1966. Kendal, Abbot Hall Art Gallery, *Treasures from North West Houses.*

Colnaghi 1967. London, P. & D. Colnaghi & Co. Ltd, *A loan Exhibition of English Drawings from the Whitworth Art Gallery, Manchester.*

USA 1967. Jacksonville, Fla., Nashville, Tenn. and New Orleans, La., *Landscapes of the Norwich School, An American Debut.*

Courtauld Galleries 1968. London, Courtauld Institute Galleries, *The William Spooner Collection and Bequest.*

Detroit & Philadelphia 1968. Detroit, Institute of Arts, and Philadelphia, Museum of Art, *Romantic Art in Britain Paintings and Drawings 1760–1860.*

Harrogate 1968. Harrogate, Corporation Art Gallery, *English Water-Colours (Memorial Exhibition to William Wycliffe Spooner).*

Manchester 1968. Manchester, City Art Gallery, *Art and the Industrial Revolution.*

RA 1968–9. London, Royal Academy, *Royal Academy of Arts Bicentenary Exhibition 1768–1968.*

Bath 1969. Bath, Holbourne of Menstrie Museum, *Masters of the Watercolour.*

Leger Galleries 1969. London, Leger Galleries Ltd, *English Watercolours.*

Reading 1969. Reading, Museum and Art Gallery, *Girtin and Some of his Contemporaries.*

Birmingham 1970. Birmingham, Museum and Art Gallery, *Wales and the Wye Valley.*

Bourges 1970. Bourges, Maison de la Culture, *David Cox et son Temps. L'Aquarelle Anglaise au XIX^e Siècle.*

Colnaghi 1970. London, P. & D. Colnaghi & Co. Ltd, *Loan Exhibition of Drawings and Watercolours by East Anglian Artists of the 18th and 19th centuries.*

Rye 1971. Rye, Art Gallery, *English Landscape Drawings.*

Arts Council 1971. The Hague, Mauritshuis, and London, Tate Gallery, *The Shock of Recognition.*

Bedford 1972. Bedford, Cecil Higgins Art Gallery, *The English Tradition, an exhibition of watercolours from two private collections.*

Colnaghi 1972. London, P. & D. Colnaghi & Co. Ltd, *English Drawings and Watercolours.*

Leeds 1972. Leeds, City Art Gallery, *The Lupton Collection.*

Paris 1972. Paris, Petit Palais, *La peinture romantique anglaise et les preraphaélites.*

New York & RA 1972–3. New York, The Pierpoint Morgan Library (1972) and London, Royal Academy (1973), *English Drawings and Watercolours 1550–1850 in the Collection of Mr and Mrs Paul Mellon.*

Bristol 1973. Bristol, City Art Gallery, *English Watercolours. The Spooner Collection and Bequest.*

Brussels 1973. Brussels, Musée d'Art Moderne, *English Watercolours of the 18th and 19th Centuries from the Whitworth Art Gallery, Manchester.*

Kendal 1973. Kendal, Abbot Hall Art Gallery, *John Sell Cotman 1782–1842. Watercolours and Sketches.*

Tate 1973. London, Tate Gallery, *Landscape in Britain c.1750–1850.*

Russia 1975. Leningrad, Hermitage Museum; Moscow, Pushkin Museum; Volgograd, City Museum, *English Watercolours of the 18th and 19th Centuries from the Whitworth Art Gallery.*

Agnew 1975. London, Thomas Agnew & Sons Ltd, *102nd Annual Exhibition of Watercolours and Drawings.*

Norwich 1975. Norwich, Castle Museum, *John Sell Cotman Drawings of Normandy.*

New Zealand & Australia 1976–8. Wellington, National Gallery of Art of New Zealand, and Sydney, The Art Gallery of New South Wales, Australia (and other locations in Australia), *Drawings and Watercolours from the Spooner and Witt Collections.*

Aldeburgh 1977. Aldeburgh, Festival Gallery, *Masterpieces of British Drawing from the Whitworth Art Gallery.*

USA 1977. Phoenix, Arizona, Art Museum; Salt Lake City, Utah Museum of Fine Arts; San Diego, Ca., Fine Arts Gallery, *Exhibition of 42 Watercolours from the Victoria and Albert Museum.*

Yale 1977. New Haven, Conn., Yale Center for British Art, *English Landscape 1630–1850.*

Norwich 1978. Norwich, Crome Gallery, *One Hundred and Seventy Years of Cotman Painting.*

Sudbury 1978. Sudbury, Gainsborough's House, *Paintings and Drawings by John Sell Cotman.*

Tokyo & Kifu 1978–9. Tokyo, National Museum of Western Art, and Kifu, *European Landscape Painting*.

Dortmund 1979. Dortmund, Museum für Kunst und Kunstgeschichte, *Englische Aquarelle von der Samlung der Leeds City Art Gallery*.

Munich 1979–80. München, *Zwei Jahrhunderte englische Malerei, Britische Kunst und Europa 1680 bis 1880*.

Burnley 1980. Burnley, Townley Hall Art Gallery and Museums, *Paintings from the Norwich School*.

Arts Council 1980–81. Sheffield, Graves Art Gallery; Cheltenham, Art Gallery and Museum; Swansea, Glynn Vivian Art Gallery; Southampton, Art Gallery; and Wakefield, Elizabethan Exhibition Gallery, *More than a Glance*.

Arts Council 1981. York, Portsmouth, Birmingham, Sheffield, Canterbury, *British Watercolours 1760–1930 from the Birmingham Museum and Art Gallery*.

New York 1981. New York, Museum of Modern Art, *Before Photography*.

Nottingham 1981. Nottingham, Castle Museum, *Great British Watercolours*.

Agnew 1982. London, Thomas Agnew & Sons Ltd, *109th Annual Exhibition of Watercolours and Drawings*.

References
(bold type indicates abbreviation in text)

Antique Collector, January – February 1945.

The Architect, 15 February 1889; 31 October 1890.

Arnold's Magazine, 1834

Bernard Barton, *The Poems and Letters* of, 1849.

Binyon 1897. Laurence Binyon, *John Crome and John Sell Cotman*, Seeley & Co. Ltd, Portfolio Series, London, 1897.

Binyon 1903. Laurence Binyon, 'Life and Work of John Sell Cotman', Masters of English Landscape Painting, J. S. Cotman, David Cox, Peter de Wint, ed. Charles Holmes, *The Studio*, Special Number, 1903.

Binyon 1933. Laurence Binyon, *English Water-Colours*, A. & C. Black Ltd, London, 1933.

Laurence Binyon, 'The Art of John Sell Cotman', *Burlington Magazine*, Cotman Number, July 1942.'

Boase 1959. T. S. R. Boase, *English Art 1800–1870*, The Oxford History of English Art, Clarendon Press, Oxford, 1959.

Boase JWCI 1959. T. S. R. Boase, 'Shipwrecks in English Romantic Paintings', *Journal of the Warburg and Courtauld Institutes*, Volume 22, 1959.

Burlington August 1954. 'Current and Forthcoming Exhibitions, East Anglia and the Netherlands', *Burlington Magazine*, August 1954.

Bury 1934. Adrian Bury, 'Water-Colour: The English Medium, The Exhibition of British Art at Burlington House,' *Apollo*, February 1934.

Bury 1937. Adrian Bury, 'The Gentle Genius. John Sell Cotman of Norwich', *The Connoisseur*, July 1937.

Bury 1960. Adrian Bury, 'The Leeds Art Gallery. Some Important English Water-Colours and Drawings', *Old Water-Colour Society's Club*, vol.xxxv, 1960.

Clifford 1965. Derek Clifford, *Watercolours of the Norwich School*, Cory, Adams & Mackay, London, 1965.

Connoisseur Jan. 1923. 'National Gallery Additions'. *The Connoisseur*, January 1923.

Connoisseur March 1929. 'Current Art Notes', *The Connoisseur*, March 1929.

Cotman correspondence in the British Museum, Trinity College, Cambridge, The North Yorkshire County Record Office, Northallerton (see **Holcomb**), and Mr Christopher Barker's Collection.

Country Life, 8 March 1941; 20 October 1960.

Cundall 1908. H. M. Cundall, *A History of British Water Colour Painting*, John Murray, London, 1908.

Cundall 1920. H. M. Cundall, 'The Norwich School', *The Studio*, Special Number, ed. Geoffrey Holme, London, 1920.

Cundall 1922. H. M. Cundall, 'The Cotman Exhibition at the Tate Gallery', *The Studio*, August 1922.

Davies 1939. Randall Davies, 'Water-Colours at the Whitworth Art Gallery, Manchester', *Old Water-Colour Society's Club*, vol.xvii, 1939.

Davies 1942. Randall Davies, 'Water-Colours in the Laing Art Gallery, Newcastle upon Tyne', *Old Water-Colour Society's Club*, vol.xx, 1942.

Davis 1961. Frank Davis, 'Crome, Cotman and Company: A Loan Exhibition in Manchester', *The Illustrated London News*, 25 February 1961.

Davis 1965. Frank Davis, 'Homage to Hobbema', *The Illustrated London News*, 8 May 1965.

Dickes 1905. William Frederick Dickes, *The Norwich School of Painting*, Jarrold & Sons, London and Norwich, 1905.

Eastword, September 1974, 'Abraham and Isaac in Bedford'.

Finberg 1905. Alexander J. Finberg, *The English Water Colour Painters*, Duckworth & Co., London, and E. P. Dutton & Co., New York, 1905.

Finberg 1912. Alexander J. Finberg, 'The Historical Collection of British Water-Colours at the Grafton Galleries, Part II', *The Connoisseur*, February 1912.

Finberg & Taylor 1918. Alexander J. Finberg and E. A. Taylor, 'The development of British landscape painting in water-colours', *The Studio*, 1918.

Gentleman's Magazine, vol.83, July–September, 1813.

Girtin and Loshak 1954. Thomas Girtin and David Loshak, *The Art of Thomas Girtin*, A. and C. Black, London, 1954.

Goldberg 1967. Norman L. Goldberg, 'America honours the Norwich School', *The Connoisseur*, February 1967.

Hamilton 1971. Jean Hamilton, *The Sketching Society 1799–1851*, London, Victoria and Albert Museum, 1971.

Hardie 1942. Martin Hardie, 'Cotman's Water-Colours: The Technical Aspect', *Burlington Magazine*, Cotman Number, July 1942.

Hardie vol.II 1967. Martin Hardie, 'Water-Colour Painting in Britain', vol.II, *The Romantic Period*, ed. Dudley Snelgrove with Jonathan Mayne and Basil Taylor, Batsford, London, 1967.

Michael Harrison, 'John Sell Cotman, 1782–1842, A Memoir', *Apollo*, July 1942.

Hawcroft 1962. Francis W. Hawcroft, 'English Water-Colours and Drawings in the collection of Sir Edmund Bacon Bart', *Old Water-Colour Society's Club,* vol.XXXVII, 1962.

Hawcroft Burlington 1962. Francis W. Hawcroft, 'Three works by Cotman', *Burlington Magazine*, February 1962.

Hemingway 1979. Andrew Hemingway, *The Norwich School of Painters 1803–1833*, Phaidon, Oxford, 1979.

Andrew Hemingway, 'Cotman's "Architectural Antiquities of Normandy": Some Amendments to Kitson's Account', *The Walpole Society*, vol.XLVI, 1976–8.

Andrew Hemingway, ' "The English Piranesi" – Cotman's Architectural Prints', *The Walpole Society*, vol.XLVIII, 1982.

Hendy 1942. Philip Hendy, 'The Collections at Temple Newsam, v. Old Pictures from the Leeds Art Gallery', *Apollo*, February 1942.

Holcomb 1975. Adele Holcomb, 'John Sell Cotman's Dismasted Brig and the Motif of the Drifting Boat', *Studies in Romanticism*, XIV, 1975.

Holcomb 1978. Adele Holcomb, *John Sell Cotman*, British Museum Prints and Drawings Series, British Museum Publications Ltd, 1978.

Adele Holcomb, *John Sell Cotman in the Cholmeley Archive*, texts transcribed and edited by A. M. Holcomb and M. Y. Ashcroft, North Yorkshire County Record Office Publications No.22, 1980.

Holmes 1904. C. J. Holmes, 'John Sell Cotman as a Painter in Oils', *Burlington Magazine*, January 1904.

ILN. *Illustrated London News*, 29 January 1955; 5 November 1960; 31 March 1962.

Johnson 1934. Charles Johnson, 'British Art at Burlington House', *The Connoisseur*, January 1934.

Kaines Smith 1926. S. C. Kaines Smith, *Cotman*, British Artists Series, Philip Allan & Co. Ltd, London, 1926.

H. Isherwood Kay, 'John Sell Cotman's Letters from Normandy 1817–1820', Parts I and II , *The Walpole Society*, vols. XIV and XV, Oxford, 1926–7.

Kendal, Abbot Hall Art Gallery, Director's Report for 1970–1 and for 1972–3.

Kitson 1930. Sydney D. Kitson, 'John Sell Cotman', *Old Water-Colour Society's Club*, vol.VII, 1930.

Kitson 1933. Sydney D. Kitson, 'Notes on a Collection of Portrait Drawings formed by Dawson Turner', *The Walpole Society* 1932–3, vol.XXI, 1933.

Kitson 1937. Sydney D. Kitson, *The Life of John Sell Cotman*, Faber & Faber Ltd, London, 1937.

Klingender 1968. Francis D. Klingender, *Art and the Industrial Revolution*, ed. and revised by Arthur Elton, Evelyn, Adams & Mackay, 1968. First publ. 1947.

H. G. Knight, *An Architectural Tour of Normandy*, London, 1834.

Leeds Art Gallery, Annual Report, 1934–5.

Leeds Art Calendar, vol.2, no.7, 1949; vol.9, no.31, 1955.

Lemaître 1955. Henri Lemaître, *Le Paysage Anglais à l'Aquarelle 1760–1851*, Bordas, Paris, 1955.

Lucas 1934. E.V. Lucas, 'Mr Beeny Looks On the Royal Academy Exhibition – "The Blue Cotman" ', *Punch*, 24 January 1934.

Lytton 1911. Neville Lytton, *Water-colour*, London, 1911.

Mayne 1962. Jonathan Mayne, *Metropolitan Museum of Art Bulletin*, vol.XX, 1962.

NACF Report 1933. Thirtieth Annual Report 1933, National Art-Collections Fund, 1934.

Oppé 1923. A. P. Oppé, 'The Watercolour Drawings of John Sell Cotman', *The Studio*, Special Number, ed. Geoffrey Holme, London, 1923.

Oppé December 1923. A. P. Oppé, 'Cotman and the Sketching Society', *The Connoisseur*, December 1923.

A. P. Oppé, 'Cotman and his Public', *Burlington Magazine*, Cotman Number, July 1942.

Owen & Stanford 1981. Felicity Owen and Eric Stanford, *William Havell 1782–1857*, Exhibition Catalogue, Reading Museum and Art Gallery, 1981.

David Phillips, *English Watercolours in Nottingham Castle*, Nottingham Castle Museum, 1981.

Pidgley 1975. Michael Pidgley, *John Sell Cotman's Patrons and the Romantic Subject Pictures in the 1820s and 1830s*, unpublished Doctoral Thesis, University of East Anglia, 1975.

PMT 1922. Percy Moore Turner, 'Cotman and Crome', A Monthly Chronicle, *Burlington Magazine*, May 1922.

Popham. A. E. Popham, 'The Etchings of John Sell Cotman', *The Print Collectors' Quarterly*, J. M. Dent & Sons, London, October 1922.

Preview, City of York Art Gallery Bulletin, no.32, 1955, and no.36, 1956.

Rajnai & Allthorpe 1975. Miklos Rajnai assisted by Marjorie Allthorpe-Guyton, *John Sell Cotman Drawings of Normandy in Norwich Castle Museum*, Norfolk Museums Service, 1975.

Rajnai & Allthorpe 1979. Miklos Rajnai and Marjorie Allthorpe-Guyton, *John Sell Cotman 1782–1842. Early Drawings (1798–1812) in Norwich Castle Museum*, Norfolk Museums Service, 1979.

Miklos Rajnai assisted by Mary Stevens, *The Norwich Society of Artists 1805–1833. A dictionary of contributors and their work*, published for the Paul Mellon Centre for Studies in British Art by the Norfolk Museums Service, 1976.

Reeve MS. Manuscript catalogue of the Reeve Collection, BM.

Reeve 1911. James Reeve, *Memoir of John Sell Cotman*, Jarrold Norwich, 1911.

Reynolds 1951. Graham Reynolds, *British Watercolours*, London, Victoria and Albert Museum, 1951.

Reynolds 1971. Graham Reynolds, *A Concise History of Watercolours*, Thames & Hudson, London, 1971.

Rienaecker 1953. Victor Rienaecker, *John Sell Cotman 1782–1842*, F. Lewis, Leigh-on-Sea, 1953.

Roget 1891 (reprint 1972). John Lewis Roget, *A History of the Old Water-Colour Society*, originally published in two volumes by Longmans Green & Co., London 1891, reprinted Antique Collectors Club, Woodbridge, 1972.

Rothenstein 1933. Sir John Rothenstein, *An introduction to English Painting*, London, 1933.

Skilton 1965. Charles Skilton, 'Windmills and Watermills in Water-Colour', *Old Water-Colour Society's Club*, vol.XL, 1965.

Hammond Smith, 'British landscape artists working in France 1814–1824', unpublished paper, 1975.

Summerson. John Summerson, *English Castles*, n.d.

Troutman 1968. Philip Troutman, 'The Evocation of Atmosphere in the English Water-colour', *Apollo*, July 1968.

Walker's Monthly, February 1929.

Revd T. Warton *et al.*, *Essays on Gothic Architecture*, 3rd edn, London, 1808.

V & A 1934. *Victoria and Albert Museum Annual Review 1934.*

Wedmore 1876. Frederick Wedmore, *Studies in English Art*, first series, London, 1876.

Wedmore 1888. Frederick Wedmore, 'John Sell Cotman', *The Magazine of Art*, October 1888.

Whitworth Art Gallery, Manchester, *Twenty Early English Water-Colour Drawings in the*, 1951.

Scott Barnes Wilcox, 'The Panorama and Related Exhibitions in London', unpublished M.Litt. Thesis, University of Edinburgh, 1976.

Wilenski 1933. Reginald Howard Wilenski, *English Painting*, London 1933.

Wilenski 1954. As above, 3rd edition, revised.

Williams 1952. Iolo A. Williams, *Early English Watercolours and some cognate drawings by Artists born not later than 1785*, publ. by The Connoisseur, 1952.

Wilton 1977. Andrew Wilton, *British Watercolours 1750 to 1850*, Phaidon, Oxford, 1977.

Witt Handlist 1956. *Handlist of the Drawings in the Witt Collection*, London University, 1956.

Sir William Worsley, *Early English Watercolours at Hovingham Hall*, 1963.

J. Leslie Wright Collection 1939. Catalogue of J. Leslie Wright Collection of Early Watercolour Drawings 1939.

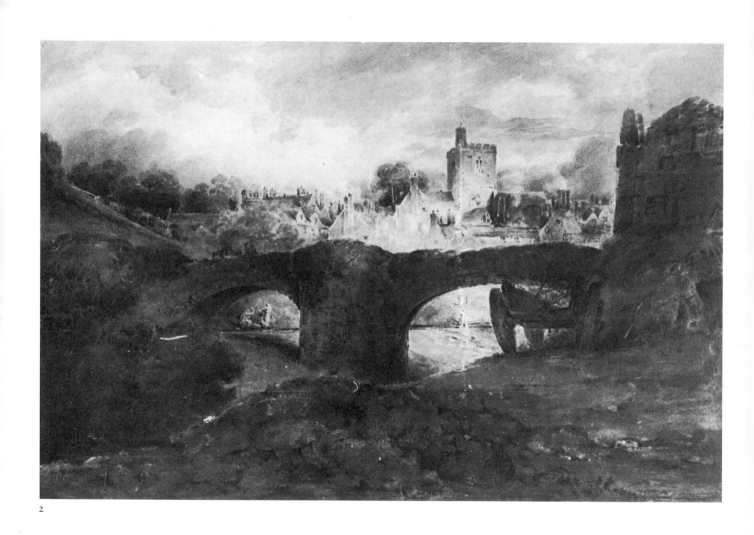

2

JOHN SELL COTMAN 1782–1842
Watercolours, drawings, oil paintings and etchings

Measurements are given in centimetres, followed by inches in brackets, height before width.

Dates without brackets are those inscribed on the work by the artist.

Dates in brackets are those supported by some documentary evidence.

Dates in square brackets are suggested and approximate.

Abbreviations not occurring in *References* or *Exhibitions*:

BM British Museum; CB Commonplace Book of the Cholmeley family at Brandsby; DT Dawson Turner; l.l. lower left; l.r. lower right; MS manuscript; NCM Norwich Castle Museum; repr: reproduced; V & A Victoria and Albert Museum.

1 A cottage in Guildford Churchyard, Surrey 1800 (repr. in colour)

pencil and watercolour on wove paper; 35.6 × 53.2 (14 × 20$\frac{15}{16}$)
Signed and dated l.l. *Cotman 1800*
Inscribed in pencil on verso *Cotman 14 March 1800* and title (?record of an old inscription)

Prov: purchased from the Fine Art Society 1976.
Exh: ?RA 1800 (342); Nottingham 1981 (44).
Ref: Clifford 1965 pl.28a; David Phillips, *English Watercolours in Nottingham Castle* 1981 pp.8–9 pl.v in colour.
Nottingham Castle Museum

Cotman's first appearance as an exhibitor was at the Royal Academy in 1800 at the age of eighteen. Five of the six watercolours shown, almost certainly including this one, seem to originate from his assumed visit(s) to Fetcham, to the country cottage of his first mentor, Dr Monro. It is revealing to compare the preparatory drawing, dated 1800 (Christie's 25 July 1972 lot 25), with this watercolour: a solid unremarkable cottage in a sober setting was transmuted into a tottering, gaunt building dominating a scene of romantic mood.

2 Brecknock (1801)

watercolour on wove paper; 37.5 × 54.7 (14$\frac{3}{4}$ × 21$\frac{1}{2}$)

Prov: purchased from the Palser Gallery by the late Sir Hickman Bacon 1900.
Exh: ?RA 1801 (311); Hull 1938 (1); Arts Council 1946 (27); Agnew 1946 (37); Arts Council 1948 (27); Boston and Ottawa 1948–9 (?); RA 1951–2 (485), Souvenir Catalogue pl.18; Bedford 1952 (9); Norwich 1955 (52); Whitworth 1961 (45); Colnaghi 1970 (26); Sudbury 1978 (17).
Ref: Dickes 1905 p.252; Kitson 1937 pp.25–6; ILN 25 Feb. 1961 repr.; Hawcroft 1962 p.29; Clifford 1965 p.32 pl.28b.
Private Collection

Cotman must have passed through Brecknock (i.e. Brecon), on the way from Goodrich to Aberystwyth,

between 4 and 18 July during his 1800 tour of Wales (see Rajnai & Allthorpe 1979 pp.38,39). This majestic, darkly brooding watercolour and its presumed companion at the 1801 exhibition, the *Llantony Abbey* in the Tate Gallery, are impressive achievements by an artist making his second public appearance. Kitson, who preferred to look at them from the vantage point of the mature works, considered these drawings 'solemn efforts to obtain a monumental impression', but 'laboured' and without 'that joyous mastery of his medium which Cotman was to obtain a few years later…'

A reduced copy or version was with the Manning Gallery in 1970.

3 The kitchen in the artist's father's house 1801

pencil and watercolour on wove paper; 25.7 × 20.3 (10$\frac{1}{8}$ × 8) (sight)
Signed and dated l.r. *J S Cotman Aug 22. 1801*. Illegible inscription below signature.

Prov: the Revd James Bulwer; J. R. Bulwer QC by 1888; the Misses Bulwer by 1922.
Exh: NAC 1888 (19); Tate 1922 (207) as *Kitchen of the Artist's House;* Palser Gallery 1940 (24) with title as at Tate.
Ref: Dickes 1905 p.252; Kitson 1937 p.26.
Private Collection

A domestic genre-scene, rare in Cotman's oeuvre. No evidence has yet

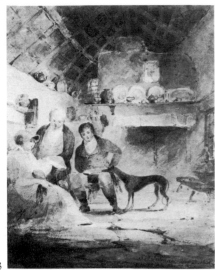

3

come to light to substantiate either form of the traditional title, but it may have some foundation as it seems to have been handed down by the artist's friend and patron, James Bulwer. If so, the date may be that of a significant event in Cotman's life because – at least later on – he was fond of commemorating important occurrences in this way (e.g. the etching of Croyland bears the date of his wedding day; the etching of Howden the date of Miles Edmund's birthday).

4 The Devil's Bridge, Cardigan 1801

pencil and watercolour on wove paper;
$27.9 \times 18.6 \ (11 \times 7\frac{5}{16})$
Signed and dated l.r. *J S Cotman 1801*.

Prov: Hon. Mr Justice McCardie; sold after his death Sotheby's 28 June 1933 lot 26; Kitson Bequest 1939.
Exh: Tate 1922 (206); Bedford 1960 (3); Sudbury 1978 (27).
Ref: Kitson 1937 pp.20,26.
Victoria and Albert Museum, London

Presumably based on a sketch Cotman made during his journey through Wales in the previous year. He must have passed Devil's Bridge on the way from Brecon to Aberystwyth, where he had arrived by 18 July. The later drawing at

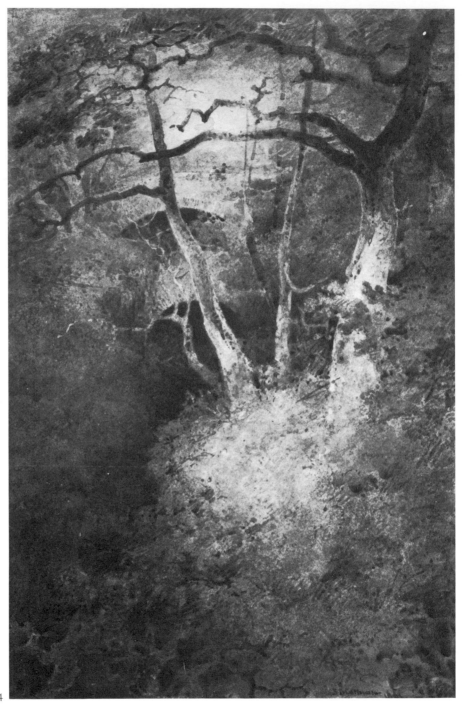

4

Leeds and the softground etching of the same subject is of different design, probably influenced by Letitia Byrne's 1809 etching after Cotman's friend, Paul Sandby Munn. The watercolour in the J. Leslie Wright Bequest in Birmingham is more likely to be a copy by another hand than a replica.

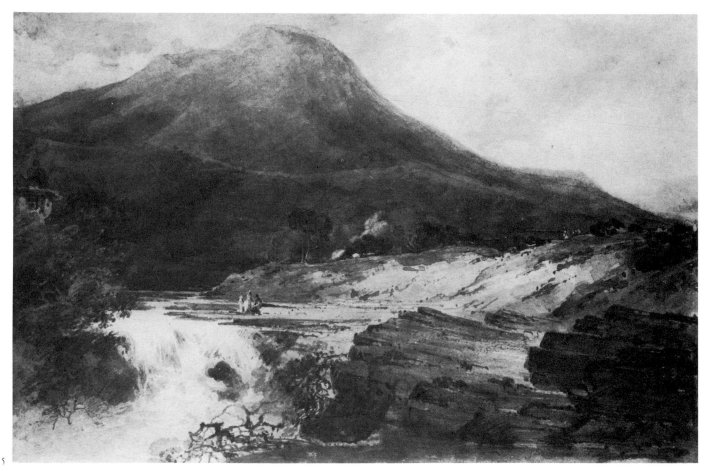

5

5 Llangollen 1801

pencil and watercolour on wove paper;
19 × 28.3 (7½ × 11⅛)
Signed l.r. *J S Cotman*

Prov: Seale-Haynes; purchased by Paul
Oppé 1904 £36.6*s*.
Exh: Tate 1922 (9); Ashmolean 1933 (1);
Sheffield 1952 (5); RA 1958 (147);
Ottawa 1961 (11).
Ref: Cundall 1920 p.19 pl.XXXIV;
Kitson 1937 pp.22,45; Rienaecker 1953
pl.10 fig.15.
Private Collection

Kitson suggests that the homeward leg
of Cotman's route led through
Llangollen both in 1800 and also in 1802
during the assumed second visit to
Wales. The name does not occur among
his exhibits but there are two drawing
copies recorded bearing the inscription
Llangollen N. Wales (674 and 2522). No
other work by Cotman shows so clearly
and convincingly the strong influence
that Girtin exerted on him at this period.

6 St Peter Mancroft, Norwich [1801]

pencil and watercolour on laid paper;
33.2 × 43.9 (13¹⁄₁₆ × 17⁵⁄₁₆) (sight)

Exh: Tate 1922 (218); Ashmolean 1933
(10).
Private Collection

View of the church from Haymarket
looking north. The scene also appealed
to John Thirtle, Cotman's brother-in-
law: the right-hand two-thirds of the
picture is the subject of one of his most
attractive watercolours (Marjorie
Allthorpe-Guyton *John Thirtle* 1977
fig.56). The centre block of cottages
screening the nave was demolished late
in the last century. This drawing is the
most impressive among Cotman's first
renderings of sites that were familiar to
him since his infancy (e.g. *Devil's Tower*
and *Bishop's Bridge* in NCM).

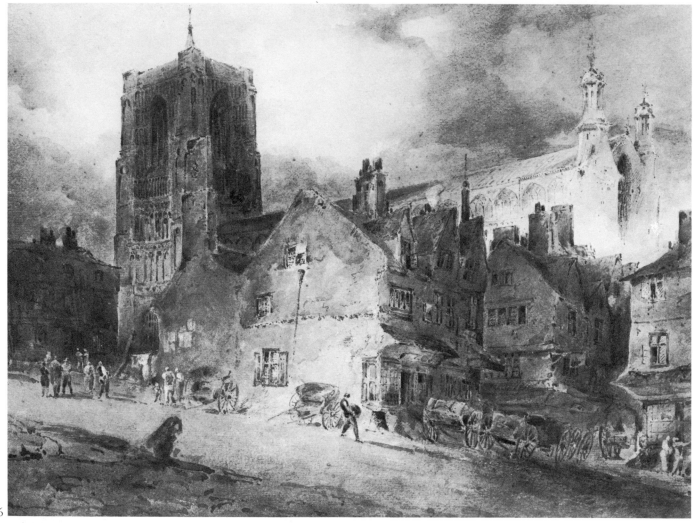

6

7 The Old College House, Conway
1802

pencil and watercolour on wove paper,
laid down on original mount; 28 × 19
($11 × 7\frac{1}{2}$)
Signed and dated in pen and brown ink
on verso of mount *Cotman 1802*

Prov: Christie's 17 Dec. 1970 lot 9, bt
Agnew; purchased from them.
*The Trustees of Cecil Higgins Art Gallery,
Bedford*

It seems possible that Cotman visited
Conway towards the end of his tour of
Wales in 1800, probably in mid- or late
August in the course of a slow progress
northwards. Kitson's suggestion that he
was there in July and probably met
Girtin in Sir George Beaumont's party
is an attractive conjecture, but does not
stand up to scrutiny (see Introduction,
p.10, and Rajnai & Allthorpe 1979 p.40).
 The subject reappeared in Cotman's
oeuvre during his first Norwich period,
both as a watercolour and as an etching
(Popham 18), and again in 1824 when
the title occurs among his exhibits with
the Norwich Society (154).

8 A view of Dolgelly 1802

pencil, black and grey wash and indian
ink on wove paper; 26.7 × 39.5
($10\frac{1}{2} × 15\frac{9}{16}$)
Said to be inscribed (or ?signed and
dated) on verso *Dolgelly. Cotman 1802*.

Prov: Christie's 17 Nov. 1970 lot 8 as by
John Varley, bt Agnew; purchased from
them.
Ref: Rajnai & Allthorpe 1979 p.44.
*The Trustees of Cecil Higgins Art Gallery,
Bedford*

View of Dolgelly from the north-east, its well-known bridge seen in line with the church. Cotman must have passed through here on the way from Aberystwyth to Harlech between 18 and 30 July 1800, and Kitson suggests that he and Munn stayed at Dolgelly from 19 to 23 July 1802 as there are dated drawings by Munn to support this. A closely related view (from the south-east) is in the NCM and a fine later watercolour developed from it is in the Fitzwilliam Museum, Cambridge.

The crisply handled patchwork of small pools of wash is typical of Cotman's work of 1801–2.

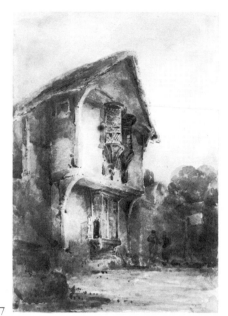

7

9 **Bristol Ferry 1802**

pencil, watercolour and bodycolour on wove paper laid down on original mount; 19.7 × 28 ($7\frac{3}{4}$ × 11) (sight)
Inscribed, signed and dated in brown ink on verso of mount *Bristol. Ferry J S Cotman 1802.*

Prov: A. Richards.
Exh: Agnew 1975 (65); Agnew 1982 (83).
Thomas Agnew & Sons Ltd

Cotman's only convincingly documented visit to Bristol is his stay with the Nortons in June 1800 prior to his tour of Wales. Apart from drawing the portraits of several members of the

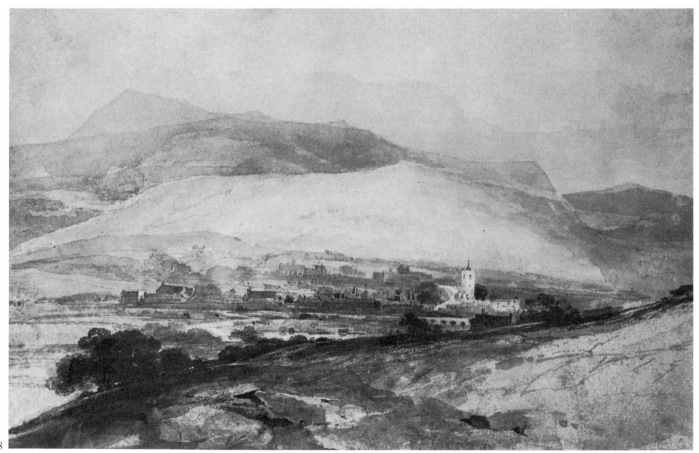

8

43

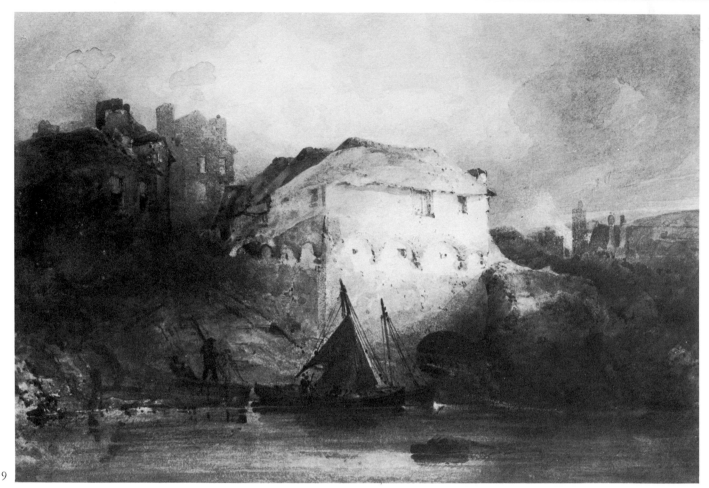

9

family, he sketched a few sites in the city, St Mary Redcliffe (see no. 11) and the ferry house among them. The subject of the present watercolour was made use of again a few years later in the upright composition in oil now at Edinburgh (see no.116).

10 Ashtead Churchyard, Surrey [1802]

pencil and grey wash on wove paper laid down on original mount; 12.9 × 21.1 ($5\frac{1}{16} \times 8\frac{5}{16}$)
Inscription in pen and brown ink on verso of mount *Ashted Church yard Surry*

Prov: ?Cotman's sale, Christie's 1 May 1824 (lot 5 consisted of four drawings, one with this title); bt by S.D. Kitson

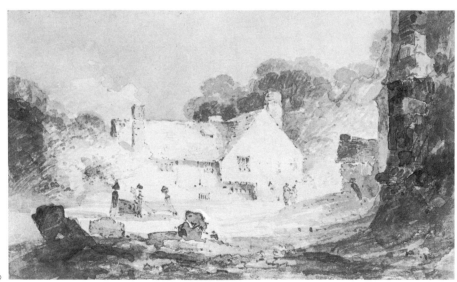

10

11

from Squire's Gallery 1934; Kitson
Bequest 1938.
Ref: Kitson 1937 p.15 fig.2.
Leeds City Art Galleries

Like the two Leeds pencil drawings of
the Well House, Ashtead, dated 1799,
this is thought to be a result of Cotman's
assumed stay at Dr Monro's country
cottage at Fetcham in the summer of
1799 or at least prior to the 1800 Royal
Academy exhibition, where drawings of
several sites of the region were shown
by him (Dorking, Guildford,
Leatherhead). The cottage and the
wooden grave posts became the subject
of a softground etching and of at least
three watercolours, one in the collection
of the late Alec Cotman and two in the

Ashmolean Museum, not necessarily all
by Cotman himself.
 Kitson points out that the same scene
appears as background to Edridge's
portrait of Hearne, dated 1800, in the
Victoria & Albert Museum.

11 **St Mary Redcliffe, Bristol; Dawn**
[1802–3]

pencil and watercolour on wove paper;
38 × 53.5 (14$\frac{9}{16}$ × 21$\frac{1}{16}$)

Prov: Dawson Turner; bt at his sale,
Puttick & Simpson 16 May 1859 and
seven following days, lot 812 (with
several others, seven by Cotman).
Exh: Norwich 1955 (50); Bedford 1960
(2); Paris 1972 (64).

Ref: Kaines Smith 1926 p.73; Binyon
1933 p.142; Kitson 1937
pp.27,28,73,fig.6; Williams 1952 p.158;
Lemaitre 1955 p.274 n.2; Hawcroft 1962
p.29; Hardie vol.11 1967 p.74;
Holcomb 1978 p.9 pl.9.
The Trustees of the British Museum

See no.9 for Cotman's stay in Bristol in
1800. A second visit the following year,
suggested by Kitson on account of a
single portrait dated 5 November 1801
of one of the Bristol Nortons, is less
certain: the sitter could have travelled to
London. There are three versions of the
subject, all varying in detail, one of
which is signed and dated 1801 (Private
Collection, USA).
 A singularly masterful interpretation

45

of early industrial England: a city lorded over by a beautiful and proud gothic church stained by, and wrapped in, the smoke that fills the sky and blots out the sun. ('Dawn' was not part of the title at the time of the first appearance of the drawing, i.e. the Dawson Turner sale.)

Engraved in mezzotint by Sir Frank Short in the *Portfolio* vol.19, 1888.

12 **Bedlam Furnace** [1802–3]

watercolour on wove paper; 26 × 48.6 ($10\frac{1}{4}$ × $18\frac{3}{8}$)

Prov: the late Sir Hickman Bacon.
Exh: Hull 1938 (4); Arts Council 1946 (25); Arts Council 1948 (25); Norwich 1955 (51); Whitworth 1961 (46); Arts Council 1971 (19); Tate 1973 (263).
Ref: Oppé 1923 p.viii; Kitson 1937 p.41 fig.5; Hawcroft 1962 p.29; Clifford 1965 pl.29b; Klingender 1968 pp.101 & 102 pl.VI in colour.
Private Collection

Kitson suggests that this watercolour is the fruit of Cotman's assumed second visit to Wales, in 1802, in the company of Paul Sandby Munn, who in fact exhibited a composition of this title in the Royal Academy of 1803 (625). However, the title of Cotman's drawing is recent, apparently Kitson's invention: the subject does not appear among Cotman's exhibits nor in any of his sales. While in the Hickman Bacon collection, the drawing was called *Scene in the Black Country*.

Whatever the geographical location, it does not alter the fact that, like the ageing de Loutherbourg and the young Turner among others, at this early period Cotman was not averse to sampling the romance of the advancing industrial revolution; he homed in with keen interest on its more picturesque or sublime aspects.

13 **Weird Scene – Moonlight 1803**

pencil and grey wash on laid paper; 21.2 × 31.4 ($8\frac{3}{8}$ × $12\frac{3}{8}$)

Signed in pen and brown wash l.r. *J. S. Cotman*; inscribed and dated on verso in ink (apparently not in Cotman's hand) *The moon looks* [*ab*]*road from her clo* [*ud.*] *The grey-skirted mist is near; the dwelling of the g* [*ho*]*sts! – Ossian's poems – Vol.2., .65 –* The beginning of the inscription as recorded by James Reeve *Wednesday, March 23rd, 1803. Subject* – and the end *J. S. Cotman, Prest – J. Varley, J. Webster, Neil, Heyward, P. S. Munn: Visitor, W. Munn.* are no longer visible.

Prov: Cotman Sale, Murrell, Norwich 26–27 Nov. 1862 lot unidentified, bt James Reeve; purchased from him with the rest of his collection 1902.
Exh: NAC 1888 (122); BFAC 1888 (89).
Ref: Roget 1891 (reprint 1972) vol.1 p.499 as *The Moon looks abroad . . .*; Binyon

12

13

1897 p.54; Reeve MS; Dickes 1905 p.254, repr.; Kaines Smith 1926 pp.13,14; Kitson 1937 p.34; Rienaecker 1953 p.12 pl.12 fig.19; Holcomb 1978 p.8 pl.6.
The Trustees of the British Museum

Done at one of the Sketching Society meetings, when Cotman was the president and so the host of the gathering and the proposer of the subject as well. The earliest known date on such a drawing by him is 5 May 1802 and the latest 26 January 1804. He chose a subject from Ossian on at least one other occasion; towards the end of 1803 he engaged the help of his new friend, Mrs Cholmeley, in finding a suitable subject for a meeting at which he was again the president.

14 **Doorway of the Refectory, Rievaulx Abbey 1803** (repr. in colour)

pencil and watercolour on laid paper, laid down on original mount;
35.8×25.4 ($14\frac{1}{16} \times 10$)
Inscribed twice in pencil along top edge *Ivy* and l.r. *Rivaulx Abbey/Augt 8* [?] *1803*; also numbered in pen and brown ink l.r. *6*

Prov: Christie's 28 Nov. 1928 lot 1, bt Paul Oppé £4. 8s. 6d.
Exh: Sheffield 1952 (6); RA 1958 (148); Ottawa 1961 (12).
Ref: Kitson 1930 pl.IV; Kitson 1937 p.54; Rienaecker 1953 pl.13 fig.20 as *The North Transept Arch*.
Private Collection

Cotman and his friend Munn arrived at Brandsby 7 July 1803 and made excursions to promising sites, starting the next day. After spending Friday the 8th at Castle Howard, they headed for Helmsley and Rievaulx from which they returned ' in raptures, thinking it altogether the finest ruin they had ever seen' (Mrs Cholmeley, 17 July 1803). Cotman went again to Helmsley on his own to work at Rievaulx Abbey on 7 August and stayed two more days, one of which is the date on the sketch (previously read as 7 which equally fits). Kitson rightly considered this remarkably 'modern'-looking watercolour of great interest: 'It is the first dated drawing by Cotman which shows a change of style from the "blue

15

drawing" to that of his mature work, with its flat washes and its likeness to oriental methods.' Other Rievaulx drawings can be found at the Tate, in the Victoria & Albert Museum, in Bedford (*see* no.17) and in Leeds. His RA exhibit of the Abbey in 1804 (498) has not yet come to light. The Refectory Doorway was etched by Cotman in 1801 (Popham 12) for his *Miscellaneous Etchings* of 1811. It was particularly admired by Francis Cholmeley 'as a work of art I prefer to any' (24 February 1811).

15 **Waterfall 1803**

pencil and watercolour on wove paper; 21.3 × 32.4 ($8\frac{3}{8}$ × $12\frac{15}{16}$)
Signed and dated l.l. *J S Cotman 1803*; signed in pencil on verso *JSC* in the midst of geometrical figures.

Prov: the late Sir Hickman Bacon.
Exh: Whitworth 1937 (5); Hull 1938 (52); Arts Council 1946 and 1948 (20).
Ref: Kitson 1937 p.47; Pidgley 1975 p.5 n.18.
Private Collection

Kitson describes it as 'a wide waterfall, at the end of a lake (possibly Llyn Ogwen)', a place he assumes that Cotman visited in July 1802 in the company of Munn, by whom there are dated sketches. A preparatory drawing of the same size, Sotheby's 29 April 1971 lot 35, was apparently once in Sir Henry Englefield's collection (see D3491 in the MS Catalogue of L. G. Duke's collection).

16 **Ouse Bridge, York 1803**

pencil and brown wash on wove paper; 19 × 37.1 ($7\frac{1}{2}$ × $14\frac{5}{8}$)
Signed and dated l.r. *J S Cotman 1803*.

Prov: acquired from the artist by Archdeacon Charles Parr Burney; by descent to his daughter Mrs Rosetta D'Arblay Wood; by descent to her daughter Edith, Lady Powell, who bequeathed it 1934.
Exh: Sudbury 1978 (29).
Ref: V & A 1934 p.18 fig.5; Kitson 1937 p.50 fig.12; Hardie vol.II 1967 p.75; Pidgley 1975 p.64 n.209; Rajnai & Allthorpe 1979 p.45.
Victoria and Albert Museum, London

This is one of the very first finished drawings of Cotman's Yorkshire period. Cotman first visited York in the company of Paul Sandby Munn at the beginning of July 1803, on their way to Brandsby where they arrived on 7 July. Dates on their York sketches indicate that they stayed in the city the previous three days, during which they drew several subjects: the Bridge, St Mary's Abbey, the Water Tower, etc. Neither of Cotman's two existing dated sketches of the bridge (NCM and V & A) is for this monochrome. They too are taken from the south, but from the opposite bank, as is one of Munn's sketches and Girtin's watercolour (Girtin & Loshak pl.63). Cotman later made a drawing copy of this subject which he exhibited in 1809 (163).

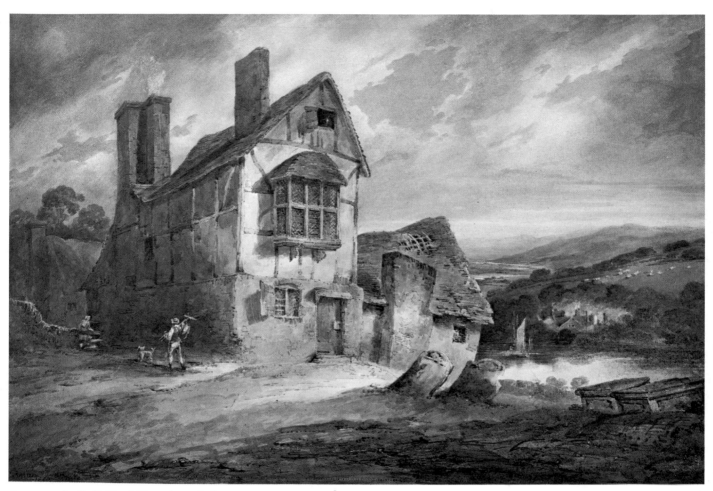

A cottage in Guildford Churchyard, Surrey 1800 (no. 1)

Doorway of the Refectory, Rievaulx Abbey 1803 (no. 14)

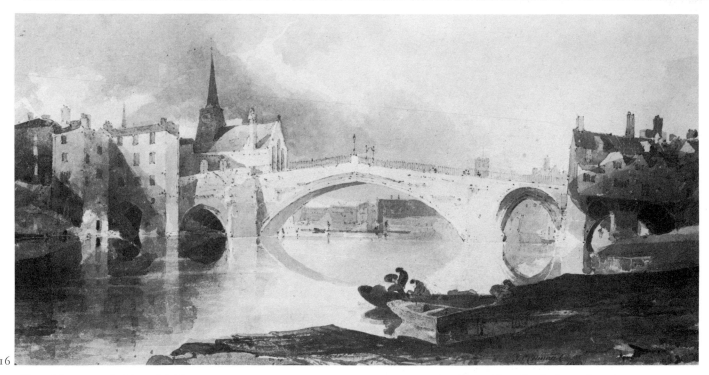

16

The 16th-century bridge with its impressive central arch spanning 81 feet to accommodate the floodwaters, and the picturesque cluster of buildings at either end, including the Chapel of St William on the north-west side, seldom failed to attract artist-visitors to the city.

17 **The Doorway to the Abbot's Hall, Rievaulx Abbey** [1803]

pencil and brown wash on laid paper; 32.7 × 21.1 (12⅞ × 8⅝₁₆) (uneven)

Prov: S. D. Kitson; by descent to the Misses Kitson, who presented it 1973.
The Trustees of the Cecil Higgins Art Gallery, Bedford

See no.14. This too must be the result of Cotman's first or second visit to Rievaulx, because apart from dining at Rievaulx Terrace towards the end of his stay, he does not appear to have been in the vicinity again until July 1805 when he went to Helmsley for the last time, from the 25th to 27th, shortly before

17

departing for Rokeby. Stylistically this would give too late a date for the drawing, which shows the rather decorative way of handling of the period 1803–4.

18 **Tree Study** [1803]

pencil on wove paper; 35.2 × 26.2 (13⅞ × 10⅝₁₆)

Prov: J. J. Cotman; bt from him by James Reeve 1864; purchased from him with the rest of his collection 1902.
Ref: Reeve MS.
The Trustees of the British Museum

One of forty-six tree studies – many of which are equally impressive – acquired from James Reeve by the British Museum. Those where Cotman concentrates on structure and quirky formations of growth seem to date from his first visit to Yorkshire, in 1803. It is no wonder that his tree studies highly impressed and delighted Mrs Cholmeley: 'Cotman has sent . . . some excellent sketches and such fine bold, wild trees as make Mr. Green's [a York friend] look very tame indeed, and plainly shew the boldness and spirit of Cotty's genius. His trees look like Shakespeare by Mr. Green's Minor Poets.' (26 November 1803).

51

18

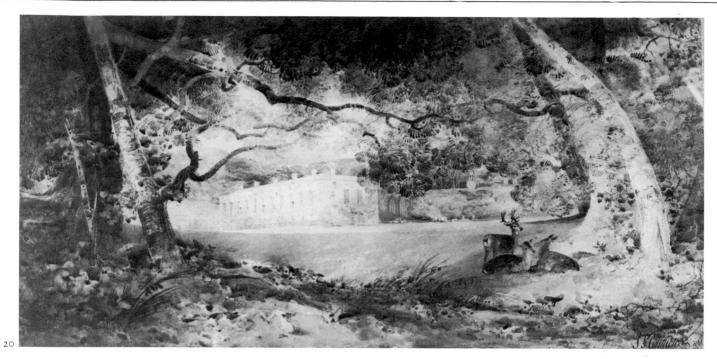

20

The curiously twisting branch coming towards the spectator became an important feature in one of Cotman's finest compositions, the *Horses Drinking* (no.49).

19 Newburgh Priory from Brink Hill near Coxwold (1804) (repr. in colour)

pencil and watercolour on wove paper;
38.9 × 79.4 (15$\frac{1}{16}$ × 31$\frac{1}{4}$) (sight)
Signed l.r. *J S Cotman*

Prov: acquired from the artist by Mr Thomas Wynn and Lady Charlotte Bellasis; by descent to the present owner.
Exh: RA 1804 (409 or 418); Leeds 1958 (11).
Ref: Kitson 1937 pp.62,89; Pidgley 1975 p.46 n.158.
Captain V. M. Wombwell

In the course of his first tour of Yorkshire in 1803, Cotman's only recorded visit to Newburgh Priory, the seat of the Bellasis family whom he had met before, was on 9 September (CB),

five days before leaving Brandsby to embark on 'a little tour' (see no.23) and to return to the south. The sketches done on that day supplied material for the two large watercolours exhibited at the RA in 1804. He was already working on them by November 1803 (see no.20) and apparently finished both in the first weeks of the following year: 'Cotman has written to Mr. Belasyse', wrote Mrs Cholmeley on 22 January 1804, 'requesting leave to frame and exhibit his two draw [in]gs of Newburgh. I think the little Dribble cannot fail to consent!'

Perhaps Cotman's purpose in choosing the distant view of the Priory was to include Coxwold with Shandy Hall, Sterne's residence where the last volumes of *Tristram Shandy, A Sentimental Journey* and *Letters to Eliza* were written.

20 Newburgh Priory; the Long Gallery from Crow Wood (1804)

pencil and watercolour on wove paper;
39 × 79.5 (15$\frac{3}{8}$ × 31$\frac{5}{16}$)
Signed and dated l.r. *J S Cotman 1804*

Prov: acquired from the artist by Mr Thomas Wynn and Lady Charlotte Bellasis; by descent to the present owner.
Exh: RA 1804 (409 or 418); Leeds 1958 (12).
Ref: Kitson 1937 pp.62,89; Pidgley 1975 p.46 n.158.
Captain V.M. Wombwell

See no.19. Of the pair, it was probably this drawing on which Cotman first worked. It was already in progress in November and excited the interest of Mrs Cholmeley's brother, Sir Henry Englefield. Cotman 'is doing Mr. Belasyse's house', wrote Mrs Cholmeley 12 November 1803, 'the *near* view of it, w [hi]ch my b [rothe]r [Sir Henry] says will be a very beautiful drawing, and that he has managed the great tree in the foreground vastly well indeed.' The

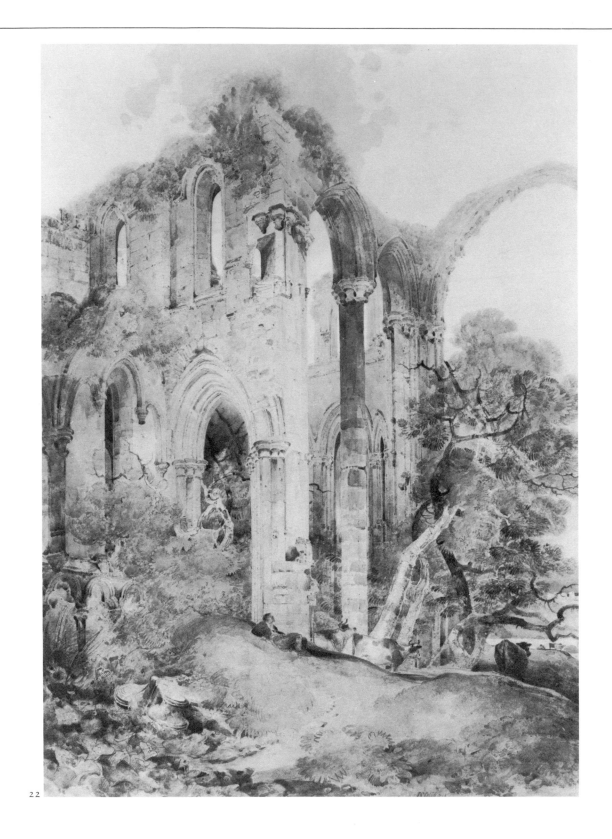

22

vignette-shape composition for such a large watercolour is somewhat odd and certainly old fashioned when compared with the much more advanced distant view of the same date.

The house, originally an Augustinian Priory, had been the seat of the Bellasis family from the time of the Dissolution of the Monasteries. At the time of Cotman's visits to Yorkshire it was owned by the Cholmeleys' friends Lady Charlotte Bellasis, the daughter of the second Earl of Fauconberg, and her husband Thomas Wynn, who assumed the name of Wynn Bellasis. One of the rooms contains the reputed tomb of Oliver Cromwell.

21 **Cader Idris, from Barmouth Sands** (1804) (repr. in colour)

pencil and watercolour on wove paper; 36.6 × 54 ($14\frac{7}{16}$ × $24\frac{1}{4}$)

Prov: ?the artist's sale, Christie's 17 & 18 May 1843 lot 206 as *Barmouth Sands*, bt D. White 13*s*.; J. Beausire; Ralph Brocklebank; his Trustees by 1922; Francis Gill; F. J. Nettlefold by 1829; Alan D. Pilkington who presented it with the rest of his collection 1973.
Exh: ?RA 1804 (375) as *Near Barmouth, North Wales*; Tate 1922 (140); Colnaghi 1958 (28).
Ref: Dickes 1905 p.250,258; *Connoisseur* March 1929 p.186, frontispiece in colour; Kitson 1937 pp.48,62; Rienaecker 1953 pl.3 in colour; Rajnai & Allthorpe 1979 p.41.
The Provost and Fellows, (from the Pilkington Collection) Eton College

This impressive drawing turns back to a view experienced four years earlier and first given full expression in a smaller watercolour of 1801 in NCM (see Rajnai & Allthorpe for other versions). Cotman passed through the area some time between 18 and 30 July 1800, slowly progressing northward through the region during his tour of Wales that year. The Norwich watercolour, much

simpler in composition and much more summary in execution, was here elaborated into an exhibition piece in which the pictorial interest of the busy group of boats and (for Cotman) large-scale figures are balanced by mountainous white clouds diagonally opposite.

22 **Fountains Abbey** (1804)

pencil and watercolour on wove paper; 85.9 × 60.9 ($33\frac{13}{16}$ × $23\frac{15}{16}$)
Signed l.l. *J S Cotman*
Numbered in pencil along lower edge *1* to *10* ?for transfer.

Prov: Mrs Worthington; Percy Moore Turner 1934; Lady Holmes who presented it 1945.
Exh: ?RA 1804 (564).
Ref: Kitson 1937 pp.53,62–3; Rajnai & Allthorpe 1979 pp.47–8 (accepting the Ashmolean version as the 1804 exhibit).
Fitzwilliam Museum, Cambridge

On his first tour of Yorkshire, Cotman and P.S. Munn left their base, Brandsby, after only a week: on 14 July 1803 they embarked on a short tour of the county, returning on 2 August. In fact half of their time away was spent in one location. 'We have heard from our 2 artists from Ripon', wrote Mrs Cholmeley on 23 July; 'They are delighted beyond measure with Fountains Abbey and have seated themselves there a week to draw at their leisure.' Cotman made at least six drawings of the Abbey and exhibited the subject five times between 1804 and 1839. Kitson was surely right when he identified this watercolour with the 1804 exhibit, but went wrong when he assumed that it was bought by Dawson Turner. Turner's drawing, which is now in the Ashmolean, is smaller and shows an exterior view of the east end, unlike this and the pencil drawing, dated 1804, in NCM (Rajnai & Allthorpe no.27), which is an interior view with the great

sanctuary window and the Chapel of the Nine Altars seen from the south-west. It is an impressive achievement, retaining the vigour and qualities of Cotman's works of more usual size, even if Kitson was unhappy about the great arch leaping away from the bulk of the masonry. Comparison with Girtin's rather similar view of 1798 at Sheffield does indeed show that Cotman's solution of the composition was not the most fortunate.

23 **The Rivers Humber, Ouse and Trent, from Welton, near Hull, Yorkshire** [1804]

pencil and watercolour on wove paper; 25.7 × 42.3 ($10\frac{1}{8}$ × $16\frac{5}{8}$) (sight)
Signed l.r. *J S Cotman*
According to Kitson verso inscribed with title.

Prov: see no.24.
Exh: Agnew 1960 (72); Kendal 1973 (23).
Ref: Kitson 1937 pp.61,62, fig.22; Skilton 1965 p.44; Rienaecker 1953 pl.21 fig.37.
Leeds City Art Galleries

An opportunity to sketch this view occurred at the end of the artist's first stay in Yorkshire when, in the company of his hosts and their son, 'Mr. Cotman left Brandsby on a little tour to Beverley, Hull, Howden, Selby, Leeds and Wakefield' (CB 14 September 1803), where they parted, Cotman heading back to the south. As this picture and its companion (no.24) first came to light at the Heath Hall sale in 1935, Kitson's plausible suggestion is that they were acquired direct from the artist by J. Smyth MP, owner of the Hall in Cotman's time and one of the subscribers – Miss Smyth being another – to his *Miscellaneous Etchings* in 1811. Cotman and his party might have paid a visit to Smyth on this tour, as Heath Hall is next to Wakefield, their last port of call.

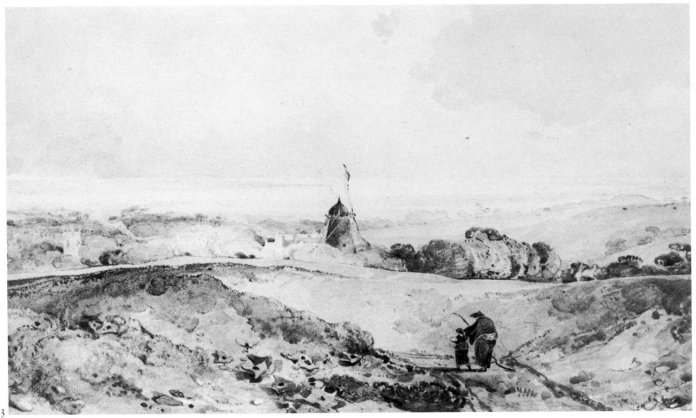

23

An impressive rendering of the same scene done some years later (1807–10), with the focus of the composition, the dark windmill, enlarged and turned white, and with some other changes, is in the Municipal Art Gallery at Pietermaritzburg. 'Seen in the clear light of its South African resting-place, it seems to be an abstract vision of England.' (Kitson.)

24 Kirkthorpe, Yorkshire 1804

pencil and watercolour on wove paper; 26×42.2 ($10\frac{1}{4} \times 16\frac{5}{8}$) (sight)
Signed and dated l.r. *J S Cotman 1804*

Prov: ? acquired from the artist by J. Smyth MP of Heath Hall; by descent to Col. Smyth (d. 1935); his sale, Heath Hall 24 July 1935, bt Walker Galleries $15\frac{1}{2}$ gns; bt from them by S. D. Kitson August 1935; Kitson Bequest 1938.

Exh: Agnew 1960 (76); Kendal 1973 (22).
Ref: Kitson 1937 pp.61,69, fig.20; *Country Life* 20 Oct. 1960 repr.; ILN 5 Nov. 1960 repr.
Leeds City Art Galleries

Like *The Rivers Humber, Ouse and Trent...* (no.23), this is a result of the artistically very fruitful 'little tour' Cotman made at the end of his first stay in Yorkshire in 1803. As Kirkthorpe is only a short distance from Wakefield, the point of Cotman's departure homewards (and the church is close by Heath Hall, the residence of the first owner of this watercolour), it must have been the last subject sketched on this tour.

A less successful contemporary composition of the same view is in the Leslie Wright Collection, Birmingham Art Gallery.

25 The Vaults below Slingsby Castle 1804

pencil and watercolour on wove paper; 21.5×33 ($8\frac{1}{2} \times 13$)
Signed and dated in brown ink l.r. *J. S. Cotman 1804.*

Prov: ? acquired from the artist by Edward Worsley.
Exh: Scarborough 1950 (41).
Ref: Sir William Worsley, *Early English Water-Colours at Hovingham Hall* 1963 (7); Pidgley 1975 chapter 1 n.160.
Private Collection

There is no mention of Slingsby in the Cotman–Cholmeley correspondence or in the Brandsby Commonplace Book. However, we have Cotman's own testimony that he sketched this site on 4 August 1803: a preparatory drawing in pencil and brown wash in the Mackintosh collection is inscribed by

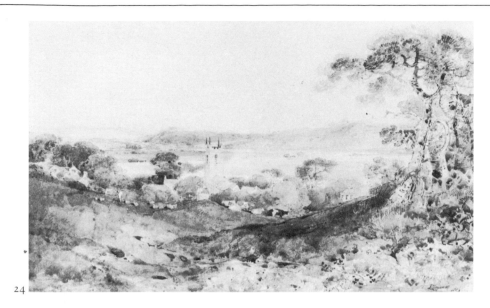

24

him with the name of the location and
this date. Slingsby is about two miles
east of Hovingham, the seat of the
Worsleys, about whom both the
correspondence and the Commonplace
Book are silent but who seem to have
acquired a number of Cotman drawings
at the time of Cotman's visits and later.

Another subject of this locality,
Entrance to the town of Slingsby, Yorkshire,
one of four drawings in lot 5 in
Cotman's sale of 1 May 1824, was
apparently intended to be etched,
presumably for his *Miscellaneous Etchings,*
for the lot is described as 'treated with
great taste – not published'.

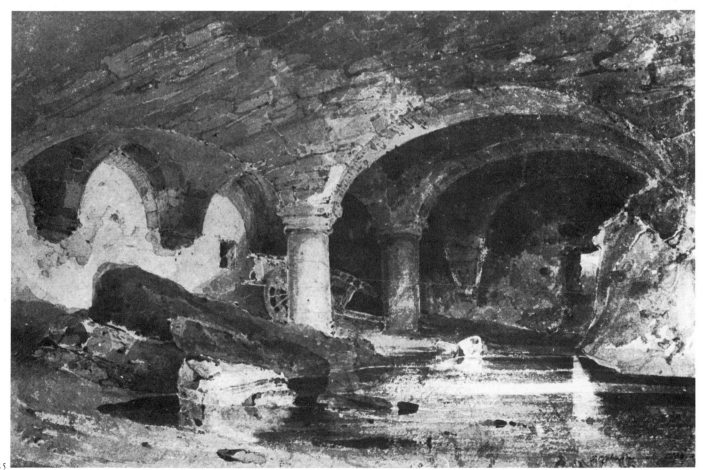

25

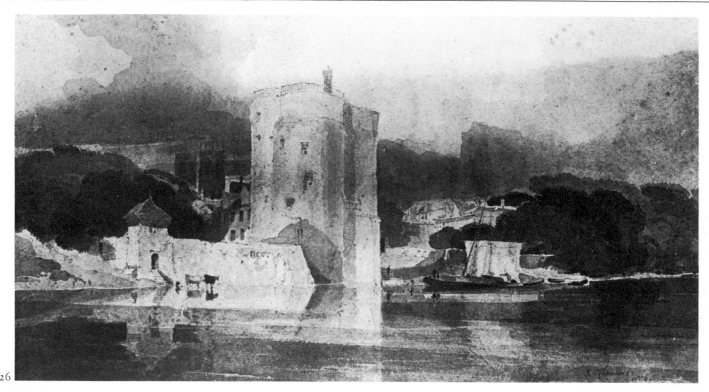

26

26 The Water Tower, York 1804

pencil and grey wash on laid paper;
22.2 × 43.2 (8¾ × 17)
Signed and dated l.r. *J S Cotman 1804*
Inscribed on verso *York*

Prov: purchased in 1914 £75.
Exh: Tate 1922 (177); Brussels 1929
(38); Whitworth 1937 (45); Arts Council
(Whitworth) 1948 (33); Agnew 1954
(78); Arts Council 1960 (19); Colnaghi
1967 (49); Colnaghi 1970 (28).
Ref: Kitson 1937 p.60 fig.17; Lemaitre
1955 p.291 n.1, pl.23.
*Whitworth Art Gallery, University of
Manchester*

For Cotman's first visit to York, and
probably the only one that was devoted
to sketching, see no.16. It was very
likely on Tuesday, 5 July 1803, that he
drew the view, as there is in the Victoria
& Albert Museum a drawing of the
same subject and of that date by his
companion Paul Sandby Munn.
Cotman's impressions were turned into
two compositions: an upright in
watercolour now in Leeds (Kitson 1937
fig.16) and this one in monochrome,
with a version in watercolour now in
the Ashmolean Museum (Kitson 1937
fig.18).

 A drawing of this subject appeared as
lot 205 in the artist's sale 17 & 18 May
1843. As it was listed among the
watercolours, it was probably the
Ashmolean version.

27 Doorway to the Refectory, Kirkham Abbey 1804

pencil and watercolour with some gum
arabic or varnish on wove paper;
37.8 × 26.7 (14⅞ × 10½)
Signed and dated l.r. *J. S. Cotman 1804*–

Prov: Turry Abbey; H. C. Green; his
sale, Sotheby's 10 Oct. 1962 lot 66 repr.;
Mr & Mrs W. W. Spooner; Spooner
Bequest 1967
Exh: Courtauld Galleries 1968 (54);
Colnaghi 1970 (27); Rye Art Gallery
1971 (unnumbered); Bristol 1973 (10);
New Zealand & Australia 1976–8 (45).
Ref: Troutman 1968 p.56 fig.10.
*Courtauld Institute Galleries, London
(Spooner Bequest)*

On his first visit to Yorkshire, Cotman
arrived at his base, Brandsby, on
Thursday, 7 July 1803, and by the 10th
he had already visited Castle Howard,
Rievaulx Abbey, Helmsley Castle and

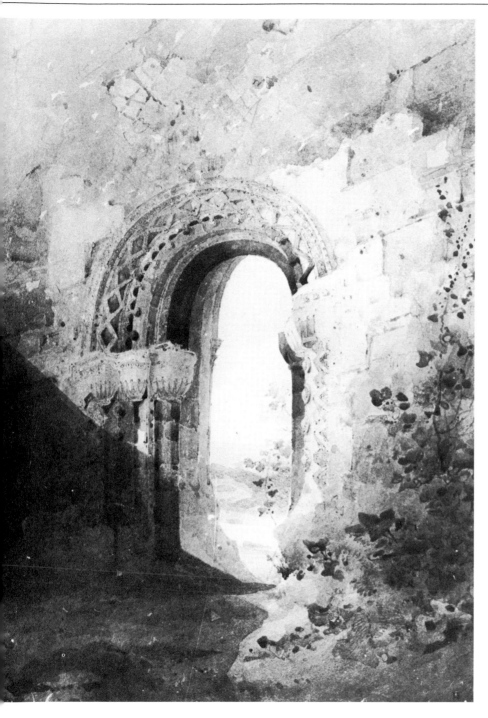

also Kirkham Abbey. 'They [Cotman and Munn] were delighted with Kirkham and have made some exquisite drawings of it. I wish you c[oul]d see them,' wrote Mrs Cholmeley on 16 July. She and Cotman spent the day there on 30 August, and he is likely to have visited the Abbey ruins again (for the last time) when he was staying at nearby Whitwell for four days in July 1805. It is tempting to assume that this startlingly beautiful watercolour is based on one of the 'exquisite drawings' mentioned by Mrs Cholmeley. Etched for his *Miscellaneous Etchings* 1811 (Popham 11).

28 Harlech Castle [1804]

pencil and watercolour on wove paper; 26.4 × 42.7 (10$\frac{3}{8}$ × 16$\frac{13}{16}$)
Signed l.r. *J S Cotman*

Prov: Col. Herbert A. Powell by 1922; presented by NACF (H. Powell Bequest) 1967.
Exh: Tate 1922 (5).
Ref: Kitson 1937 p.43; Hardie vol.II 1967 p.74; Rajnai & Allthorpe 1979 p.39.
The Trustees of the Tate Gallery

Cotman definitely visited Harlech during his tour of Wales in 1800, and a second visit in 1802 is suggested by Kitson. According to the evidence of two dated sketches in NCM, Cotman reached the Castle by 30 July 1800 and remained there at least for another day. He must have been impressed, as the noble ruin became the subject of a number of watercolours which span his whole career, of three or more pencil drawings in addition to those already mentioned, of a drawing copy and of two softground etchings. The five recorded watercolours show four different aspects of Cotman's attitude to

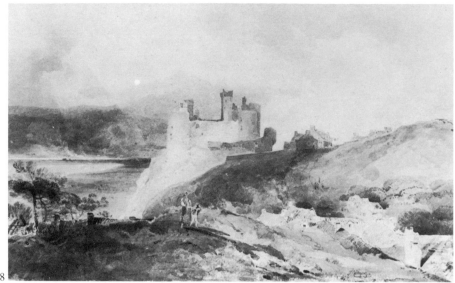

28

his subject. Among them this picture is the closest to a true rendering of the scene, clearly based on the NCM sketches, as is one of the softgrounds. Another that approximates fairly closely to reality and depicts goats and cattle below the Castle is the drawing described by Kitson (pp.258–9). The one in the Ulster Museum must be Cotman's 1800 RA exhibit, drawn before he ever visited Harlech, presumably from an etching or after a sketch by someone else. The NCM's large watercolour is a capriccio showing the castle in an arcadian setting. The fifth, that in Birmingham, is hardly more than a reminiscence of Harlech done in the last phase of Cotman's career (see no.106).

29 'Towered cities please us then' – Milton [1804]

pencil and grey wash on laid paper; 36.6 × 48.2 (14⅜ × 19)

Prov: J. S. Hayward; by descent to J. Howard Barnes whose children presented it with the rest of his Sketching Society drawings.
Ref: Oppé *Connoisseur* 1923 p.192 pl; Kitson 1937 p.36; Hamilton 1971 p.7

pl.5; Owen & Stanford 1981 p.36.
Victoria and Albert Museum, London

One of the Sketching Society drawings preserved by Hayward, himself a member. Dated drawings done at the Society's meetings by Cotman range from 5 May 1802 to 26 January 1804, but these dates do not necessarily limit the period of his participation. The possible influence of Turner's *The Fifth Plague of Egypt* has already been pointed out but the striking similarity between the compositions of Havell and Cotman and the shared aqueduct motif, which does not appear in Turner, point to an even closer prototype. The Piranesian feeling reveals Cotman's early interest in the great Italian whom he 'decidedly' followed as an etcher.

Cotman preserved a sizeable collection of Sketching Society drawings right through his life. In the sale of his drawings by Murrell, Norwich, 26–27 November 1862, lot 58 was: 'A folio of twenty seven drawings by various artists, viz. Cotman, Varley, Webster, Hayward, & Munn, members of the Sketching Club, & friends of the late Mr. John Sell Cotman London 1803.' The lot went for 16s. (See also nos. 13, 52 and 53.)

29

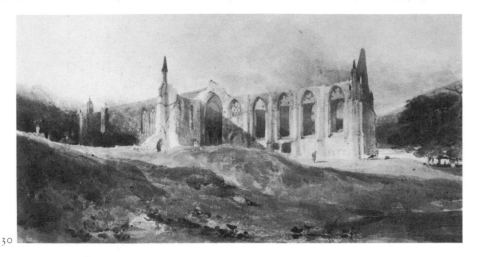

30

30 **Bolton Abbey** [1804–5]

pencil and watercolour on wove paper;
22.2 × 43.1 (8¾ × 17)
Signed l.r. *J. S. Cotman*

Prov: purchased from Palser Gallery by
T. & S. Girtin 1913; by descent to
present owner.
Exh: Sheffield 1953 (11); Leeds 1958
(14); RA 1962 (64); Reading 1969 (60).
Ref: Kitson 1937 pp.53,60; ILN

31 March 1962 repr; Rajnai & Allthorpe
1979 p.46.
Tom Girtin Collection

The only opportunity Cotman had to
visit Bolton Abbey was on his three-
week tour – 14 July to 2 August 1803 –
in the company of P. S. Munn, starting
from and returning to Brandsby. Dated
sketches of this tour (see Rajnai &
Allthorpe) show that they must have

called briefly at Bolton on the way from
Gordale Scar, which Munn drew on
26 July, and Kirkstall Abbey where
Cotman was sketching two days later. A
very similar view, but slightly from the
south-west instead of the south-east and
earlier in date, is now in the Mellon
Collection, and a later version is
mentioned by Kitson. While the present
watercolour does not fit readily in the
Cotman chronology, a date just before
the Greta drawings would seem
appropriate.

31 **Covehithe Church, Suffolk** [1804–5]

pencil and watercolour on laid paper;
40 × 56.7 (15¾ × 22⁵⁄₁₆)

Prov: acquired from the artist by
Dawson Turner; bt at his sale, Puttick
& Simpson 16 May 1859 and seven
following days lot 812 (with several
others, seven by Cotman).
Ref: Kitson 1937 pp.67,69,73 fig.25;
Pidgley 1975 p.7 n.27.
The Trustees of the British Museum

In 1804 Cotman did not go to Yorkshire
until the end of September. He seems to
have spent some time in July in the
company of Dawson Turner while this
most influential man in the artist's life
was staying with his family and friends
on the Suffolk coast at Covehithe.
Cotman's response to the ruined church
there, to Castle Acre Priory and to
Croyland Abbey, which he visited in
quick succession, provides an amusing
and characteristic impression of his
enthusiastic and excitable nature. This
fine watercolour, whether coloured on
the spot, as Kitson suggests, or not,
clearly shows how impressed he was
with the ruin, yet when he reaches Castle
Acre he feels only contempt for it: 'Cove
Hythe – pish, my dear Sir must not be
named with this.' (9 August 1804, in Mr
C. Barker's collection) – only to dismiss
Castle Acre, nine days later, in favour of
Croyland Abbey: 'Croyland is most
delicious. You know how I esteemed

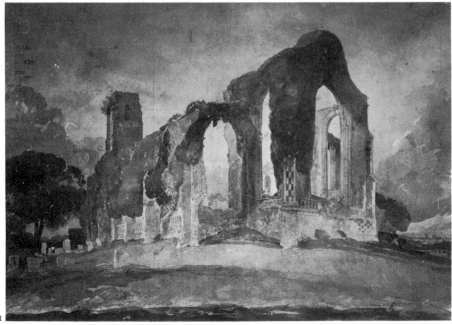

31

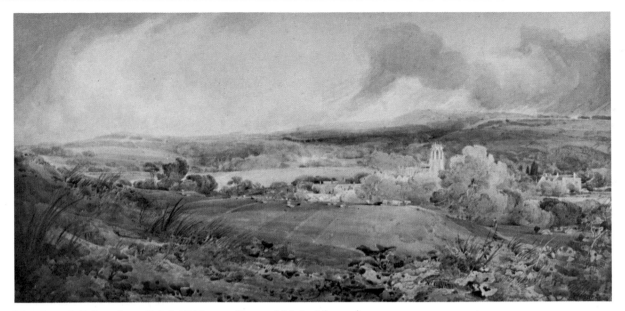

Newburgh Priory from Brink Hill near Coxwold (1804) (no. 19)

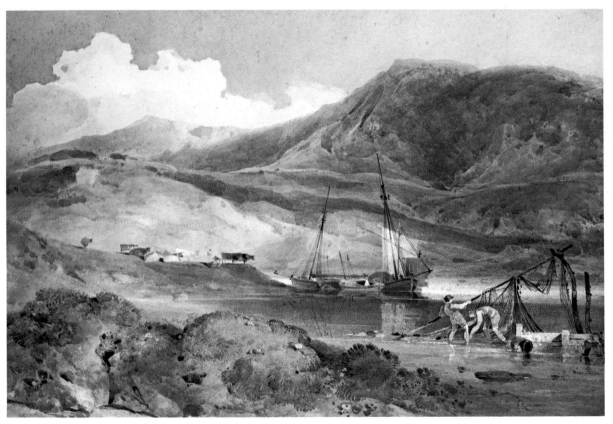

Cader Idris, from Barmouth Sands (1804) (no.21)

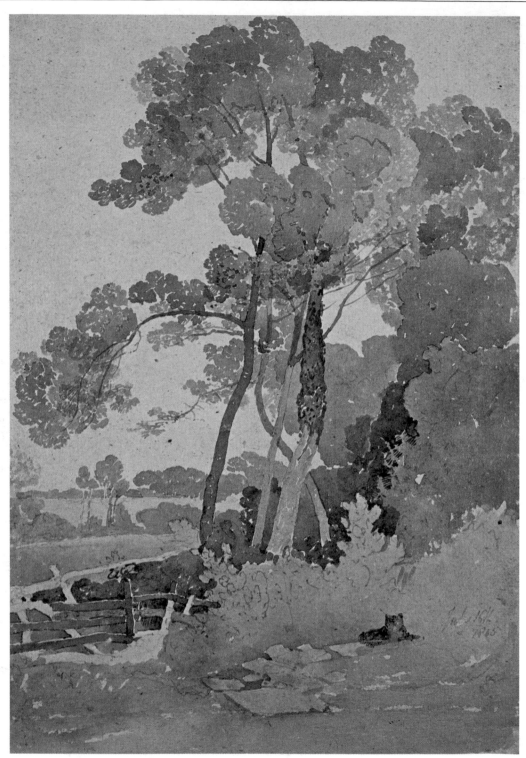

Near Brandsby, Yorkshire 1805 (no. 34)

Howden. This, oh! this is far, far superior. Castle Acre to it is as nothing.' (18 August 1804, in same collection.)

32 **Cottage at Covehithe** [1804–5]

pencil and watercolour on laid paper;
32.4 × 48.2 (12¾ × 19)
Signed and inscribed with title in pencil on verso

Prov: C. B. Bolingbroke; Colnaghi's; Christie's 4 June 1974 lot 124, bt Stanhope Shelton; purchased from him.
Exh: Colnaghi 1972 (38) pl.XXI; Sudbury 1978 (23).
Levens Hall Collection

The Colnaghi catalogue draws attention to an interesting feature in both Covehithe drawings: at the bottom of each 'there is a horizontal strip which has been painted almost carelessly'. From this it was assumed 'that Cotman used this part of the paper to check his washes indicating that both drawings were drawn on the spot without the usual facilities of the artist's studio to mix and prepare colours'. Nevertheless, it seems unlikely, or at least questionable, that Cotman would have coloured on the spot drawings of this size.

33 **Study of Trees, Harrow 1805**

pencil and watercolour on laid paper;
35.9 × 27.9 (14⅛ × 11)
Dated in pencil l.r. *July 1st. 1805.* and inscribed in pencil l.l. *Harrow Midilex* [*sic*]

Prov: Presented by A. E. Anderson 1916.
Exh: Tate 1922 (87); Whitworth 1937 (11); Arts Council 1960 (20) pl.1; Colnaghi 1967 (29) pl.XII; Colnaghi 1970 (36); Brussels 1973 (19); Russia 1975 (45) repr.
Ref: *Walker's Monthly* Feb. 1929 repr.; Kitson 1937 pp.77–8; Davies 1939 pl.XX; Hardie 1942 p.172; *Twenty Early*

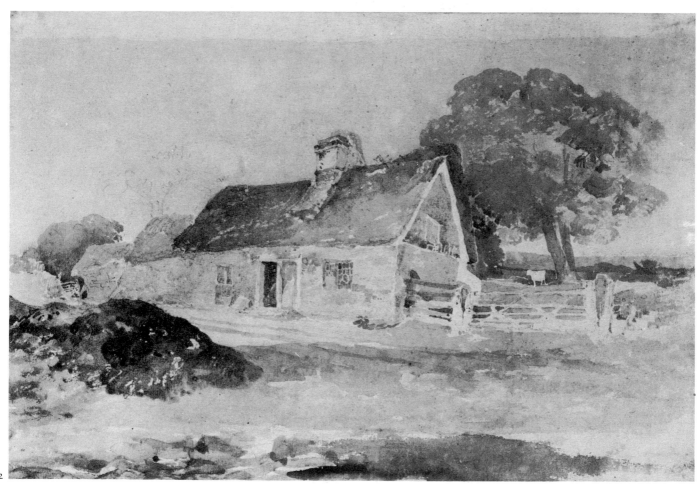

32

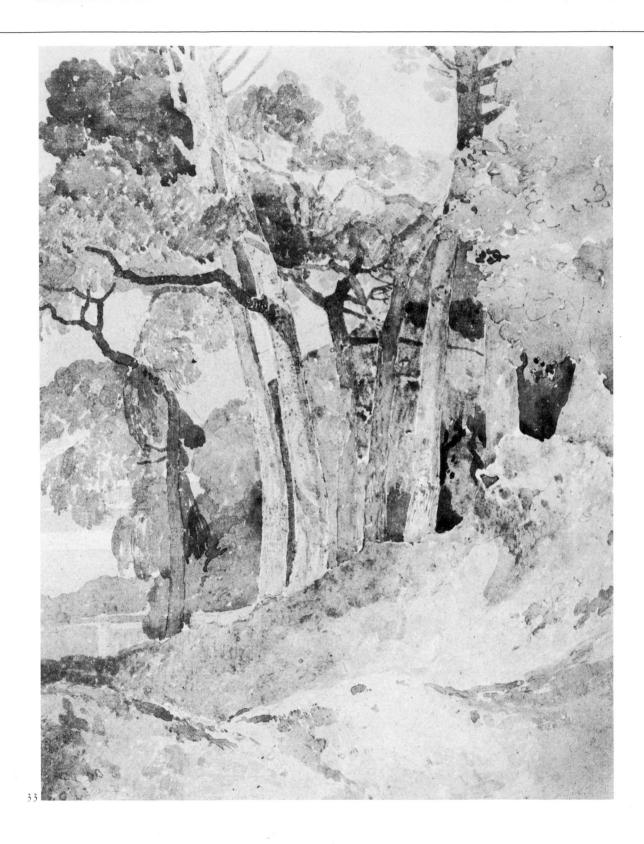

33

English Water-Colour Drawings in the Whitworth Art Gallery 1951 pl.20; Lemaitre 1955 p.278 n.1; Clifford 1965 p.69 pl.30b; Hardie vol.11 1967 p.81.
Whitworth Art Gallery, University of Manchester

One of the rare dated or firmly datable watercolours of 1805–6: it was sketched twelve days before Cotman arrived at Brandsby for his third and last stay in Yorkshire. One can still agree with Kitson's appreciative comment: 'It is the first example of Cotman's essays in the contrasting values of blues and yellows. Here the trees, freely and confidently rendered, are blue, while the sandy foreground is a brilliant yellow . . . It was done evidently to satisfy himself, and not as an article of commerce.'

34 **Near Brandsby, Yorkshire 1805** (repr. in colour)

pencil and watercolour on laid paper; 32.9 × 22.8 ($12\frac{15}{16}$ × 9)
Dated in pencil towards l.r. *July 16th 1805*; recorded as inscribed in pencil on verso *Brandsby*, apparently not in the artist's hand.

Prov: Sutton Palmer; Christie's 11 Dec. 1933 lot 176; bequeathed by S. D. Kitson 1938.
Exh: Bedford 1960 (18); Colnaghi 1970 (37).
Ref: Kitson 1937 p.78 frontispiece in colour; Rienaecker 1953 pl.24 fig.42; Mayne 1962 opp. p.237.
The Visitors of the Ashmolean Museum, Oxford (Kitson Bequest)

Soon after Cotman arrived at Brandsby for what turned out to be his last visit, he had a day of much coming and going: 'Mr. Mitchell came in the morning & return[e]d to York after dinner. Mr., Mrs., Miss & Mr. Richard Selby came to dinner,' records the Brandsby Commonplace Bok for 16 July. In the midst of this socialising he must have found time to do some sketching which

resulted in this, one of his most charming watercolours. 'It remains a fascinating example', wrote Kitson, 'of the translation of an ordinary scene into a patterned harmony at the hands of an inspired artist.' The light patch of the bushes behind the dog, silhouetted against the darker background, points forward to works such as *Brignall Bank*, while the decorative, almost Sandby Munn-like handling of the foliage, harkens back to the past.

35 **In Rokeby Park** [1805–6] (repr. in colour)

pencil and watercolour on laid paper; 32.9 × 22.9 ($12\frac{15}{16}$ × 9)

Prov: acquired from the artist by Francis Gibson of Saffron Walden; descended from him in the Fry family until the 1960s; purchased from Agnew 1971.
Exh: Norwich 1903 (13); Tate 1922 (22); RSBA 1923 (23 or 32); New York and RA 1972–3 (122) repr.; Yale 1977 (174), pl.CXLVI.
Ref: Rajnai & Allthorpe 1979 p.61.
Yale Center for British Art, Paul Mellon Collection

This watercolour is one of a number which was still in the artist's possession in the last decade of his life, when his newly acquired patron and friend, Francis Gibson, the Saffron Walden banker, acquired it with some others (see no. 36). Although there is an engaging immediacy of contact with nature in this drawing, the arbitrary colour itself prevents it from being considered a nature study. The more likely progress in the creation of this and similar watercolours is that suggested by Christopher White in the Yale catalogue: 'Before the motif, he may either have sketched in the underdrawing in pencil, which can be seen on the present study, or as we know from the case of *Greta Woods from Brignal Park* [*sic*], made a pencil study,

which he then worked up in water-colour on another sheet.'

Of course it is well known from Cotman's oft-quoted letter to Dawson Turner that in 1805 his 'chief Study has been colouring from Nature'. There is also evidence that he had already been doing this at least as early as 1803. When Katherine Cholmeley reported to her brother on one of their excursions to Byland Abbey, she included the observation: 'Mr. Cotman made some sketches and tinted one he had taken when there before with Mr. Munn.' (16 August 1803). None of the Greta watercolours, nor, for that matter, any of his known watercolours of any period, appear to be 'close copies of that ficle Dame' (nature), so the evidence is unillustrated as yet.

36 **Greta Woods** [1805–6] (repr. in colour)

pencil and watercolour on laid paper; 43.5 × 33.4 ($17\frac{1}{8}$ × $13\frac{1}{8}$)

Prov: acquired from the artist by Francis Gibson of Saffron Walden; by descent in the Fry family to present owner.
Exh: Tate 1922 (45); RA 1934 (740); Amsterdam 1936 (202); Whitworth 1937 (15); Geneva & Zurich 1955–6 (21); Arts Council 1959 (391).
Ref: Oppé 1923 pl.VI; Binyon 1933 p.144; Johnson 1934 p.12; Rienaecker 1953 pl.24 fig.44; Hawcroft, *Burlington* 1962 p.70; Hardie vol.11 1967 p.78 pl.71; Pidgley 1975 pp.106–7 n.363; Rajnai & Allthorpe 1979 p.61.
Private Collection

The view in this, one of the most outstanding of the Greta drawings, is practically the only one which can be identified with certainty as a site within Rokeby Park proper. It is only a short walk from the Hall, with the small bridge still in position and the river bank bordering Mortham woods as luxuriant as ever. Cotman arrived at

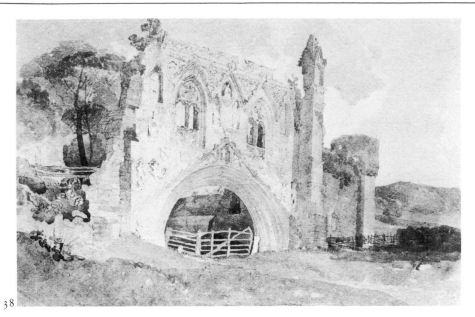

38

Rokeby, the seat of the Morritts, with his friend, the young Francis Cholmeley on the last day of July 1805 and stayed about three weeks until their hosts' departure from home forced Cotman to take up lodgings at an inn. His friend had left earlier. Although most of Cotman's subjects were taken from the stretch of the river some distance away, he was deeply attached to the house and immediate surroundings and felt most unhappy during his remaining days at Greta Bridge: 'I am plaguedly pale to be cut off from such a party & to remain on the spot in front of the park gates & when I pass the House I really am quite wretched, but now I do not pass it I always avoid it systematically . . .' (29 August).

37 Duncombe Park, Yorkshire [1805–6]
(repr. in colour)

pencil and watercolour on laid paper; 32.4 × 22.8 (12¾ × 9)

Prov: J. J. Cotman; pledged by him as part of a large collection to William Steward, a pawnbroker at Great Yarmouth; the sale of this collection, Spelman, Norwich, 16 May 1861, bt

Samuel 2 gns; bt from him by James Reeve; purchased from him with the rest of his collection 1902.
Exh: NAC 1888 (44), repr.; BFAC 1888 (8).
Ref: Binyon 1897 p.58 repr. p.59; Finberg 1905 p.137; Reeve MS; Binyon 1903 p.vii repr. C15; Dickes 1905 p.269; Kaines Smith 1926 p.112; Binyon 1933 p.145; Kitson 1937 p.368; Rienaecker 1953 pp.30,44; Hardie vol.11 1967 p.77; Holcomb 1978 p.10 pl.19; Hemingway 1979 p.23 pl.18 in colour.
The Trustees of the British Museum

According to the NCM priced copy of the 1861 sale catalogue, *Duncombe Park* was lot 111 and was bought by Miller for £2.5s., not as given above in Prov., which follows the usually very accurate James Reeve, its last private owner.
There is no way of ascertaining whether the traditional title is a true indication of the location. If it is, Cotman must have sketched the scene on one of his rare visits to Duncombe Park, first in 1803 and again on 1 November 1805 in the company of Ann and Francis Cholmeley junior. Because of the close proximity of the two places he could also have sketched

it during one of his stays at Helmsley; in 1805 he is recorded as having spent three days there, 25–27 July, just before departing to Rokeby.
Kitson justly calls it a 'fairy like drawing, which is perhaps, the highest manifestation of Cotman's lyrical gift'.

38 Gateway of Kirkham Abbey [1805–6]

pencil and watercolour on laid paper still on its original mount; 27.9 × 42.7 (11 × 16¹³⁄₁₆)

Prov: Palser Gallery 1918; Frank W. Keene; Christie's 10 Nov. 1933 lot 83 as *Castle Acre Priory*, bt Permain; Ernest E. Cook; presented by NACF from his Bequest 1955.
Exh: Dijon 1957 (74)
Ref: Finberg & Taylor 1918 pp.18–19 pl.III in colour; Kitson 1937 pp.78–9; *Preview* no.32 1955 p.330, and no.36 1956 repr. p.359.
York City Art Gallery

Kirkham had already inspired some 'exquisite drawings' by Cotman on his first visit to Yorkshire in 1803, and one of these was developed into an equally exquisite watercolour in 1804 (see no.27). The present work is certainly later and its delicate tones suggest 1805–6 as the most likely date. If so, Kitson might have been right when he assumed – without firm authority – that it was during his four days' stay at Whitwell-on-the-Hill, close by the ruined Abbey, that Cotman sketched the gateway. He went there the day after he drew the picnic site near Brandsby, subject of entry no.34.

39 Falstaff Tower, Caister Castle [1805–6]

pencil and watercolour on laid paper; 44.5 × 34.5 717½ × 13⅝)

Prov: Palser Gallery; Sir Michael Sadler by 1922; presented by NACF from his Bequest 1933.

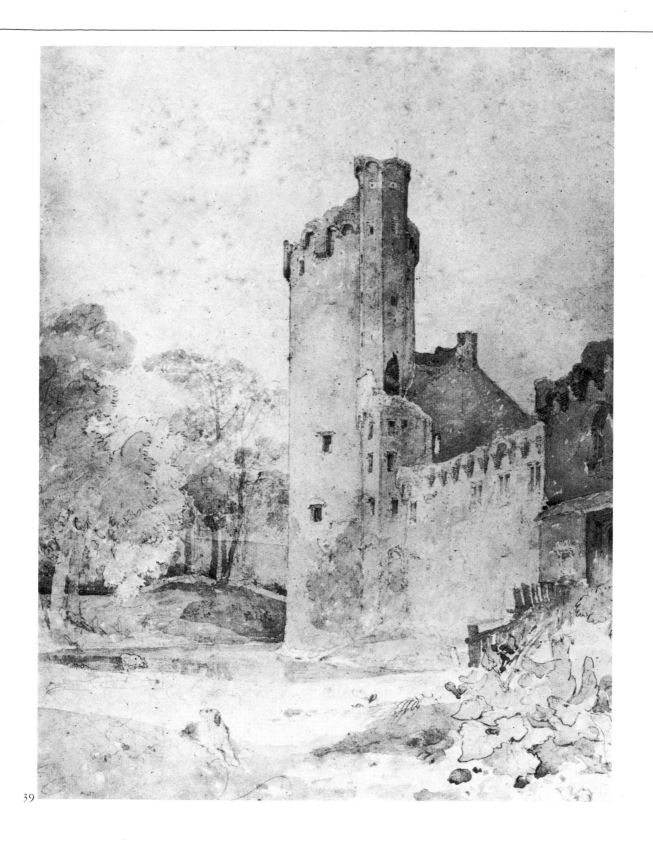

39

Exh: Tate 1922 (184); Barnsley 1937 (unnumbered).
Ref: NACF Report for 1933 p.37 fig.14a; Kitson 1937 pp.67–8,69.
From the Cooper Art Collection by permission of the Trustees in conjunction with South Yorkshire County Council, the Cooper Gallery, Barnsley

Caister Castle, built by Sir John Fastolf in 1432–5, was a favourite subject with Norwich artists. Apart from those by Cotman, paintings of the ruins were exhibited by John Crome, his son John Berney, Robert Ladbrooke and Alfred Stannard. Kitson assumes that the present watercolour was done during Cotman's visit to Yarmouth after his stay at Covehithe in the summer of 1804, but stylistically it fits in better with his works of 1805–6. His contribution to the 1810 exhibition (172) must be a later rendering of this same subject or perhaps the preparatory drawing for his 1815 etching of Fastolf's Tower, a very similar view (Popham 175).

40 **Bank of the Greta, Yorkshire** [1805–6]

pencil and watercolour on wove paper; 22.5 × 33 ($8\frac{7}{8}$ × 13)

Prov: ?J. J. Cotman; ?pledged by him as part of a large collection to William Steward, a pawnbroker at Great Yarmouth; bt from him by James Reeve; purchased from him with the rest of his collection 1902.

Exh: NAC 1888 (39); RA 1892 (40).
Ref: Reeve MS; Dickes 1905 p.269; ?Kitson 1937 p.83; Holcomb 1978 p.10 pl.22; Rajnai & Allthorpe 1979 p.61.
The Trustees of the British Museum

In the MS catalogue of his collection, as also in the 1888 catalogue, Reeve called it an outdoor sketch. This is hardly acceptable: the drawing looks more like a design for a backdrop of a weird play than a close look at nature. The curious splodges, indicating ?dock leaves, in the foreground can almost be taken as stamps of authenticity or date marks on his work of this period.

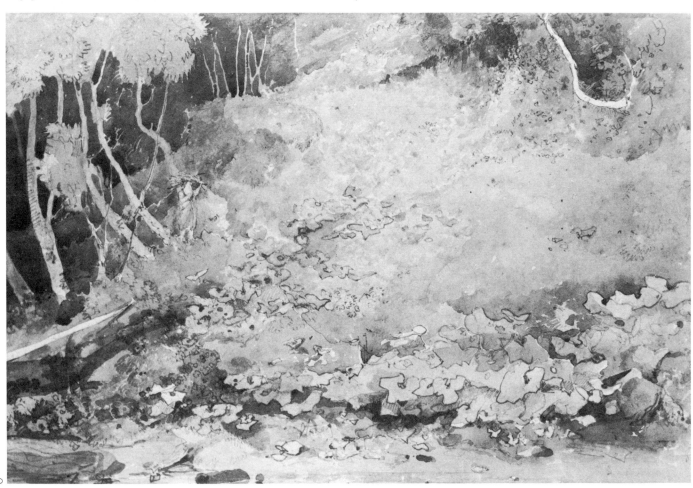

40

41 **Trees near the Greta River** [1805–6]

pencil and watercolour on laid paper;
33.2 × 23 ($13\frac{1}{16}$ × $9\frac{1}{16}$)

Prov: the late Sir Hickman Bacon.
Exh: Arts Council 1946 and 1948 (19);
Bedford 1952 (12); Whitworth 1961
(59).
Ref: Oppé 1923 p.ix, pl.iv.
Private Collection

Taking as his subject the vegetation of
jungle-like density overrunning the
ledge by the river, Cotman came as close
as he ever did to naturalism proper.
However, this closeness is more
apparent than real. The strange green
cliffs of the trees blotting out the
distance and the skeletal formation of
the dead tree in the foreground are
recreations rather than representations
of things seen.

42 **Durham Cathedral** (1806)

pencil and watercolour on wove paper;
43.6 × 33 ($17\frac{3}{16}$ × 13)

Prov: acquired from the artist by
Dawson Turner; bt at his sale, Puttick
& Simpson 16 May 1859 and seven
following days, lot 812 (with several
others, seven by Cotman).
Exh: ?RA 1806 (461); ?NSA 1807 (18); RA
1951–52 (488); Norwich 1955 (54)
Ref: Binyon 1897 p.56 repr. p.57;
Dickes 1905 p.261; Finberg 1905 p.137
repr. opp. p.134; Cundall 1920 p.19;
Oppé 1923 p.ix pl.v; Binyon 1933 p.146;
Kitson 1937 pp.52,85,95,132,369,fig.36;
ILN 29 Jan. 1955 repr; Holcomb 1978
p.11 pl.27; Rajnai & Allthorpe 1979
p.78.
The Trustees of the British Museum

Contrary to Kitson's statement about a
visit in 1803, Cotman had never been to
Durham before 1805, his last stay in
Yorkshire. Even then it was only due to
the combination of Mrs Cholmeley's
gentle bullying, the bad weather at
Greta Bridge, and a desire to meet up

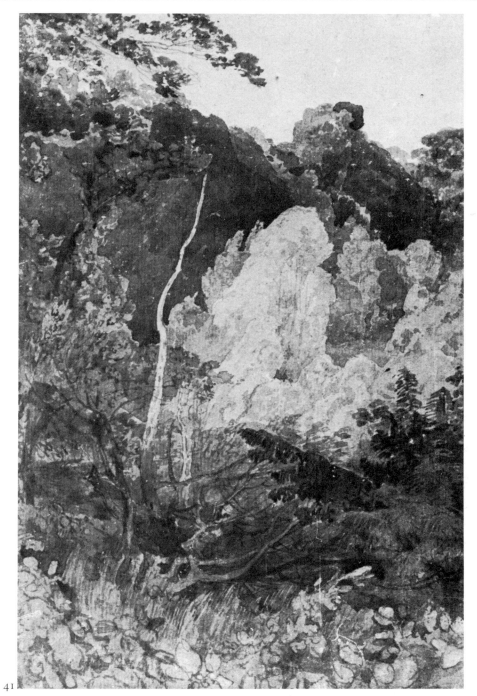

41

with his Brandsby friends passing
through the city, that Cotman arrived at
Durham on 4 September for a stay of a
week or so. He missed the Cholmeleys
by a few hours and it rained
continuously the first day and night he
spent there; nonetheless he was well
pleased with what he found, writing to
Francis Cholmeley on 6 September, 'It is
a delightfully situated City – I have

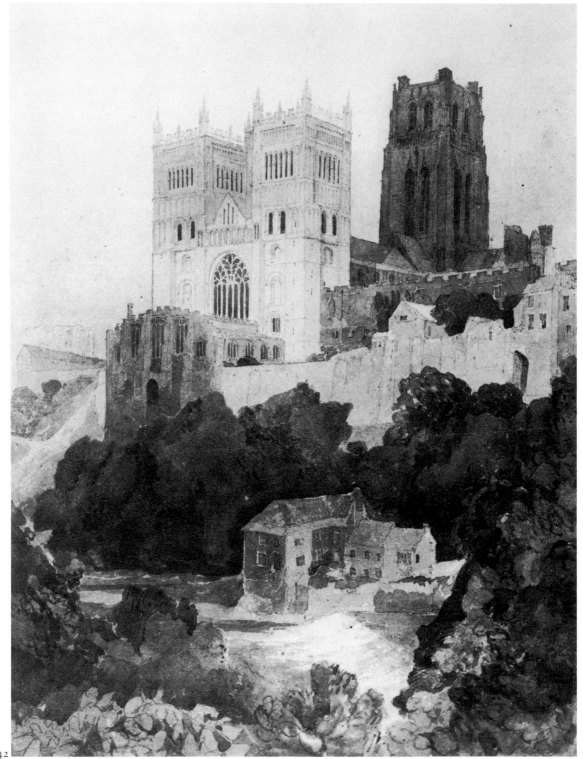

42

made but one outline since I've been here to my shame but I hope to be more industrious . . .' The Cathedral, which he found 'magnificent tho not so fine as that of York' (letter to DT 30 November 1805), provided him with at least five views, this one being the finest of them all (for other versions see Rajnai & Allthorpe).

43 **Barnard Castle from Towler Hill** (1806) (repr. in colour)

pencil and watercolour on wove paper; 33 × 43.2 (13 × 17)
Inscribed in pencil on verso *Barnard Castle* and numbered *2*

Prov: ?acquired from the artist by Edward Worsley of Hovingham; descended in the family until 1932; Sotheby's 20 July 1932 part of lot 109 'A parcel containing watercolours and other drawings, chiefly of the English School, etc.', bt Meatyard; bt from him by S. D. Kitson; Kitson Bequest 1938.
Exh: ?RA 1806 (540); Ashmolean 1933 (8); RA 1934 (736); Amsterdam 1936 (200); Leeds 1937 (7); Paris 1938 (177); RA 1951–2 (494), Souvenir Catalogue pl.19; Geneva and Zurich 1955–6 (18); Leeds 1958 (13); Agnew 1960 (86); Whitworth 1961 (48); Washington and New York 1962 (16); Colnaghi 1970 (34) pl.VIII.
Ref: Kitson 1937 pp.82, 89, 95, fig.32; Hardie vol.II 1967 p.77; Rajnai & Allthorpe 1979 p.60.
Leeds City Art Galleries

Barnard Castle is less than three miles north-west of Rokeby Park and Greta Bridge, from where Cotman must have visited it during August 1805, just as Walter Scott did a few years later when he too stayed as a guest of the Morritts of Rokeby. Both artist and poet were impressed with the view from the nearby hill in the bend of the River Tees; Cotman produced this magnificent watercolour and Scott some lines full of the ambience of the place, in *Rokeby*:

The Sultry summer day is done,
The western hills have hid the sun,
But mountain peak and village spire
Retain reflection of his fire.
Old Barnard's towers are purple still,
To those that gaze from Toller-hill.

It is one of the very few Greta period watercolours which did not remain in the artist's hands, having apparently been bought directly by the Squire of Hovingham at the time.

44 **Castle Eden Dean** (1806)

pencil and watercolour on laid paper; 43.5 × 38.2 (17⅛ × 15)

Prov: Dawson Turner; presented by him to E. Magarth, a fellow-member of the Athenaeum Club 1834; purchased from William P. Paterson £165 in 1911.
Exh: ?RA 1806 (341); Tate 1922 (39); RA 1951–2 (649A).
Ref: PMT 1922 p.248 pl.11 fig.C; Kitson 1937 pp.87,95; Pidgley 1975 chapter 1 n.29.
The Trustees of the National Galleries of Scotland

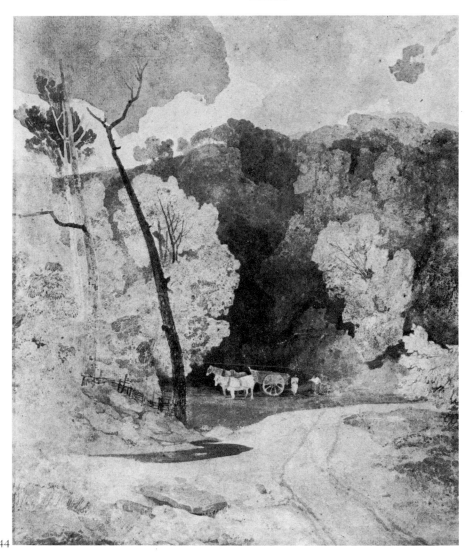

44

Cotman's visit to Castle Eden Dean, like his stay in Durham (see no.42), was not pre-planned. Mrs Cholmeley's enthusiastic letter about the site, sent to her son at Rokeby with the instruction to 'Give this letter to Cotty, who will probably value it more than yourself', had much to do with it. Castle Eden Dean 'far surpassed my most sanguine expectations,' wrote Mrs Cholmeley, '... Immense rocks rise on either side, sometimes abrupt, sometimes receding and of various colours and kinds. Fine ash, oak and elm flourish tho' almost apparently growing out of the rock itself, which rocks are sometimes cloath [e]d w [i]th festoons of ivy, sometimes with thick dark mosses of yew (which grow there in great abundance) and sometimes presenting a bold naked surface, seen thro' the light airy foliage of the ash.' This sounds much like the description of the river banks of Greta, of which in fact it reminded her, as it did Cotman. The expected similarity sent him there on the eleven-mile trip westward while staying in Durham for a week or so from 4 September 1805. He was obviously delighted with what he found. A preparatory study in pencil and grey wash and of a much less elegant composition is in the BM.

45 Hell Cauldron called On the Greta, where the Greta joins the Tees [1806]

pencil and watercolour on laid paper; 44×33.7 ($17\frac{5}{16} \times 13\frac{1}{4}$)

Prov: ?acquired from the artist by Sir Henry Englefield; Mrs Rice; Christie's 12 June 1936 lot 114, bt Gooden & Fox; Ernest E. Cook; presented by NACF from his Bequest 1955.
Exh: Whitworth 1937 (13); Agnew 1960 (80); USA 1967 (31); Colnaghi 1970 (31).
Ref: Johnson 1934 p.12; Kitson 1937 p.84; *Leeds Art Calendar* vol.9 no.31 1955 p.25 repr. p.24; Bury 1960 p.91 pl.VII; Rajnai & Allthorpe 1979 p.61.
Leeds City Art Galleries

The traditional title is incorrect. The site represented is not the confluence of the two rivers but a spot just above the bridge where the river widens after a narrow passage, called Hell Cauldron. The drawing must be the fruit of the not very propitious period after his return to London from Yorkshire in late November 1805. Mrs Cholmeley was worried about the lack of progress on his drawings: 'Why does he finish none? Surely this is not a wise plan, for he can have none to shew to those who call on him ...' she wrote on 24 February 1806. Consequently she was very pleased to hear that her brother, Sir Henry Englefield, had ordered some drawings, among them perhaps the present one, as she remarked: 'I am very glad his Hell Cauldron is a good one and hope Bob [Sir Henry] will like it.' (15 and 31 March). The more worked up Edinburgh version (see no.68) seems definitely later than the beginning of 1806 and does not appear to have left the possession of the artist and his sons until 1861.

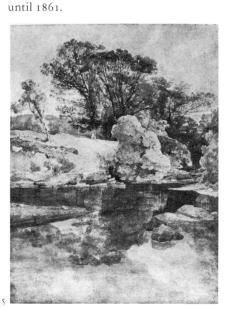

45

46 Drop Gate, Duncombe Park [1806]
(repr. in colour)

pencil and watercolour on laid paper; 33×23 ($13 \times 9\frac{1}{16}$)

Prov: J. J. Cotman; pledged by him as part of a large collection to William Steward, a pawnbroker at Great Yarmouth; the sale of this collection, Spelman, Norwich, 16 May 1861 lot 126, bt J. Norgate £2.2s.6d.; James Reeve; purchased from him with the rest of his collection 1902.
Exh: Bedford 1960 (21); New York 1981 (9).
Ref: Reeve MS; Binyon 1903 p. vi repr. C16; Oppé 1923 p.ix pl.III; Kaines Smith 1926 pp.99,143,152; Binyon 1933 p.145 repr. p.140; Bury 1937 p.30; Kitson 1937 pp. 79,104,368 fig.31; Hardie 1942 pp.172,175; Williams 1952 p.160; Rienaecker 1953 pp.33,43 pl. 14 fig.23; Clifford 1965 p.76; Hardie vol.II 1967 pp.77,81, 94, pl.69; Reynolds 1971 pp.95–7; Pidgley 1975 p.148; Wilton 1977 pp.36–7, 180 pl.98; Holcomb 1978 p.10 pl.20.
The Trustees of the British Museum

Like so many other drawings that are now regarded as his *chefs-d'oeuvre*, the *Drop Gate* never succeeded in finding a purchaser in the artist's lifetime. It is not known why it is associated with Duncombe Park rather than with another site. If the identification is correct he must have sketched the scene on one of the opportunities discussed in the entry for no.37. Described by Kitson as 'a tonal symphony of outstanding character', it is one of the best examples of Cotman's unique sense of abstract values: balance, contrast and pattern.

47 Aqueduct, called Telford's Aqueduct at Chirk [1806]

pencil and grey wash on wove paper; 20×16.1 ($7\frac{7}{8} \times 6\frac{5}{16}$)

Prov: ?The artist's sale, Christie's 17–18 May 1843 part of lot 164 *An Aqueduct; and 2 landscapes* among 'Drawings in bistre and indian ink'; Madan Bequest 1962.
Exh: Colnaghi 1962 (42).
Ref: ?Kitson 1937 p.44.
The Visitors of the Ashmolean Museum, Oxford (Madan Bequest 1962)

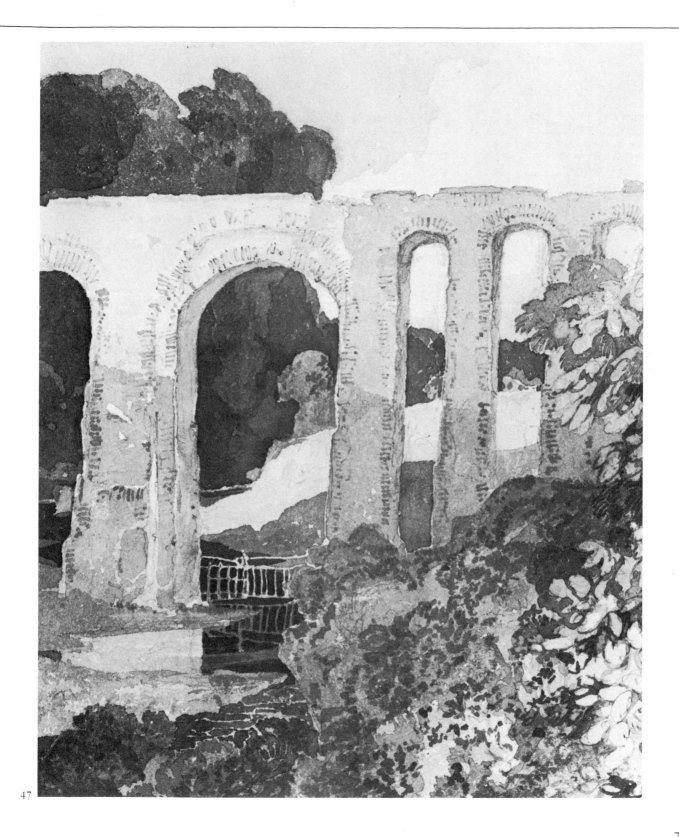

47

Like the *Pastoral Scene* (no.48), on stylistic evidence this must be the product of the period immediately following Cotman's visit to Greta Bridge, that is, the winter of 1805–6 and the spring of 1806. It is curious that, although his head must have been full of recently gathered images of the Greta, Rokeby Park, Durham, Castle Eden Dean and Ray Wood at Castle Howard, Cotman turns here to a subject which he could not have experienced except in a print or painting – unless it is a vague reminiscence of Chirk, which he last saw some years before. The aqueduct, near Llangollen, differing both in proportion and detail, was nearly finished at the time of his visit to Wales in 1800 and virtually complete in 1802 when he may have toured the region again.

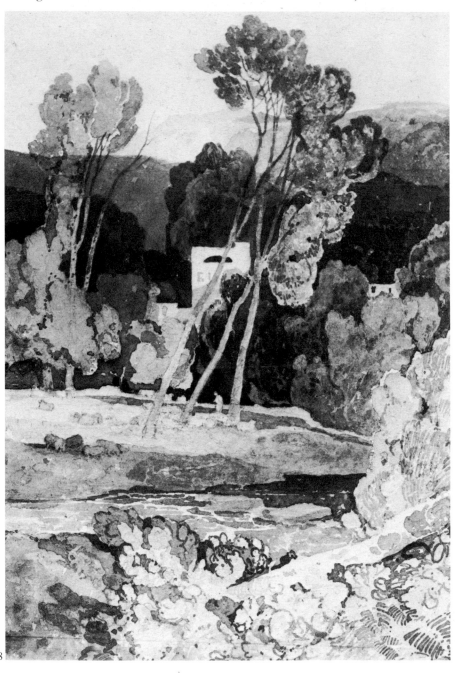

48

48 Pastoral Scene; Composition [1806]

pencil and brown wash on laid paper; 31.6×21.8 ($12\frac{7}{16} \times 8\frac{9}{16}$)

Prov: Purchased 1885.
Ref: Binyon 1903 p.viii repr. C55; Williams 1952 p.160; Rienaecker 1953 p.44; Holcomb 1978 p.11 pl.26.
The Trustees of the British Museum

In the BM catalogue Binyon suggests a 'modified and adapted' Duncombe Park as an inspiration; Holcomb's sensitive response to the drawing is that 'it extends Cotman's experience of the Greta Woods into the imagined realm of a Grecian Arcadia'. The pastoral subject and mood, and the treatment of foliage and foreground, place this drawing of Claudian temper in the period immediately following Cotman's third and final visit to Yorkshire.

49 Horses Drinking (1806)

pencil and brown wash on laid paper; 27.9×20.9 ($11 \times 8\frac{1}{4}$)

Prov: J. J. Cotman; pledged by him as part of a large collection to Christie, a pawnbroker at Norwich; the sale of this collection, Murrell, Norwich, 26–27 Nov. 1862, bt James Reeve; purchased from him with the rest of his collection 1902.
Exh: ?RA 1806 (460).
Ref: Binyon 1903 repr. C9; Kitson 1937 p.94 fig.41; Rienaecker 1953 p.43 pl.19 fig.32; Lemaitre 1955 p.430 fig.33; Holcomb 1978 p.11 pl.30.
The Trustees of the British Museum

Apart from the RA exhibition of 1806, the title occurs again among Cotman's

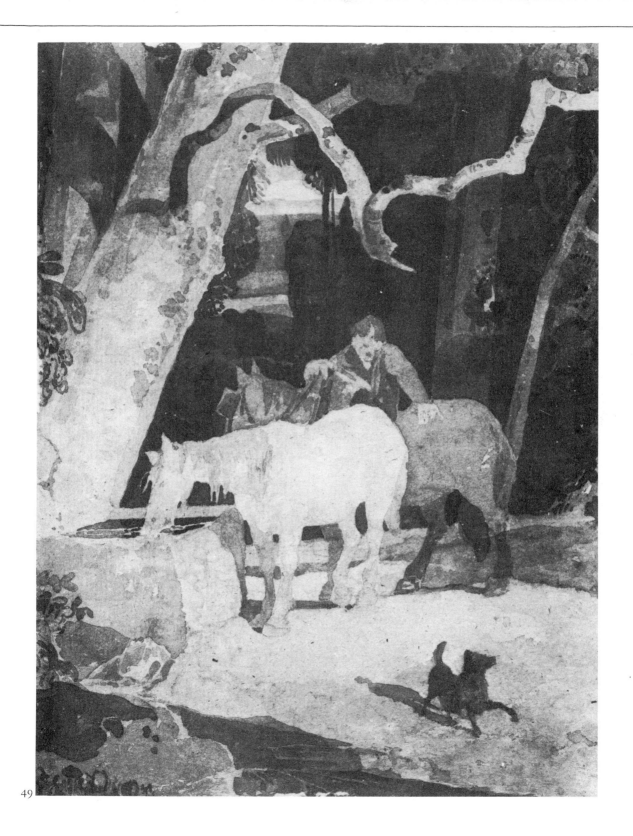

49

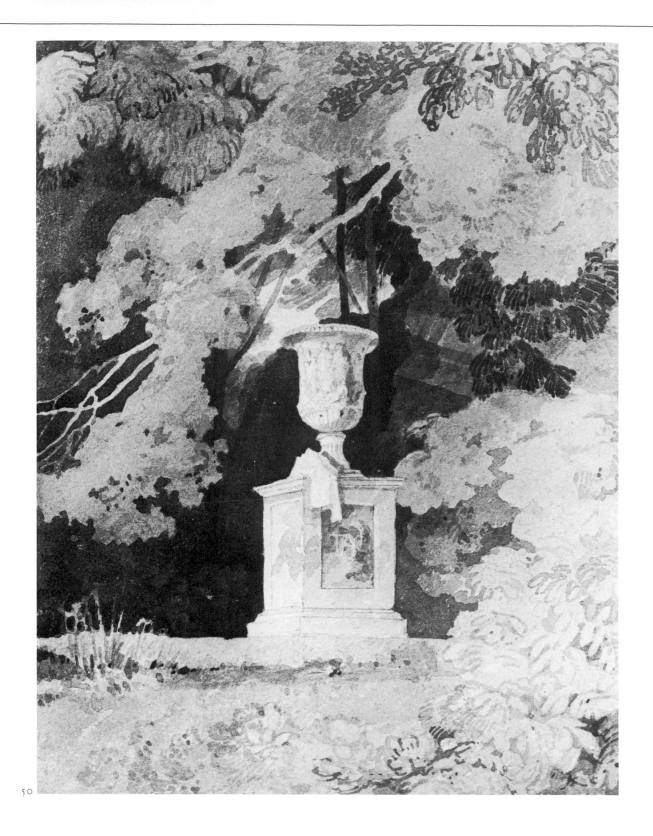

50

Norwich exhibits of 1808 (75), with the addition: 'a Sketch for a large Picture'. Memories of paintings by Nicholas Berchem and Karel Dujardin might well have contributed to the composition, but the rest of Kitson's suggestion is unacceptable: it is neither a 'Sketch', as the Norwich exhibit is called, nor is it a fragment, albeit the central one, of a larger composition. It is probably the most mysteriously beautiful of all Cotman's compositions: 'pure Cotman in his most whimsical and individual mood'. An outline drawing of the two horses and the rider is at Leeds and the tree study from which Cotman directly adapted the contorted branch, looking like an invention of the artist, is no.18 in this catalogue. The white horse appears again, reversed, in the oil painting of 1808, *Yarmouth Beach with figures* (see no.115).

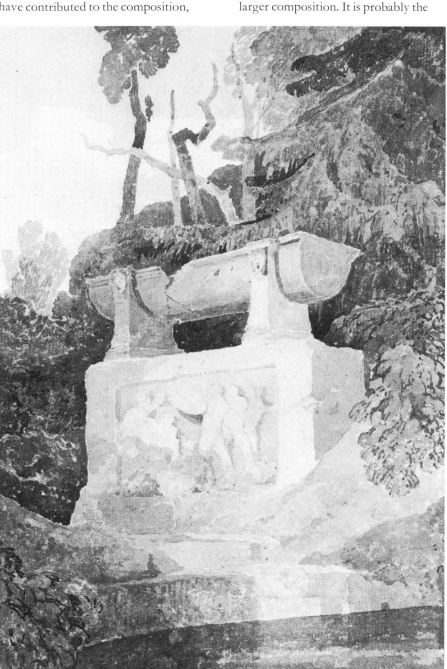

51

50 At Castle Howard, Yorkshire [1806]

pencil and grey wash on wove paper; 20.6 × 16.1 ($8\frac{1}{8}$ × $6\frac{3}{8}$)
Inscribed in ink on verso of mount *Castle Howard Yorkshire*

Prov: purchased from R. Jackson 1884 £1.1s.
Ref: Kitson 1937 p.88 fig.39.
Victoria and Albert Museum, London

See entry for no.51. 'The drawing breathes an air of classical calm, aloof from all the happenings of the outer world', is Kitson's perceptive comment. The sponge-like foliage on the left of the urn, the leaves drawn with the brush, seen best at top and lower right, and the arcadian mood date it to a period after his visit to Greta Bridge and before he started 'building' pictures with robust blocks of colour. A preliminary drawing in the decorative style of 1803–4 is in the BM.

51 Composition: A sarcophagus in a Pleasure-Ground [1806]

pencil and watercolour on laid paper; 33 × 21.6 (13 × $8\frac{1}{2}$)

Prov: acquired from the artist by Dawson Turner; bt at his sale, Puttick & Simpson 16 May 1859 and seven following days, lot 812 (with several others, seven by Cotman).
Exh: Bedford 1960 (20).
Ref: Bury 1937 p.30; Kitson 1937

pp.88,137,369 fig.38; Williams 1952
p.160 pl.CXXVI fig.256; Lemaitre 1955
pp.278 n.1, 284; Pidgley 1975 p.148;
Holcomb 1978 p.11 pl.29; Rajnai &
Allthorpe 1979 p.62.
The Trustees of the British Museum

Kitson assumes that this represents a
scene in the grounds of Castle Howard
which Cotman visited at least three
times. It was, in fact, the very first place
he went to with Sandby Munn on 8 July,
the day after their arrival at Brandsby in
1803. He visited it again with a party of
the Cholmeleys' guests on 4 August the
same year. Two years later, when
staying at Rokeby, he formed a firm plan
to spend some time at Castle Howard.
He wrote to Francis Cholmeley, 29
August 1805: '. . . I have no time for
Durham. I want to get to Ray Wood.' –
that is, part of the park where eighteen
pedestals were set up in 1705. He did
stay at Castle Howard from 4 – 11
October, calling back with Harriet
Cholmeley on the 12th. Kitson rightly
calls this watercolour 'a drawing of
severe beauty, with an atmosphere of
solemn stillness', which evokes a
classical mood similar to Keats's *Ode on a
Grecian Urn* of fourteen years later. A
preliminary drawing in the decorative
style of 1803–4 was in the collection of
the late Viscount Mackintosh.

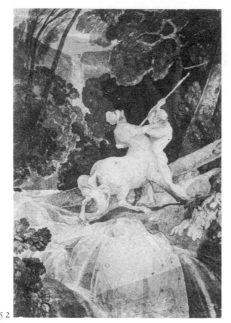

52

52 **The Centaur** [1806]

pencil and grey wash on laid paper;
32.9×22.2 ($12\frac{15}{16} \times 8\frac{3}{4}$)

Prov: J. J. Cotman; pledged by him as
part of a large collection to Christie, a
pawnbroker at Norwich; the sale of this
collection, Murrell, Norwich, 26–27
Nov. 1862, bt James Reeve; purchased
from him with the rest of his collection
1902.
Ref: Binyon 1897 p.54 repr. p.55; Reeve
MS; Binyon 1903 p.IV repr. C27; Kitson
1937 pp.89–90; Rienaecker 1953 p.12
pl.19 fig.33; Lemaitre 1955 pp.268 n. 1,
279; Holcomb 1978 p.12 pl.34.
The Trustees of the British Museum

The criss-crossing of the tree trunks, the
treatment of foliage both in mass and as
contour lines drawn with the brush, the
classical theme and mood place this
drawing in a group with *Horses Drinking*
(no. 49) and the Norwich *Boy fishing*.
Kitson surmises that the subject is based
'on the study of one of the metopes of
the Parthenon, figured in Stewart and
Revett's *Antiquities of Athens*', since the
actual frieze, part of the Elgin marbles,
did not arrive in England until a year or

two later. Reeve assumed that it was a
Sketching Society drawing, which is
possible although there is no evidence
that Cotman continued to be a member
as late as 1806, the likely date of *The
Centaur*.

53 **Cain and Abel** [1806]

pencil and watercolour heightened with
white on laid paper; 33.4×23 ($13\frac{1}{8} \times 9\frac{1}{16}$)

Prov: Christie's 6 Nov. 1973 lot 47 as
Abraham and Isaac, bt Agnew; purchased
from them 1973.
Exh: Agnew 1945 (70) as *Abraham and
Isaac*.
Ref: *Country Life*, 8 March 1941 repr.;
Antique Collector Jan.–Feb. 1945 repr.;
Eastword Sept. 1974 repr.
*The Trustees of Cecil Higgins Art Gallery,
Bedford*

A drawing of the type that is usually
associated with the Sketching Society
(see nos.13, 29 & 52), although it is later
than Cotman's last documented contacts
with that group of artists. The high
drama of western culture's best-known
fratricide is so powerfully conveyed in
this romantic scene, that one wonders
about the unfulfilled possibilities of
Cotman as a painter of figure
compositions.

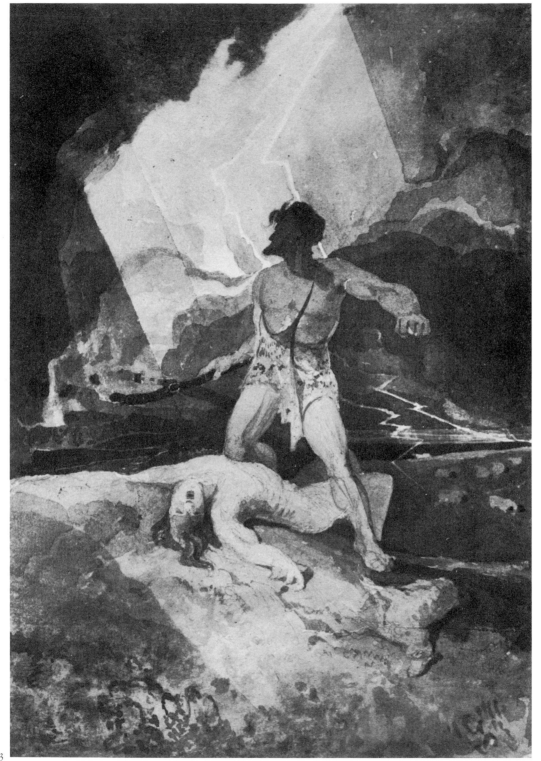

53

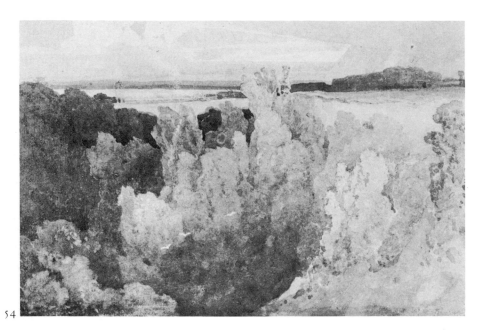

54

54 Brignall Banks on the Greta [1806–7]

pencil and watercolour on laid paper;
18.8 × 28.3 (7⅜ × 11¼)

Prov: Agnes & Norman Lupton; their
Bequest 1952.
Exh: Amsterdam 1936 (201); Leeds
1937 (8); Paris 1938 (178); Arts Council
1951 (34); Hampstead Artists' Council
1953 (19); Geneva & Zurich 1955–6
(20); Leeds 1958 (16); Agnew 1960 (82);
Detroit & Philadelphia 1968 (131) repr.;
Colnaghi 1970 (33); Leeds 1972 (9) repr.;
Kendal 1973 (25); Tate 1973 (264); Arts
Council 1980–81 (16).
Ref: Kitson 1930 pl.VI fig.b; Kitson

1937 pp.83–4; Hardie vol. II 1967 p.77;
Rajnai & Allthorpe 1979 p.61.
Leeds City Art Galleries

Brignall Banks are the wooded heights
which border Cotman's favourite
stretch of the Greta, up-river from the
bridge, starting at Hell Cauldron and
continuing for a couple of miles or
more. They are the main feature of his
Devil's Elbow and provide the
background to his *Scotchman's Stone*. In
this case the existence of a pencil
drawing – also at Leeds – clearly shows
that the watercolour was composed
with the help of this drawing in the

studio and was not painted directly from
nature. Cotman's inclination to stylise
and his sense of pattern found full
expression here.

55 Entrance to a Park (Costessey near Norwich) [1806–7]

pencil and grey wash on laid paper;
15.6 × 31.6 (6⅛ × 12⁷⁄₁₆)

Prov: Herbert Orfeur; Agnes &
Norman Lupton by 1949; their Bequest
1952.
Exh: Arts Council 1949 (14);
Bournemouth 1949 (6); Agnew 1960
(75); Leeds 1972 (12); Kendal 1973 (26).
Ref: Kitson 1937 p.69 fig.28; Rienaecker
1953 pl.18 fig.31.
Leeds City Art Galleries

Kitson dates it *c*.1804 and rightly refers
to it as a drawing 'which is among the
most lovely of all Cotman's renderings
of landscape'. There is no evidence for
or against the location given in the title,
and there are stylistic arguments for
placing it two or three years later in
company with *Chirk Aqueduct* (no.56),
Cow Tower (no.59) and *Mars, riding at
anchor off Cromer* (NCM).
 The squat, late pencil drawing of the
same scene in the V. & A. (E 278–1954),
numbered 2654 and apparently signed
by Cotman, is evidently a family
production. The watercolour of similar
title in the 1960 Bedford exhibition (13)
is unlikely to be by Cotman.

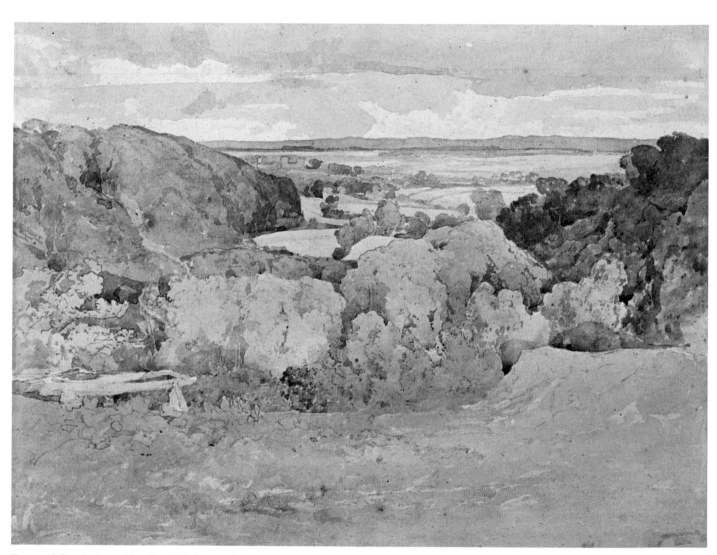

Barnard Castle from Towler Hill (1806) (no. 43)

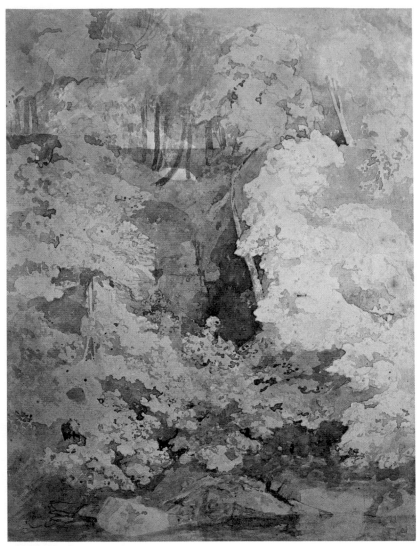

Greta Woods [1805–6] (no. 36)

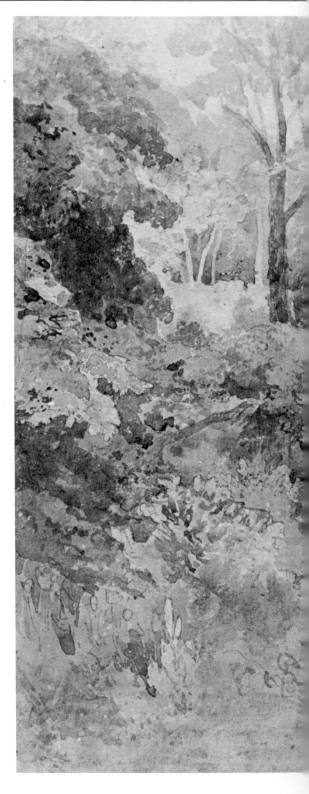

(right) **In Rokeby Park** [1805–6] (no. 35)

(far right) **Duncombe Park, Yorkshire** [1805–6] (no. 37)

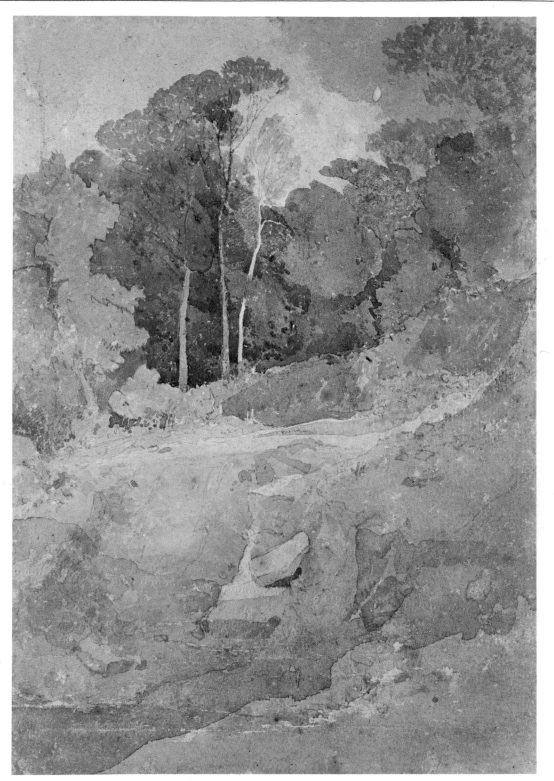

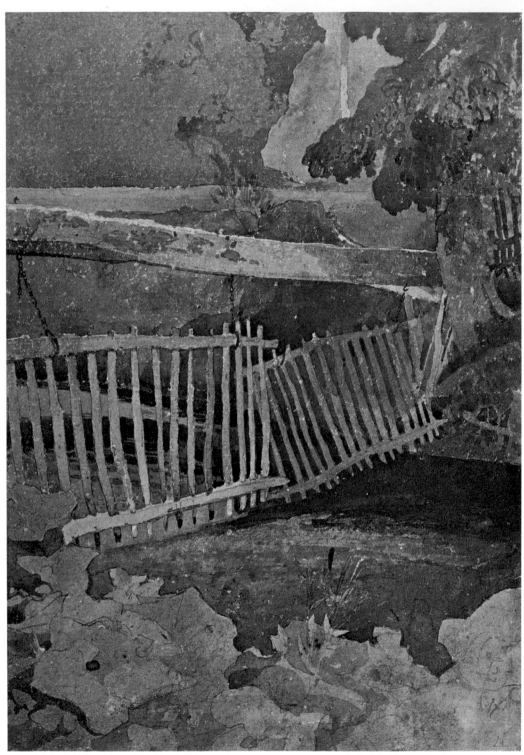

Drop Gate, Duncombe Park [1806] (no. 46)

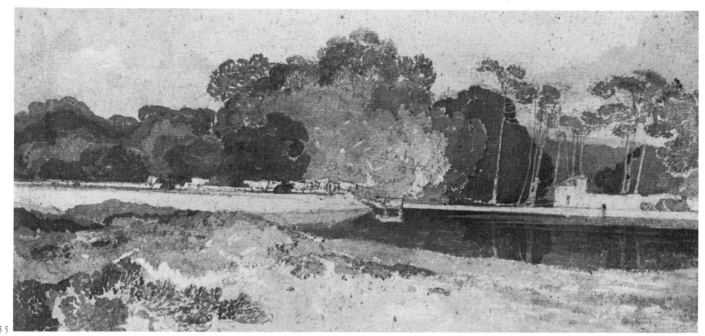

55

56 Chirk Aqueduct, so called [1806–7]
(repr. in colour)

pencil and watercolour on laid paper;
31.5×23.1 ($12\frac{7}{16} \times 9\frac{1}{8}$)

Prov: purchased from Fine Art Society
1892 £6.6s.
Exh: Whitworth 1937 (29); New York
1956 (28) repr. in colour; Minneapolis
& New York 1962 (21); Manchester
1968 (144); Colnaghi 1970 (29) pl.VI;
USA 1977 (21).
Ref: Wilenski 1933 pl.29; Kitson 1937
p.44 pl.11; Hardie 1942 p.172 pl.1;
Williams 1952 p.159 pl.CXXV fig. 255;
Wilenski 1954 pp. 94, 209 pl. 30;
Lemaitre 1955 pp.267,269,276; Boase
1959 p.37 pl.18b; Hardie vol.11 1967
p.76 pl.68 and dust jacket in colour;
Reynolds 1971 pl.67 in colour.
Victoria and Albert Museum, London

Kitson suggests that Cotman saw
Telford's Aqueduct near Llangollen at
the end of his assumed second tour of
Wales in 1802; he would have had equal
opportunity to sketch it two years
before at the time of his first visit, as it
was nearly finished then. However, it is
not at all certain that he visited the site
or that his watercolour has anything to
do with Chirk. Neither among Cotman's
exhibits nor in his sales is such a title to
be found, and no reference is made to
Chirk in his correspondence.
Furthermore, neither the proportions
nor the details shown in the watercolour
are close enough to those of Telford's
construction to establish this as its
protrayal. But whether Cotman merely
transplanted a Roman aqueduct, seen in
a print, to the green fields of England, or
whether the memory of a structure
recently erected as part of the industrial
revolution provided him with a subject
on which to exercise the classical
tendencies prevalent in his way of seeing
at the time, the result is exquisite. The
arched shapes and their rhythm,
reinforced by their reflection in the
water, were an ideal subject for the
supreme pattern-maker who discovered
abstractions of form even in fragments
of nature untouched by man.

**57 The Market Place, Norwich, taken
from Mr. Cooper's** 1807

pencil and watercolour on laid paper;
36.8×53.4 ($14\frac{1}{2} \times 21$)
Signed and dated l.r. *J S Cotman 1807*

Prov: Bernard Barton; his daughter
Lucy, Mrs Edward Fitzgerald;
bequeathed to Capt. Frank R. Barton;
Christie's 27 March 1931 lot 12, bt Alec
Martin on behalf of Mrs Morse;
L. G. Esmond Morse; inherited by
J. C. Barton; Morse Gift 1972.
Exh: NSA 1807 (130) as *A coloured
sketch* . . .; Tate 1922 (6); V & A 1932–3;
Ashmolean 1933; RA 1934 (788);
Whitworth 1937 (35); Kendal 1966 (59);
Kendal 1973 (2) repr. on cover; Sudbury
1978 (25); Burnley 1980.
Ref: *The Poems and Letters* of Bernard
Barton, 1849 p.344 'On a drawing of
Norwich Market-Place by Cotman –
taken in 1807'; Dickes 1905 p.265;
Binyon 1933 p.146; Kitson 1937
pp.109,335 pl.47; Rienaecker 1953 pl.26
fig.50; Hardie vol.11 1967 pp.83–4;
Abbot Hall Art Gallery, Kendal,
Director's Report for 1970–71 p.11 and
for 1972–3 repr. as frontispiece; Wilton

1977 p.180 pl.93 in colour; Hemingway 1979 p.23 pl.18.
Abbot Hall Art Gallery, Kendal (The Morse Gift)

Appropriately enough one of the first ambitious works Cotman did after settling in Norwich at the end of 1806 was a scene which must have belonged to his everyday experience, as he had been brought up in the immediate neighbourhood. The Mr Cooper from whose silversmith shop he took the drawing was to become the father-in-law of Cotman's second son John Joseph, not yet born. The drawing became the property of Bernard Barton, the poet, who addressed a poem to it in 1845. Looking at it, he found that:

In many an hour of thought,
And solitary musing mood of mind,
Good is it to be brought
Thus into intercourse with human kind.

To see the populous crowd
Who throng the busy market's ample space;
To hear their murmur loud
And watch the workings of each busy face.

It took Barton back thirty-eight years and told him 'more than any printed book'.

The description of this drawing as *A coloured sketch* in the 1807 catalogue is difficult to understand, unless Cotman continued to work on it after the exhibition. Kitson thought the description was appropriate 'since it is a pencil drawing, tinted with chromes and russet reds and browns'. It is true that no other fully-fledged watercolour by Cotman is known in which the pencil work plays such a prominent role. Cotman returned to the subject two years later (see no.79).

58 **Croyland Abbey, Lincolnshire** (1807)

pencil and watercolour on laid paper; 29.5 × 53.7 ($11\frac{5}{8} × 21\frac{1}{8}$)
Signed l.r. *J. S. Cotman*

Prov: acquired from the artist by Dawson Turner; bt at his sale, Puttick & Simpson 16 May 1859 and seven following days, lot 811 or 812 (both lots of several items included a *Croyland Abbey*).

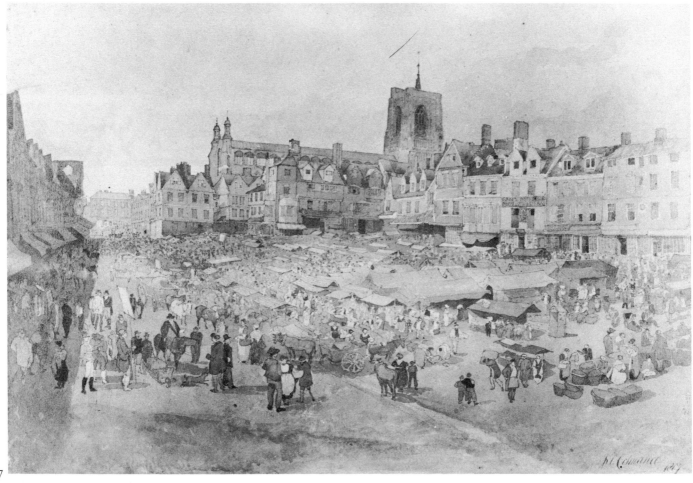

57

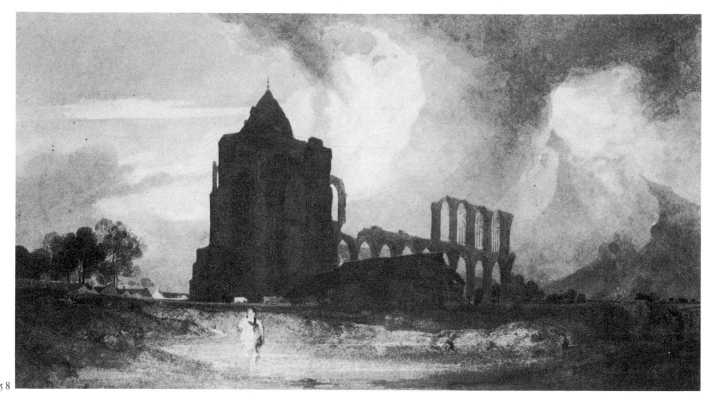

58

Exh: ?NSA 1807 (45); RA 1951–2 (510).
Ref: Binyon 1897 pp. 56–8; Dickes 1905
pp.261,262,280; Finberg 1905 p.137;
Kitson 1937 pp.73, 76–7; Pidgley 1975
p.49 n.165; Wilton 1977 p.181 pls.100 &
101 (detail) both in colour; Holcomb
1978 p.9 pl.8; Rajnai & Allthorpe 1979
p.50.
The Trustees of the British Museum

Between staying at Covehithe (see
no.31) and embarking on his second
visit to Yorkshire, Cotman sketched
two sites which contributed several
important works to his oeuvre: Castle
Acre and Croyland. The latter he found
'most delicious' in spite of the hard
times he suffered there: 'You cannot
imagine my disagreeable situation in a
paltry Inn full of the worst company I
ever heard,' he writes to Dawson
Turner, 18 August 1804. At one point
Cotman was so molested while drawing
the west front that he 'was obliged to
give one of the ringleaders a sound
flogging'. Nonetheless he 'by somehow
or other finished three sketches which
are quite sufficient to gain a good report
of the place ...'

The other two known watercolours of
this subject, those at Hull and NCM,
show the west front only. It is not
possible to determine which of the
Croyland drawings are Cotman's RA
exhibits in 1805. Neither is it established
whether it was one of these three or yet a
fourth which hung in the sitting room
of Trentham Park, the residence of the
Marquis of Stafford, where Cotman
stayed in 1806.

59 **Cow Tower, Norwich** [1807] (repr. in
colour)

pencil and watercolour on laid paper;
35 × 26.5 ($13\frac{3}{4} × 10\frac{1}{2}$)

Prov: John Wodderspoon by 1860; his
sale, Murrell, Norwich, 16 Jan. 1863 lot
326 £4.10s.
Exh: Norwich 1860 (254)
Private Collection

After settling in Norwich towards the
end of 1806 Cotman turned with keen
interest to the long-familiar sights of his
native city. He sketched the Market
Place (no.57), several aspects of the
Cathedral interior (nos. 62–5), etc.
Among the subjects he chose there are
so many which are singularly
unpromising that one has to suspect a
deliberate preference on Cotman's part,
as if he wanted to demonstrate the
power of artistic treatment on things in
themselves unattractive. Thus the
clumsy cylindrical lump of Cow Tower

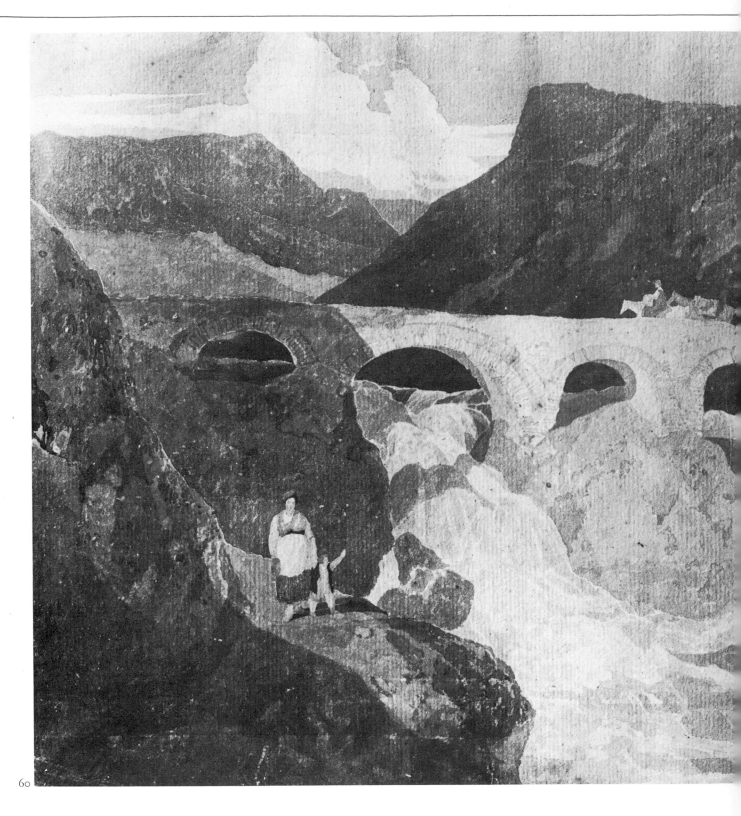

60

becomes the leit-motif of one of his most tender and lovingly orchestrated colour compositions of the period.

60 Road to Capel Curig, North Wales
[1807]

pencil and watercolour on laid paper;
33.8×44.3 ($13\frac{5}{16} \times 17\frac{7}{16}$)

Prov: purchased from Colnaghi 1869
£1.11s.6d.
Exh: Swansea 1964 (198)
Ref: Lemaitre 1955 p.286 n.1 pl.22.
Victoria and Albert Museum, London

If the title correctly identifies the scene, it must be based on sketches Cotman made either on his first visit to Wales, in 1800, or on the suggested second tour in 1802, in the company of Paul Sandby Munn. Cotman had apparently been to Capel Curig, as witnessed by his drawings and his softground etching of the interior of the small church there. The present watercolour cannot be identified with any of Cotman's exhibited works, but on stylistic evidence it must have been painted in Norwich soon after he resettled there at the end of 1806.

61 Greta Bridge [1807] (repr. in colour)

pencil and watercolour on wove paper;
22.7×32.9 ($8\frac{15}{16} \times 12\frac{15}{16}$)

Prov: a London dealer; bt from him by Mr Nurse of Norwich; bt from him by James Reeve by 1888; purchased from him with the rest of his collection 1902.
Exh: NAC 1888 (51) as *On the Greta, Yorkshire*; BFAC 1888 (7) as before; RA 1968–9 (539).
Ref: Binyon 1897 p.58 repr. p.61; Binyon 1903 pp.i,vii repr. opp. p.iv in colour; Dickes 1905 p.269 as *On the Greta, Yorkshire*; Lytton 1911 pl.13; Cundall 1920 p.19; Oppé 1923 p.x pl.VIII; Kaines Smith 1926 pp.143,146; Binyon 1933 p.145; Kitson 1937 p.84; Williams 1952 p.160; Rienaecker 1953 p.44 pl.25 fig 46; Lemaitre 1955 pp.268,286,287,289,291; Boase 1959 p.37; Clifford 1965 pp.53,69; Hardie vol. II 1967 pp.78,235 pl.70; Reynolds 1971 pp.95–7; Pidgley 1975 p.57 n.194; Holcomb 1978 pp.10,11,17 pl.25; Rajnai & Allthorpe 1979 p.84.
The Trustees of the British Museum

This watercolour and its later version dated 1810 in the NCM are probably the best known of all Cotman's work. Its principal subject, the bridge, spans the River Greta at the south gates of Rokeby Park, where Cotman stayed in 1805. It was built by Carr in 1773 – probably for the father of John Bacon Sawrey Morritt (?1772–1843), Cotman's host. Although Kitson speaks about Cotman visiting the region in 1803, it can now be taken for granted that he 'did not cross the bridge until two years later, on the evening of Wednesday 31st July, on the way to Rokeby in the company of Francis Cholmeley ... By the end of their third week there, Francis Cholmeley left to go on to Northumberland and Cotman went to stay at an inn by Greta Bridge, the address he gave to his friend in a letter of 20th August.'

A preliminary pencil drawing is also in the BM. Although it already contains the general layout of the composition, there is no hint of the serene beauty into which it was to develop when rethought in colours filling interlocking areas to constitute a surface pattern of sheer inevitability.

62 Interior of the Nave, Norwich Cathedral [1807]

pencil and watercolour on laid paper;
33.1×22.1 ($13\frac{1}{16} \times 8\frac{3}{4}$)

Prov: acquired from the artist by the Revd James Bulwer; descended in the family until the 1920s; bt from them by Walker's Gallery; S. D. Kitson; by descent to the Misses Kitson who presented it 1973.

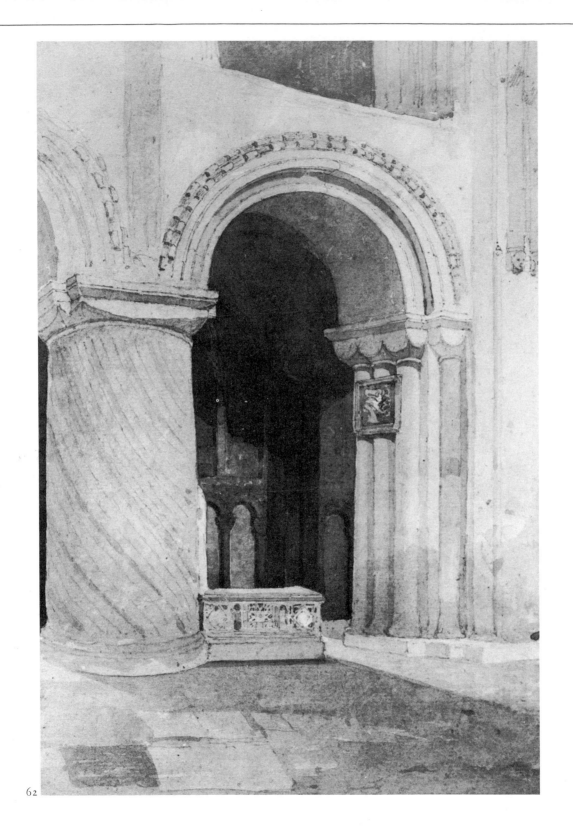

62

Exh: Walker's Gallery 1926 (8); Oxford Arts Club 1928 (8); Amsterdam 1936 (198); Arts Council 1949 (16); Bedford 1972 (18).
Ref: Kitson 1937 p.107 pl.43; Pidgley 1975 p.79 n.252.
The Trustees of Cecil Higgins Art Gallery, Bedford

It shows the two pillars on the northern side immediately west of the organ screen, seen from the centre of the nave. The tomb is that of Sir James Hobart, now practically hidden by the pews. The same unpromising view was also drawn some years later by Dickens's illustrator, Hablot Browne, for Winkler's *Cathedrals*, and served as a subject for an etching by Ellen Day. Nothing shows more clearly Cotman's artistic power at this time than the way this rather ungainly corner of the Cathedral became the vehicle for one of the most poetic interior pieces he ever did.

63 Interior of Norwich Cathedral; Stone Screen [1807] (repr. in colour)

pencil and watercolour on laid paper; 36×27.2 ($14\frac{3}{16} \times 10\frac{11}{16}$)

Prov: William Steward sale, Great Yarmouth, bt Mr Samuel; bt from him by James Reeve; purchased from him with the rest of his collection 1902.
Exh: NAC 1888 (62) repr.; BFAC 1888 (30); RA 1892 (100); Whitworth 1961 (52).
Ref: Reeve MS; Binyon 1903 p.vii repr. C18; Dickes 1905 p.271 repr.; Oppé 1923 p.xii pl. x; Kitson 1937 pp. 107,134; Rienaecker 1953 p.44; Holcomb 1978 p.13 pl.49.
The Trustees of the British Museum

The subject of the watercolour is the stone screen which divides the south transept from the ambulatory. On the left is a wooden partition with steps leading to the gallery, both now removed. Cotman exhibited the subject in 1811 (NSA 124) among 'Drawings and etchings ... chiefly intended for his Miscellaneous Etchings and his Illustrations of Blomfield's Norfolk', but it has never been etched. A fine version is in the Hickman Bacon collection and yet another, also in private hands, is more likely a successful copy than an autograph work.

64 Ambulatory, Norwich Cathedral [1807]

pencil and watercolour on laid paper; 27.4×36 ($10\frac{13}{16} \times 14\frac{3}{16}$)
Signed l.r. *J. S. Cotman*

Prov: acquired from the artist by the Revd James Bulwer; descended in the family until the 1920s; bt from them by Walker's Gallery; S. D. Kitson; his Bequest to RIBA 1937; purchased from them by Mr Paul Mellon 1975.
Exh: NAC 1888 (48) as the *Confessionary or Reliquary Chamber, Norwich Cathedral*; BFAC 1888 (27) as before; Walker's Gallery 1926 (5); Ashmolean 1933 (13); RIBA 1939 (11).
Ref: Kitson 1937 p.107 fig.44; Pidgley 1975 p.79 n.252.
Yale Center for British Art, Paul Mellon Collection

The northern leg of the ambulatory seen from its eastern tip; behind the screen on the right is Jesus Chapel, also painted by Cotman (see no. 65). He returned to this subject in 1829, when he changed it into an upright composition. The same scene was engraved in 1816 by William Radclyffe after Richard Cattermole.

65 Jesus Chapel, Norwich Cathedral [1807–8]

pencil and watercolour on laid paper; 38.6×27 ($15\frac{3}{16} \times 10\frac{5}{8}$)
Signed l.r. *J. S. Cotman*

Prov: S. D. Kitson; by descent to the Misses Kitson who presented it 1973.
Exh: Bedford 1972 (16).
Ref: Kitson 1937 p.107.
The Trustees of Cecil Higgins Art Gallery, Bedford

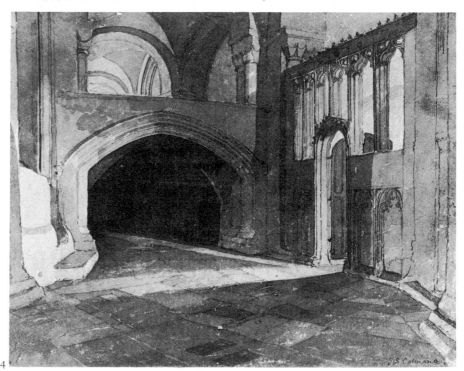

64

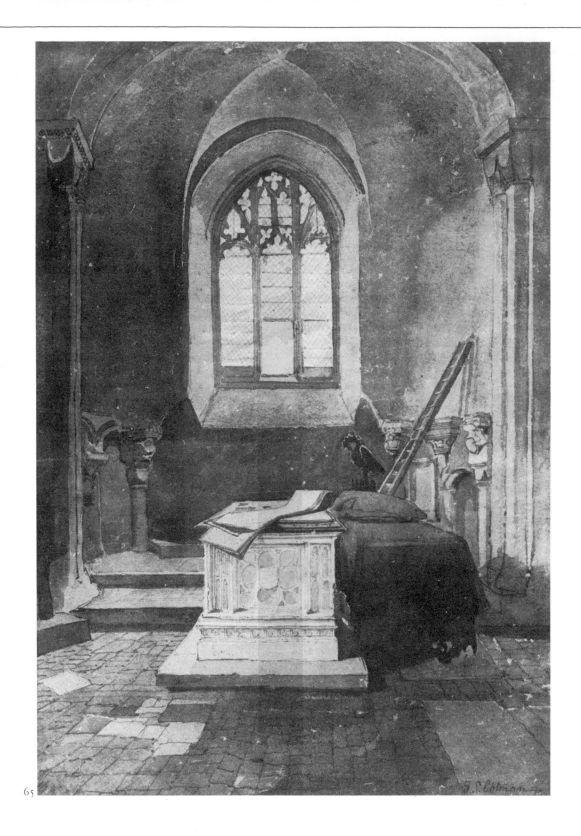

65

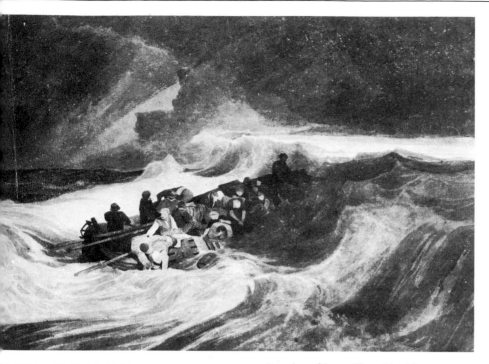

Exh: Scarborough 1950 (44)
Ref: Sir William Worsley, *Early English Water-colours at Hovingham hall* 1963 (10); Pidgley 1975 p.47 n.160, p.151 n.39; Holcomb 1975 pp.34,36–7 pl.6.
Private Collection

Turner showed the *Shipwreck* at the Royal Academy in 1805. It was bought by Sir John Leicester in the following year but shortly after, in 1807, returned to Turner's possession in exchange for the *Fall of the Rhine at Shaffhausen*. Cotman's watercolour is a partial copy, taking as its subject the foremost boat of the composition. As Cotman owned a copy of Charles Turner's mezzotint of Turner's seapiece, published in January 1807, he might have worked from this print rather than from the painting itself. Cotman's continued interest in Turner can be seen in several pencil drawings after his exhibited works in the Kitson Bequest at Leeds and the occasional comments – not always complimentary – scattered through his correspondence.

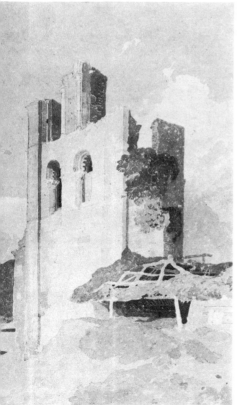

Interior of Jesus Chapel looking east, that is, in the opposite direction to that in the better-known view now in Sydney, Australia. Consequently the cloth-covered table is here seen on the right and the screen, which is also on the right, is just out of sight. This time Cotman put a broad platform under the Wyndham tomb, since removed to the nave, and included the Cathedral's medieval pelican lectern near to a pair of ladders suggesting – as Kitson remarks – that the Chapel was used at the time as some sort of lumber room. An attractive watercolour of the same composition in a private collection is more likely a contemporary copy than a version by Cotman.

66 The Shipwreck after J. M. W. Turner
[1807–8]

pencil and watercolour on laid paper; 32.5 × 47.2 ($12\frac{13}{16} \times 18\frac{5}{8}$)

Prov: ?acquired from the artist by Edward Worsley.

67 Sheriff Hutton Castle, so called
[1807–8]

pencil and watercolour on laid paper; 33 × 21 ($13 \times 8\frac{1}{2}$)
Inscribed l.l. *462* and said to be inscribed on verso *Hutton Castle, Yorkshire*

Prov: purchased by S. D. Kitson from Colnaghi 1934; his Bequest to RIBA; purchased from them by Mr Paul Mellon 1975.
Exh: RIBA 1939 (12); Aldeburgh 1950 (32).
Ref: Kitson 1937 p.126 fig.57; Summerson n.d. pl.VII in colour.
Yale Center for British Art, Paul Mellon Collection

Sheriff Hutton Castle is six miles south-east of Brandsby. Cotman visited it in the company of P. S. Munn a few days after settling in at Brandsby on 7 July 1803 and before starting his three weeks'

tour of north-west Yorkshire a week later. After Sunday, 10 July, wrote Mrs Cholmeley, they 'went to Byland . . . and Sheriff Hutton and Craike and made delightful sketches indeed of them all'. So he definitely sketched the Castle, but it is uncertain that this watercolour is based on one of these particular sketches as no part of the present ruin seems to bear any resemblance to the tower represented, nor do early engravings offer much help. The dilapidated lean-to, giving an opportunity for intricate pattern-making, is a favourite motif of Cotman at this time.

One of Cotman's exhibits with the Norwich Society of Artists in 1830 was *Sheriff Hutton Castle – Sunset* (30). It is not known whether this was a repeat of the present composition or an actual

portrayal of the Castle and so unconnected with the Yale drawing.

68 **Hell Cauldron, called Shady Pool on the Greta** [1808] (repr. in colour)

pencil and watercolour on laid paper; 45.4 × 35.2 (17⅞ × 13⅞)

Prov: J. J. Cotman; pledged by him as part of a large collection to William Steward, a pawnbroker at Great Yarmouth; the sale of this collection, Spelman, Norwich, 16 May 1861 lot 137, bt Miller 50s.; purchased from W. B. Paterson's Gallery 1913.
Exh: W. B. Paterson's Gallery 1913 (17) repr.; Tate 1922 (65); RA 1934 (729); Paris 1938 (180); Colnaghi 1966 (95) pl.37; Colnaghi 1970 (32)

Ref: PMT 1922 p.248; Cundall 1922 p.64 repr. p.71; Kitson 1937 pp.84, 368; Hardie vol. II 1967 pp.78,94 pl.72. *The Trustees of the National Galleries of Scotland*

For the first version see no.45. It is difficult to understand why this drawing, unquestionably one of the masterpieces of Cotman's oeuvre and also of painting in the medium of watercolour, never left the artist's possession. Even Kitson, never very sympathetic to works of Cotman's first Norwich period, gives it a grudging but high accolade: 'The arrangement of the trees is studied and balanced almost to the point of artificiality, and their reflections make a perfect pattern in the water below them. Yet the colour is

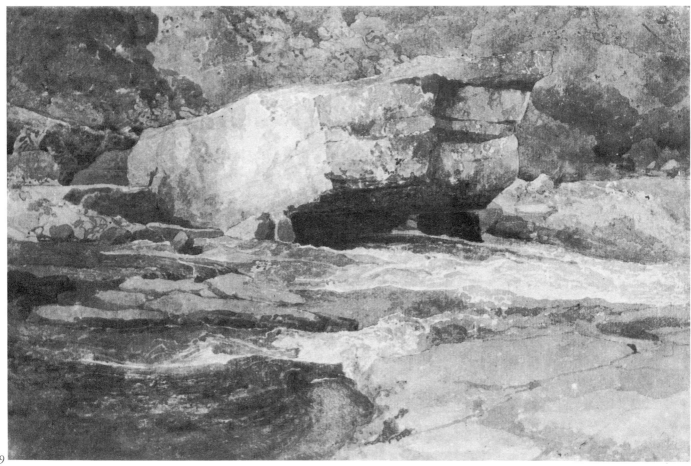

69

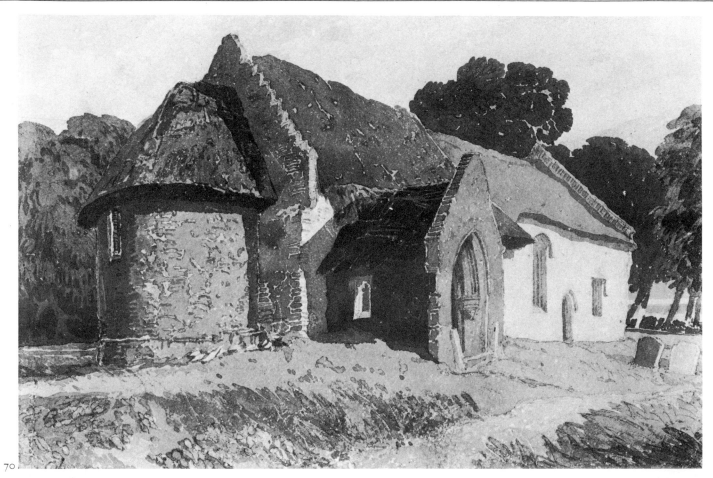

70

lovely and the air is that of some dream-land where it is always afternoon.'

69 The Scotchman's Stone, On the Greta, Yorkshire (1808)

pencil and watercolour on laid paper; 26.7 × 39.4 (10½ × 15½)

Prov: J. J. Cotman; pledged by him as part of a large collection to William Steward, a pawnbroker at Great Yarmouth; the sale of this collection, Spelman, Norwich, 16 May 1861, bt James Reeve; purchased from him with the rest of his collection 1902.
Exh: ?NSA 1808 (104 as *Study of a Rock, Greta River*); NAC 1888 (16); BFAC 1888 (19); Whitworth 1961 (50).
Ref: Binyon 1903 p.viii repr. C19;

Dickes 1905 p.268; Oppé 1923 p.ix; Binyon 1933 p.145; Kitson 1937 pp.83,368; Rienaecker 1953 p.44; Hawcroft *Burlington* Feb. 1962 p.70; Holcomb 1978 pp.10–11 pl.23.
The Trustees of the British Museum

The Scotchman's Stone is, like Hell Cauldron, above the bridge but much further up, closer to Brignall than to Greta Bridge. This is Cotman's favourite section of the river. He wrote to Francis Cholmeley junior, 29 August 1805: 'All my studies have been in the wood above the bridge, which you perceive [?] I stuck too. I think it grows upon me in my regard every day, it really is a delicious spot.' He later mentions 'the rock' and another further down, and is overawed by their size and

their travel down-river to their present position: 'I bath [e?] ever [y] mo [rni]ng or ev [eni]ng under the tree we looked at together on our going that sc [r]ambly [?] walk up the Greta to the rock. I have coloured a sketch of it which I call My Bath and a fine place it would be for one if the river was not so rapid at times as to carry down rocks of 70 or 80 tons weight.'

70 Clippesby Church, Norfolk [1808]

pencil and watercolour on wove paper; 18.3 × 27.6 (7 3/16 × 10 7/8)
Signed l.l. *Cotman*; numbered l.r. *466*

Prov: J. Leslie Wright; Mrs Dorian Williamson; Sotheby's 24 Nov. 1977 lot 108.

Exh: ? W. B. Paterson's Gallery 1913
(60); Birmingham 1938 (109); RA 1949
(270).
Ref: J. Leslie Wright Collection 1939
no.69.
Private Collection

Clippesby is a small village about ten
miles north-west of Yarmouth just off
the Norwich–Yarmouth road, so
Cotman had plenty of opportunity to
sketch it during his residence in East
Anglia. The number is assumed to
indicate that it was intended to be
loaned to pupils for copying and the low
figure would suggest that it must have
been one of the 600 with which in 1809
Cotman started 'his circulating
collection, established for the use of
students'. See also no.67. In view of the
fully worked up character, high quality
and unworn state of many of the
numbered watercolours, the assumption
needs revision. It is much more likely
that they are not, and were never meant
to be, drawing copies themselves but
compositions of which drawing copies
were available.

71 **The Refectory of Walsingham Priory**
 [1808]

pencil and watercolour on laid paper;
$39.4 \times 29.1 \ (15\frac{1}{2} \times 11\frac{7}{16})$
Signed l.l. *J S Cotman*

Prov: acquired from the artist by the
Revd James Bulwer; descended in the
family until the 1920s; bt from them by
Walker's Gallery; bt from them by Sir
Michael Sadler who presented it
through the NACF 1931.
Exh: NAC 1888 (27) as *Ruins*; BFAC 1888
(23) as before; Walker's Gallery 1926
(22) pl.VI in colour; RA 1934 (723); Arts
Council 1959 (392); Agnew 1960 (74);
Whitworth 1961 (53); Arts Council
Galleries 1965 (39).
Ref: Dickes 1905 p.278 as *Ruins*; Kitson
1937 p.108; Rothenstein 1933 repr. p.161;
Bury 1934 p.86; Rienaecker 1953 pl.33
fig.65; *Leeds Art Calendar* vol.II no.7
1949 repr. p.6; Bury 1960 p.19; Hardie
vol.II 1967 p.83; Pidgley 1975 p.79
n.251; Rajnai & Allthorpe 1979 p.90.
Leeds City Art Galleries

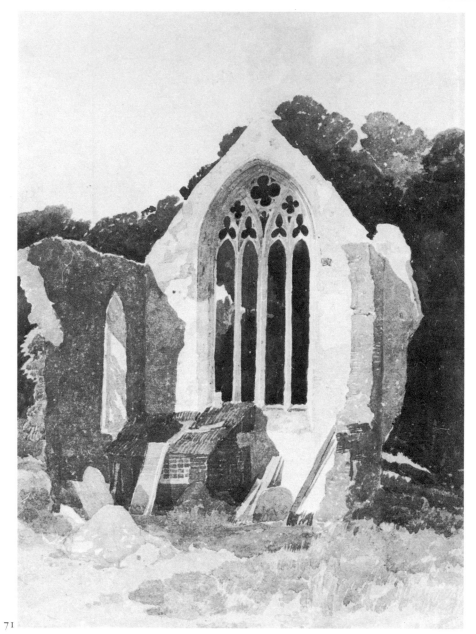

71

Little Walsingham is five miles north of
Fakenham in Norfolk. Its Priory of Our
Lady of Walsingham 'developed into
one of the most famous pilgrimage
places in England' (Pevsner). There is
evidence that Cotman visited it in
1807–8 and again in 1811 and 1815. The
present drawing, showing the large west
window of the 13th-century Refectory,
seems to be one of the results of the first
visit. For other subjects based on
sketches done at various times at
Walsingham see Rajnai & Allthorpe.

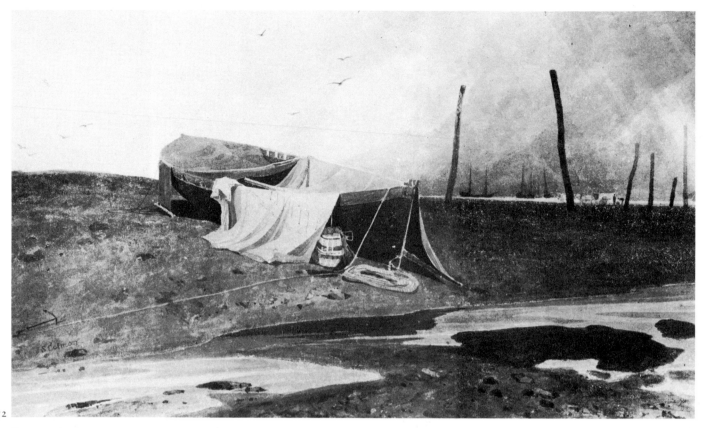

72

72 Boat on the beach [1808]

Pencil and watercolour on wove paper;
28.6×47.6 ($11\frac{1}{4} \times 18\frac{3}{4}$)
Signed l.l. *J S Cotman*

Prov: purchased from S. Hollyer 1875 £20.
Victoria and Albert Museum, London

This is the watercolour version, with
slight differences, of the oil painting
called *Boats on Yarmouth Beach* in the
Colman Collection, NCM. The main
feature of the composition, the boat,
faithfully follows the pencil study also at
Norwich (Rajnai & Allthorpe 1975
no.77), and the drawing copy based on
that study, in the same collection,
provides the correct location of the
scene, as it is inscribed 'Boat on Cromer
Beach Norfolk'.

Cotman exhibited Cromer subjects
between 1808 and 1810 and these
exhibits and his pencil studies of

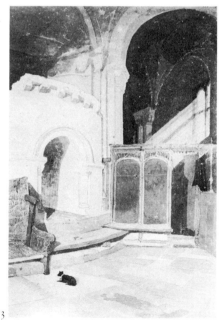

73

beached boats at Norwich are no doubt
connected with his visits to nearby
Felbrigg, the home of Ann Miles whom
he married in January 1809.

73 Interior of the Eastern Ambulatory of the Apse of Norwich Cathedral [1808]

pencil and watercolour on laid paper;
39.5×27.2 ($15\frac{1}{2} \times 10\frac{3}{4}$) (sight)
Signed l.r. *J S: Cotman*

Prov: acquired from the artist by the
Revd James Bulwer; descended in the
family until the 1920s; bt from them by
Walker's Gallery; Augustus Walker
who presented it 1926.
Exh: NAC 1888 (47); BFAC 1888 (14);
Walker's Gallery 1926 (4).
Ref: Kitson 1937 p.107; Pidgley 1975
p.79 n.252.
*The Visitors of the Ashmolean Museum,
Oxford (Walker 1926)*

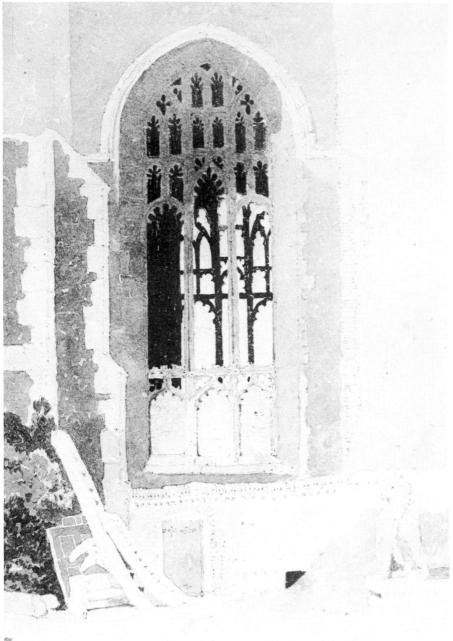

74

74 Window between St Andrew's Hall and the Dutch Church, Norwich
[1808]

pencil and grey wash on wove paper; 25×17.1 ($9\frac{7}{8} \times 6\frac{3}{4}$)

Prov: W. W. Spooner; Spooner Bequest 1967.
Exh: Colnaghi 1955 (58); Courtauld 1968 (62); RA 1968–9 (558); Rye 1971 (unnumbered); Bristol 1973 (11); New Zealand & Australia 1976–8 (44).
Courtauld Institute Galleries, London (Spooner Bequest)

It shows the three-light perpendicular window in the south wall of the cross-space of St Andrew's Hall, in fact a church of the Dominican, i.e. 'black', friars, the nave of which was turned into a public hall in the 16th century and the chancel made use of for a while as the church of the city's Dutch community. There is a signed version in Melbourne, Australia, and another, which is more likely to be a copy, in the BM, called *Window at Greyfriars Church, Norwich*. It is difficult to think of any other artist who could have distilled more, or even as much, beauty from the given subject.

75 The New Bridge, Durham [1808]

pencil and watercolour on laid paper; 43.6×32.4 ($17\frac{1}{8} \times 12\frac{5}{8}$)
Inscribed in ink on verso: *New Bridge Durham.*

Prov: purchased from the Palser Gallery by the late Sir Hickman Bacon 1900.
Exh: RA 1934 (734); Whitworth 1937 (34); Hull 1938 (50); Agnew 1946 (35); Arts Council 1946 and 1948 (26) pl. VIII; Arts Council 1951 (36); Bedford 1952 (13); Paris 1953 (23); Norwich 1955 (53); Geneva & Zurich 1955–6 (22); New York 1956 (29); Colnaghi 1970 (35).
Ref: Oppé 1923 p.ix,pl. VII in colour; Binyon 1933 pp.145–6; Johnson 1934 p.12 pl. VIII; Bury 1934 p.86 repr. p.87; Kitson 1937 p.86; Williams 1952 pp.160–61, pl. CXXVI fig.257; Rienaecker

The east end of the ambulatory looking from the south-east, with a screen which has long since disappeared. The window with the light streaming in has gone too and has been replaced by the entrance to the Lady Chapel built earlier this century. This is another example of Cotman's predilection during this period for unprepossessing subjects, as if he regarded them as a challenge. A copy by Mrs Turner, signed and dated March 1814, is in the collection of the Yale Center for British Art.

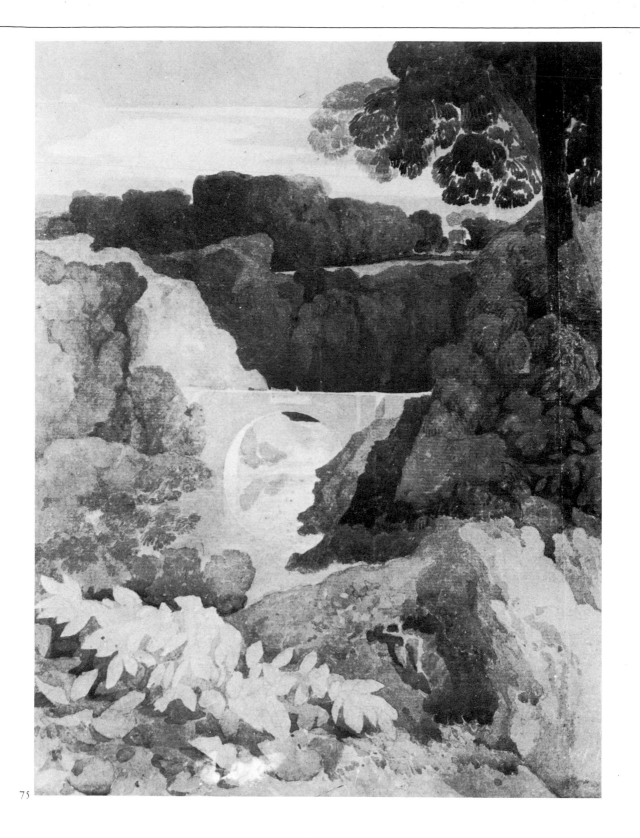

75

1953 pl.22 fig.38; Lemaitre 1955
pp.269,288; Hawcroft 1962 p.29; Rajnai
& Allthorpe 1979 p.78.
Private Collection

For Cotman's visit to Durham see no.42.
This is one of Cotman's most 'classical'
compositions, close in spirit to the
slightly later *Harlech Castle* at NCM. Both
are anchored in the tradition of the great
Italianate Frenchmen of the 17th
century. 'In Landscape it should be my
School,' wrote Cotman in connection
with a Gaspard Dughet painting
(17 October 1829, Mr C. Barker's
Collection), and at the Constable sale he
avidly bought prints after the landscapes
('the severest' he knew) of Sebastian
Bourdon, Nicholas Poussin's follower
(Kitson p.328). Cotman could well be
considered the celebrator of the beauty
of the rounded arch. He was certainly
fond of it, and he made the arch the
main or central feature of many of his
compositions and gave it an important
role in others (see nos. 29,47,56 and his
drawings of Norman architecture).

A preparatory chalk drawing of
squarer proportions is in the Fitzwilliam
Museum.

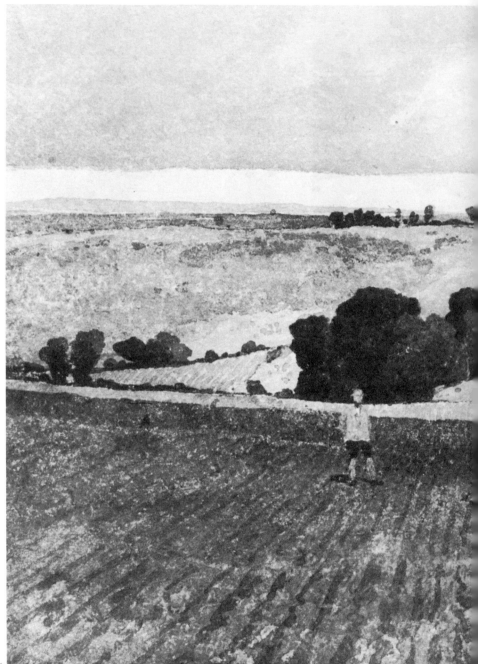

76

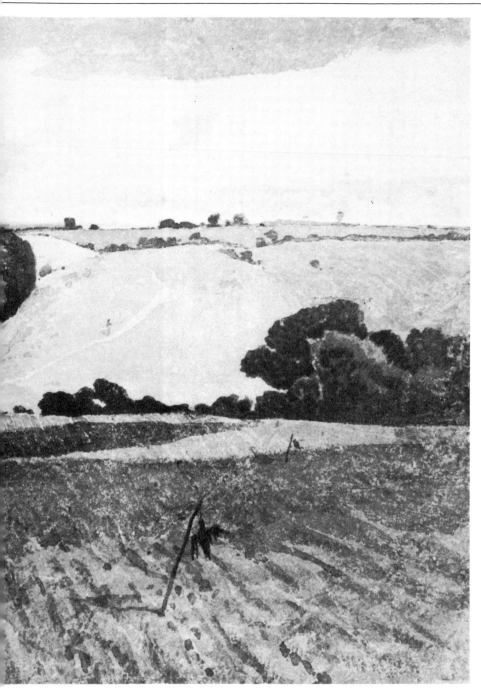

76 **The Ploughed Field** [1808]

pencil and watercolour on wove paper;
22.8×35 ($9 \times 13\frac{3}{4}$)

Prov: purchased from Palser Gallery
1923.
Exh: Brussels 1929 (42); RA 1934 (733);
Bucharest 1936 (69); Whitworth 1937
(37); Paris 1938 (181); Arts Council 1947
(46); Paris 1953 (24); Geneva & Zurich
1955–6 (24); Agnew 1960 (78);
Washington & New York 1962 (17);
USA 1967 (33); RA 1968–9 (543); Paris
1972 (70); Dortmund 1979 (4) repr. pl.1;
Arts Council 1980–81 (17) repr. p.41.
Ref: Oppé 1923 p.xi pl. XII in colour;
Kaines Smith 1926 pp.144,148,149 repr.
frontispiece; Kitson 1930 p.10; Binyon
1933 p.146; Bury 1937 repr. p.29; Kitson
1937 pp.111–12 fig.52; Hardie 1942
p.172 pl.III fig.C; Rienaecker 1953
pp.24,45 pl.28 fig.54; Lemaitre 1955
pp.267,280 n.3; Bury 1960 p.19; Mayne
1962 p.246 fig.10; Goldberg 1967 repr.;
Hardie vol.II 1967 p.84 pl.73; Reynolds
1971 fig.65; Pidgley 1975 p.148.
Leeds City Art Galleries

The location has not been identified, nor
has it been possible to link up the
drawing with any of Cotman's exhibits.
Nonetheless, it has come to represent
the quintessence of what is best in
Cotman's first Norwich period. Its
qualities made Kitson forget his
reticence to praise wholeheartedly
works of these, Cotman's greatest, years:
he declares *The Ploughed Field* 'one of the
loveliest glimpses of an imaginative
landscape ever created by Cotman's
mind and hand' and asserts that 'it marks
the summit of Cotman's contribution, in
his earlier and less sophisticated [?]
phase to the art of watercolour
painting'.

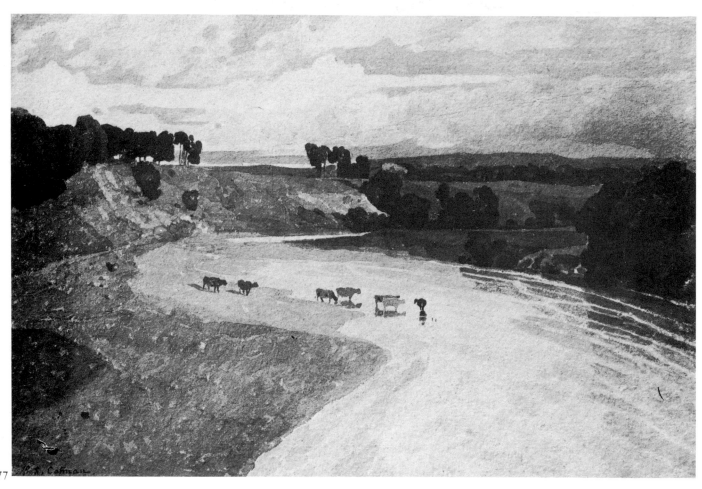

77

77 On the Tees at Rockcliffe [1808]

pencil and watercolour on wove paper;
21.3 × 31.4 (8⅜ × 12⅜)
Signed l.l. *J S. Cotman*

Prov: Archdeacon Charles Parr Burney;
Dr John Percy; presented by J. E.
Taylor. 1894
Exh: Tokyo & Kifu 1978–9 (58).

Ref: Cundall 1908 p.84 pl.xxvi in
colour; Wilenski 1933 pl.97; Reynolds
1951 pl.17; Pidgley 1975 chapter 1,
n.209.
Victoria and Albert Museum, London

Previously known as *Landscape with
River and Cattle*. The v & A has identified
the scene as the Tees between
Hawesworth and Rawcliffe Scar, with
Rockcliffe Park in the background.
There is no record of Cotman visiting
this region but he could well have done
so on the way to or from Durham.
This watercolour is markedly close

in conception and execution to
The Ploughed Field (no.76) and must be
the product of the same period. The
main difference between them is that
while the latter is a composition in
simple horizontal bands, *On the Tees at
Rockcliffe* makes compositional use of
the serpentine curve, so dear to
Hogarth.

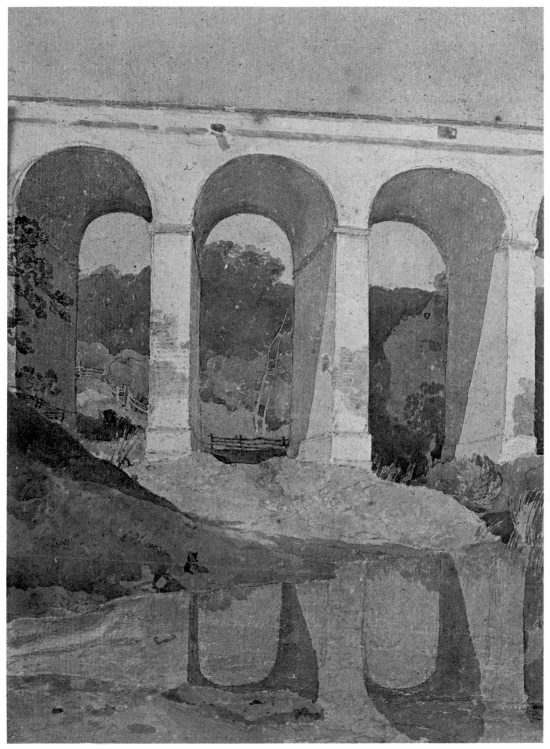

Chirk Aqueduct [1806–7] (no. 56)

Greta Bridge [1807] (no. 61)

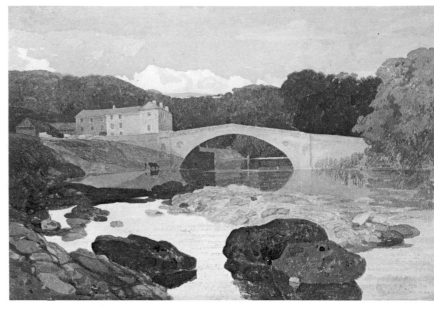

(below left)
Interior of Norwich Cathedral; Stone Screen [1807] (no. 63)

(below right)
Cow Tower, Norwich [1807] (no. 59)

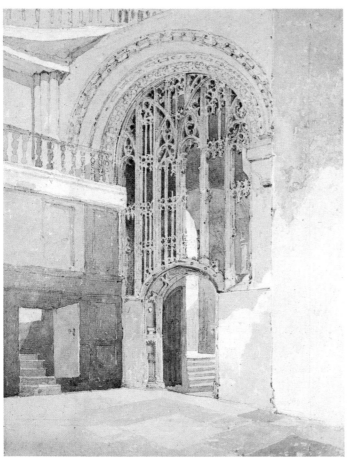

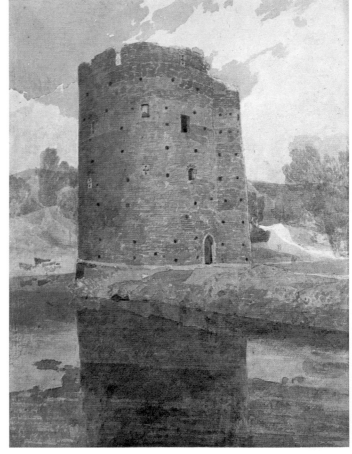

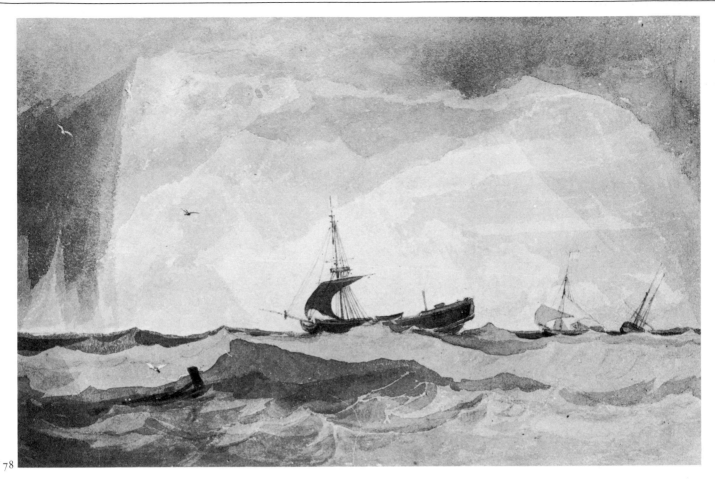

78

78 **A dismasted brig** [1808]

pencil and watercolour on wove paper;
20.1 × 31 (7$\frac{15}{16}$ × 12$\frac{3}{16}$)

Prov: acquired from the artist by the
Revd James Bulwer; his sale, Christie's
11–12 May 1836 lot 49, bt by the artist
17s.; James Reeve; purchased from him
with the rest of his collection 1902.
Exh: Bedford 1960 (44).
Ref: Binyon 1903 pp.x,xi repr. C24;
Oppé 1923 p.xi pl.xi in colour; Kaines
Smith 1926 pp.97,98,152; Kitson 1930
pp.15,20; Binyon 1933 p.148 repr. p.149;
Kitson 1937 pp.26, 255, 328 fig.109;
Rienaecker 1953 pp. 33, 47 pl.40 fig. 78;
Lemaitre 1955 pp.268,281,283 pl. 20;
Clifford 1965 p.70; Hardie vol.II 1967
p.86; Pidgley 1975 p.80 n.254, p.148;
Holcomb 1975; Wilton 1977 pp.178,180

pl.95 in colour; Holcomb 1978 p.12
pl.42.
The Trustees of the British Museum

While Kitson rightly regards it as 'well-
nigh perfect in the directness and
economy of its washes', he seems
curiously and unusually off the mark
when dating it 1824–5 by inference. The
sea and its craft held a great fascination
for Cotman throughout his life. Apart
from an oeuvre rich in seascapes,
perhaps nothing testifies his attachment
better than the description of his
Yarmouth house and its prospects, sent
to Francis Cholmeley 13 April 1812: 'I
cannot call it paradise for I have no
authority sacred or profane that
introduce ships of any kind into that
region of delight ... My small garden

leads me on to the road ... Then, a green
meadow, then the view along the banks
of which, directly before my house, lies
the condemned vessels of every nation,
rigged and unrigged in the most
picturesque manner possible. Then, our
merchan [t] vessels from an Indiaman,
Greenlandman, to a collier pass and
repass every ebb and flow of tide ...
From my house ... we reach the sea in
about $\frac{3}{4}$ of a mile, on which rides at
time [s] the Navey dimly moved in
view. Today at sea a frigate and open
brigg c [a]me to anchor. In short I have
nev [er] saw [so] animated a picture as
this spot affor [ds], it is always
changing, always new.'
 Adele Holcomb, who praises the
drawing as 'an almost lapidary image of
a distressed ship' with a 'potency of

symbolic allusion', suggests that the composition may have been influenced by F. Fittler's engraving after Nicholas Pocock illustrating William Falconer's poem, *The Shipwreck*, as published in 1804. According to an inscription on the verso, recorded by Kitson, there is a drawing of the same subject by M. E. Cotman.

79 **Norwich Market Place** (1809) (repr. in colour)

pencil and watercolour on wove paper; 40.6 × 64.8 (16 × 25½)

Prov: William Freeman; his sale, Norwich 22 Sept. 1851 lot 164, bt J. Mills; his sale (post 1860), bt Mr Dalrymple; his relative, Mrs Bircham by 1888; ? Samuel Hoare by 1894; Sir Lawrence Halsey by 1937; by descent to F. E. Halsey who presented it 1945.
Exh: ?NSA 1809 (208); BFAC 1888 (13); ? Norwich 1894 (53); Bedford 1960 (24).
Ref: Dickes 1905 p.265; Kitson 1937 p.110.
The Trustees of the Tate Gallery

A similar view to the one at Kendal, no.57, but taken from a slightly different vantage point further to the west. Kitson says that it is dated 1806 but it cannot possibly be earlier than the view of 1807 at Kendal and it must have been prepared as a showpiece for the 1809 exhibition, in which it seems to have been included. The catalogue stated that 'a Plate of this Drawing is now in the hands of the Engraver', and according to Kitson, 'Freeman is said to have made and published a large aquatint from it', but no copy has ever come to light. As Dickes gives the technique of the print as 'lithograph', the two reports probably refer to the lithograph Henry Ninham made from it some years later and not to the intended (? but never published) print mentioned in the 1809 catalogue.

81

80 **Mousehold Heath, Norwich** (1810) (repr. in colour)

pencil and watercolour on wove paper; 29.9 × 43.6 (11¾ × 17 3/16)

Prov: J. J. Cotman; pledged by him as part of a large collection to Christie, a pawnbroker at Norwich; the sale of this collection, Murrell, Norwich, 26–27 Nov. 1862 lot 253, unsold; bt James Reeve from Christie; purchased from him with the rest of his collection 1902.
Exh: ?NSA 1810 (54 or 60); Norwich IE 1867 (829); Norwich EAA 1873 (8);

Norwich BMA 1874 (142); Norwich PM 1878 (492); NAC 1888 (15); BFAC 1888 (31); RA 1891 (65).
Ref: Wedmore 1876 p.160; Wedmore 1888 pp.199,400; Binyon 1897 p.63; Reeve MS; Binyon 1903 p.x repr. C21; Dickes 1905 p.280 repr.; Binyon 1933 p.148; Kitson 1937 p.125; Holcomb 1978 p. 13 pl. 48 and on cover in colour; Rajnai & Allthorpe 1979 pp. 85–6.
The Trustees of the British Museum

Mousehold is an attractive heathland north-east of the city, which has sadly

108

81 **River Scene with Cattle** [1810]

watercolour on wove paper; 17.5 × 36.9
($6\frac{7}{8}$ × $14\frac{1}{2}$)

Prov: acquired 1914.
Exh: Tate 1922 (64); Brussels 1929 (37);
Whitworth 1937 (38); Arts Council
(Whitworth) 1948 (32); Southport 1951
(211); Delft 1952 (93); Agnew 1954
(104); Arts Council 1960 (21); Bedford
1960 (28); Whitworth 1961 (54);
Brussels 1973 (18); Kendal 1973 (28);
Russia 1975 (44); Aldeburgh 1977 (17);
Burnley 1980 (unnumbered).
Ref: Lemaitre 1955 pl.21.
*Whitworth Art Gallery, University of
Manchester*

The landscape is reminiscent of
Teesdale and was possibly based on a
sketch taken while Cotman was staying
at Greta Bridge. Its simple but firm
structure, rich colour and reflective
mood are typical of the best products of
Cotman's first Norwich period.

been contracting throughout the 19th
and 20th centuries. It was this land
which made Cotman exclaim 'Oh! rare
and beautiful Norfolk' in a letter to
Dawson Turner that describes crossing
it 'through a heavy hail-storm' (letter to
DT 20 November 1841 in Mr C.
Barker's Collection). His love for the
heath was shared by his fellow Norwich
artists: there is hardly one of them who
did not paint it.

A pencil sketch of this composition,
with the sheep but without the
foreground figures and animals, is also
in the BM. It is dated 20 April 1810. The
group of two donkeys, reversed, occurs
again in the Leeds *Buildwas Abbey* of
about the same date. The NCM *Mousehold
Heath* (Rajnai & Allthorpe 1979 no.109)
is very similar in general layout and
conception but differs in detail.

This is yet another outstanding
drawing that seems not to have left
Cotman's studio and when sold at
auction in 1862 failed to reach the
reserve price of £10 and was withdrawn
at £5. 15s.

Etched by C. J. Watson.

82 Classical landscape with Female Figure [1810]

pencil and watercolour on wove paper; 29.6 × 20.8 ($11\frac{5}{8}$ × $8\frac{3}{16}$)

Prov: G. Bellingham-Smith by 1922; F. F. Madan who bequeathed it 1962.
Exh: Tate 1922 (10); Colnaghi 1962 (40); Colnaghi 1963 (37); USA 1966 (34).
The Visitors of the Ashmolean Museum, Oxford (Madan Bequest 1962)

In spite of the title – certainly not the original but one acquired at some point in the past – the landscape is not particularly classical, although the figure does bear the appearance of such descent. A pencil sketch fixing the broad lines of the composition is in the same collection.

83 The North West Tower, Yarmouth 1811

pencil on wove paper; 30.5 × 21.8 (12 × $8\frac{9}{16}$)
Dated l.r. *June 17.11* and numbered *17*.

Prov: acquired from the artist by the Revd James Bulwer; descended in the family until the 1920s; bt from them by Walker's Gallery; bt from them by S. D. Kitson; his bequest to RIBA; purchased from them by Mr Paul Mellon 1975.
Exh: Walker's Gallery 1926 (26); RIBA 1939 (16).
Yale Center for British Art, Paul Mellon Collection

This is one of the first drawings, if not the very first, that Cotman drew with his second series of etchings in mind and while still in the throes of finishing the first. He seems to have visited Yarmouth soon after he arrived back from a stay in London, making a detour to Cambridge, Ely and King's Lynn on the return journey. This drawing is a fit inaugurator of a series of pencil

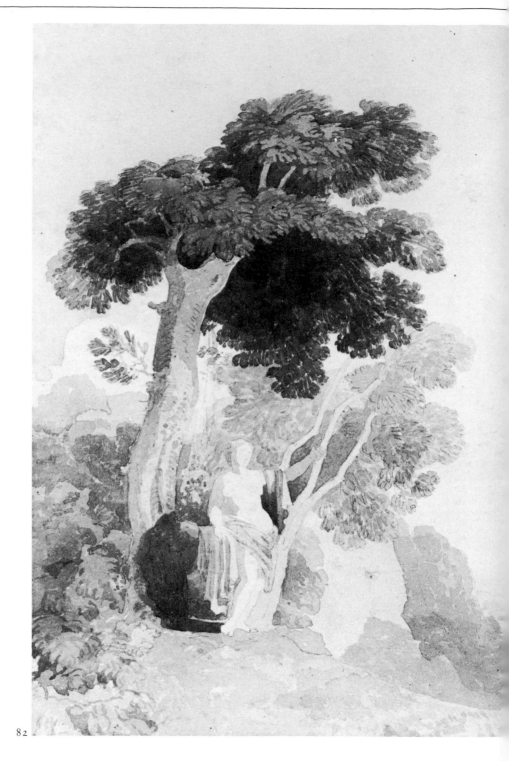

82

83

June 17 11

84

drawings done in 1811, many of which are among his most sensitive work in this medium. It is etched as plate III in the *Architectural Antiquities of Norfolk* 1818 (Popham 132). The little girl holding a saucepan, sketched on the sky, reappears, reversed, in the etching under the arch, see no.123.

84 **Castle Rising Castle, Norfolk** (1811)

pencil on wove paper; 22 × 28.6 (8⅝ × 11¼)
Numbered l.r. *43* and inscribed ?by a later hand *Castle Rising*.

Prov: Presented by F. V. Gill 1925.
Bradford Art Galleries and Museums

See no.85 for Cotman's visit to Castle Rising. He found the castle 'most delightfully situated, as well as being extremely fine in itself' (letter to DT 20 September 1811 in Mr C. Barker's Collection). This drawing, bursting out of the confines of the paper, became the subject of an etching, plate XXVI, of his *Architectural Antiquities of Norfolk*, published in 1813 (Popham 155), which clearly shows his sincerity when stating 'I decidedly follow Piranesi' (letter to DT 10 February 1811 in Mr C. Barker's Collection); see no.124.

85 **West front, Castle Rising Church, Norfolk** (1811–13)

pencil and watercolour on wove paper; 30.9 × 27.3 (12³⁄₁₆ × 10¾)

Prov: presented by A. E. Anderson 1922.
Exh: Bedford 1960 (30).
Ref: Kitson 1937 p.151.
The Visitors of the Ashmolean Museum, Oxford (Anderson 1922)

Cotman visited Castle Rising in the course of his tour of West Norfolk, undertaken in order to gather material for the etchings of his projected *Architectural Antiquities of Norfolk*. 'Lynn, ... will be my Rout – Castle Rising, and Castle Acre my chief objects,' he wrote to Dawson Turner (25 August 1811, Mr C. Barker's Collection). Having sketched numerous sites in the region south of King's Lynn, by 20 September Cotman was at Castle Rising, which he found 'most delightful'. A day or two previously he had drawn 'a range of Arches, between the ceiling & roof' in the church, 'The front ... also part of the Castle.' In this drawing a stocky church façade, set four-square in front of us, with the aid of a ruler and a compass, is turned by Cotman into a dreamlike image with the delicacy of a silken veil.

It was etched and published 20 December 1813 at Yarmouth (Popham 164).

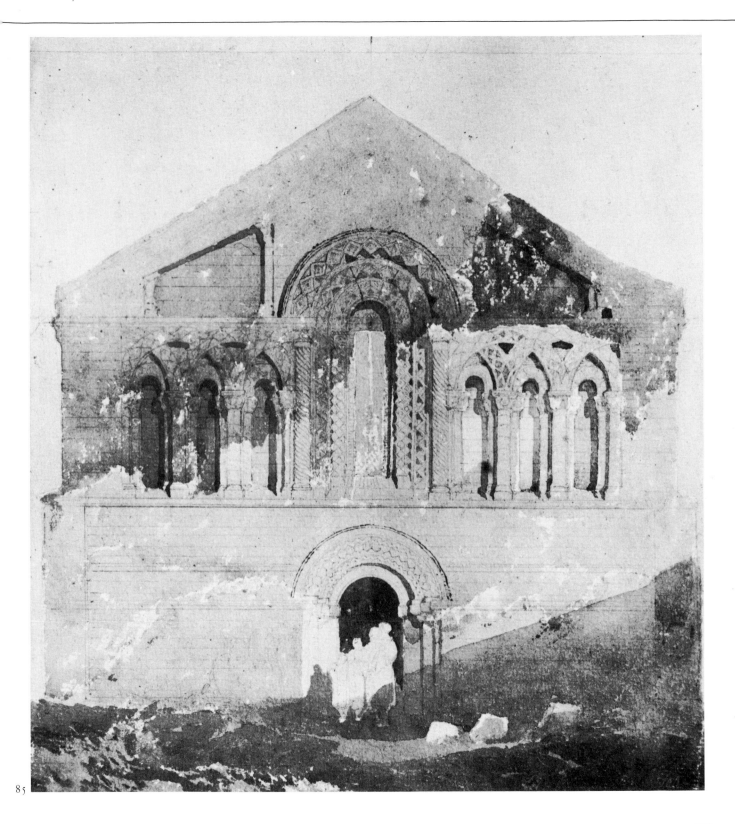

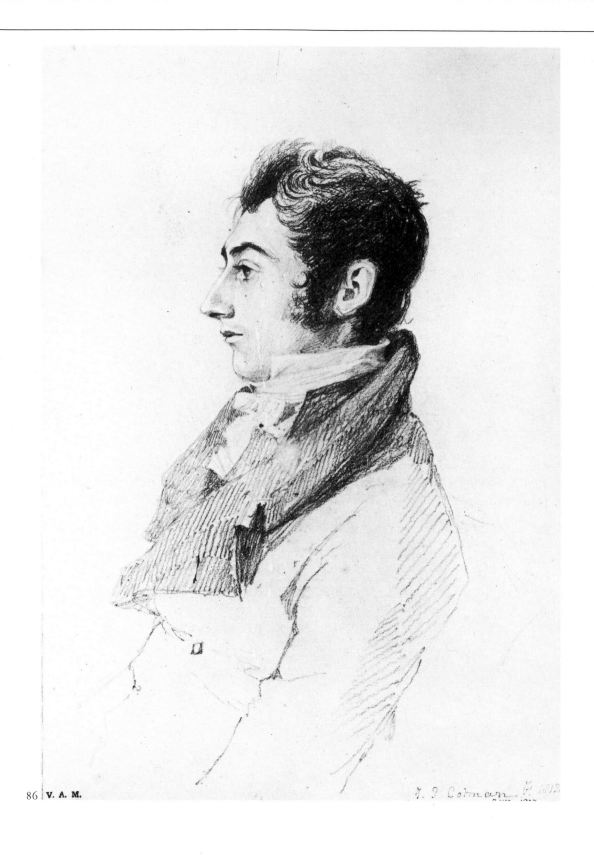

86 | **V. A. M.**

J. S. Cotman F. 1812

86 Portrait of Sir William Jackson Hooker (1785–1865) 1812

pencil on wove paper; 28.9 × 19.9
($11\frac{3}{8}$ × $7\frac{13}{16}$)
Signed and dated l.r. *J. S. Cotman F.
1812.* and inscribed under framing line
with sitter's name and letters.

Prov: Dawson Turner, presumably
commissioned by him (it is no.20 in the
first of his two bound volumes of
Collection of Original Portraits 1819);
Sotheby's 13 July 1927 lots 134 and 135
bt Hardie £36 and £37 respectively.
Ref: Kitson 1933 pp.85–6 repr.pl.XLI
fig.B; Kitson 1937 p.177.
Victoria and Albert Museum, London.

Son of a Norwich merchant, botanist,
director of Kew Gardens, Hooker
married Maria, eldest daughter of
Dawson Turner, in 1815. The portrait
was probably ordered direct from the
artist by Cotman's patron and Hooker's
future father-in-law. Although,
according to Harriet Turner, Cotman
held the opinion that portrait-painters
and artists are 'completely different' and
that 'it is [possible] to be the one, and
yet not the other', he himself produced
some attractive portraits, especially
small-scale ones in pencil and almost
exclusively of family and friends
(Nortons, Cholmeleys, Turners, etc.).
This one is the earliest by him in the
Turner album. It was etched a year later
by Mrs Dawson Turner, no.39 in her
volume of *One hundred etchings.*

87 The south façade of St Etienne at Fécamp (1817–21)

pencil and brown wash on wove paper;
32.4 × 24.5 ($12\frac{3}{4}$ × $9\frac{5}{8}$)
Signed and dated l.l. *John S. Cotman June
26 1817*; inscribed in pencil under the
ruled framing line l.l. *South Side of the
Church of St Stephen at Fecamp.*

Prov: ?Cotman Sale, Christie's 1 May 1824
lot 22; with Colnaghi *c.*1948; bt from them
by Sir Robert Witt; Witt Bequest 1952.

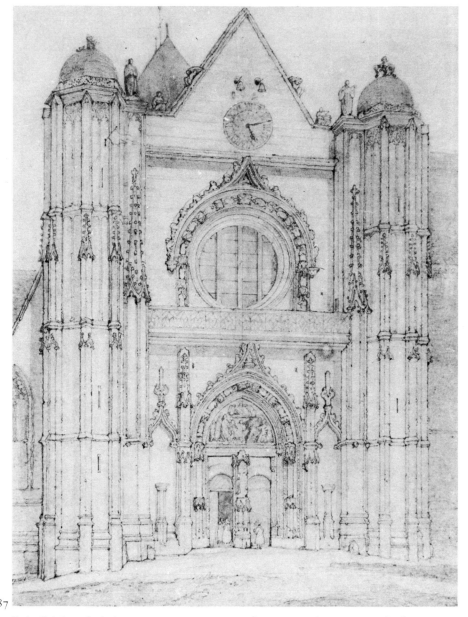

87

Exh: Calais 1961 (25).
Ref: Witt Handlist 1956 (4090); Rajnai
& Allthorpe 1975 p.70.
*Courtauld Institute Galleries, London (Witt
Bequest)*

Cotman paid two short visits to Fécamp,
once in 1817 when the sketch for this
drawing was taken, and again in 1820
when he drew the harbour for one of his

finest monochromes, now in the NCM.
In a letter to Dawson Turner written
6 July 1817 Cotman gave an amusing
account of his visit a few days
previously: '25, left Dieppe for Fécamp,
& was much disappointed with the
Cathedral there; – & sketched only the
south Front of y Church of St Etienne –
I had a leter to Monsr. Dupin, & by him
was first introduced to a french Lady,

Madame Dupin, very young & handsome & at her toilette, Monsieur was engaged & he left us to manage as well as we could, she not speaking a word of french & I not a word of English [*sic*, but meaning the other way round]. She was very polite, – & I tried to be so – They did not understand my motions & led up walk after walk up Cliffs & Vales &c–'

Cotman soon escaped the Dupins and moved on to Montevillier on 27 June. The date on the drawing is that of the visit and not of the execution. It was engraved and published 2 April 1821 as plate 71 of his *Architectural Antiquities of Normandy* (Popham 269). For a full account of his Fécamp subjects see Rajnai & Allthorpe.

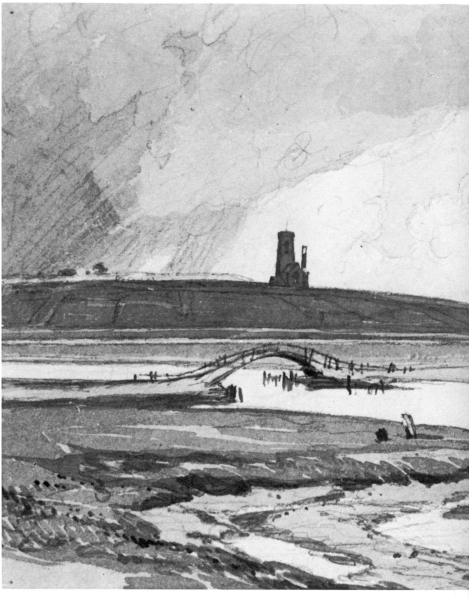

88

88 Blakeney Church and Wiveton Hall 1818

pencil and brown wash on wove paper; 17.2 × 28.5 ($6\frac{3}{4}$ × $11\frac{1}{4}$)
Signed and dated l.r. *J. S. Cotman 1818 –*

Prov: the Revd James Bulwer; by descent to Henry Bulwer; Kitson Bequest 1938
Ref: Kitson 1937 p.185 fig.84.
Leeds City Art Galleries

In addition to the continuous and overlapping etching projects which kept Cotman hard at work right through his years at Great Yarmouth, he also undertook to prepare series of drawings

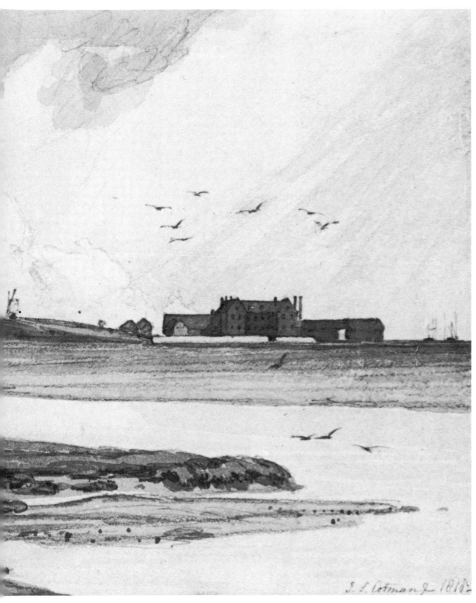

to illustrate the two volumes of *Excursions in the County of Norfolk* published by Longman 1818 and 1819 and he did some for the two Suffolk volumes as well. The small engravings by J. Greig are not very exciting, to say the least, and they give little or no hint of the quality of the drawings on which they are based. These drawings, of which the *Blakeney Church* is a good example, belong to Cotman's happiest products of the period: they are topography turned high art, and can be approached from either aspect without detriment to one's appreciation of them.

Engraved in the first volume of the *Excursions* opposite p.155.

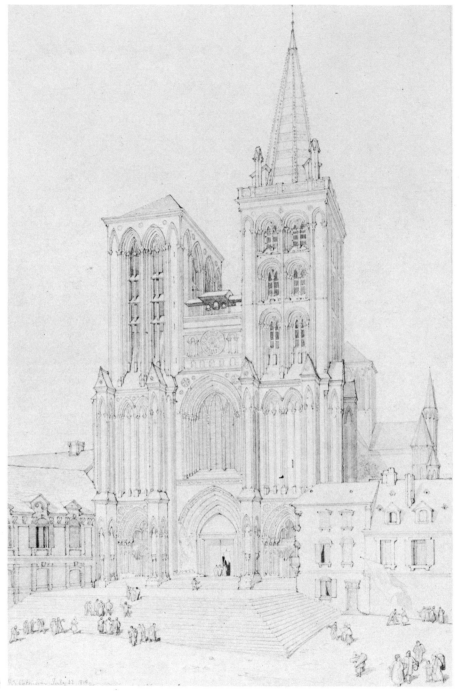

89

89 Church of St Peter, Lisieux, West Front (1818–21)

pencil and pale brown wash on wove paper; 44.5 × 28.6 (17½ × 11¼)
Signed and dated in pencil l.l.
J. S. Cotman July 23 1818 and inscribed with title under framing line l.l.

Prov: the artist's sale, Christie's 1 May 1824 ?included in lot 72; S. Angell & Horace Porter FRIBA; S. D. Kitson; his bequest to RIBA; purchased from them by Mr Paul Mellon 1975.
Exh: RIBA 1939 (61).
Ref: Kitson 1937 pp.212,238; Rajnai & Allthorpe 1975 pp.73–4.
Yale Center for British Art, Paul Mellon Collection

Cotman reached Lisieux on 22 July 1818, during his second tour of Normandy, and left on the morning of the 24th. The same day he wrote to Dawson Turner from Caen: 'Wednesday – reached Lisieux, reconnoitred & found nothing curious, though the whole on paper will not look amiss it will certainly tend to mislead the antiquary for there are three tiers of circular headed arches above the pointed ones – unless explained to y contrary . . .' In fact there is a simple explanation for the concern felt by the antiquarian in Cotman: the arches are not romanesque but of the 16th century. He also drew the south transept. Both these drawings were engraved in Cotman's *Normandy* 1822; the west front as pls.73–4, a double plate, published 2 April 1821 (Popham 271).
 Cotman's architectural drawings must be among the best of their kind ever produced. They are crisp, sensitive and crystalline, the use of the ruler unexpectedly adding to their quality rather than reducing it.

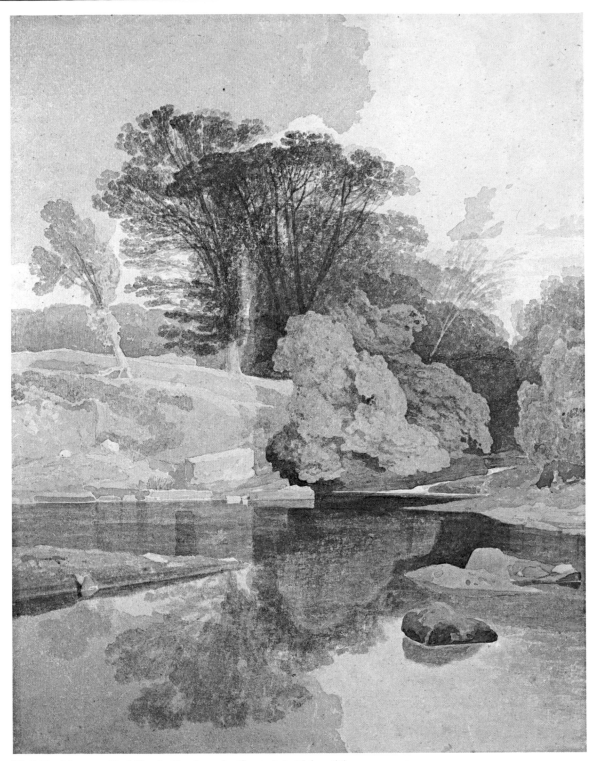

Hell Cauldron, called Shady Pool on the Greta [1808] (no. 68)

Norwich Market Place (1809)
(no. 79)

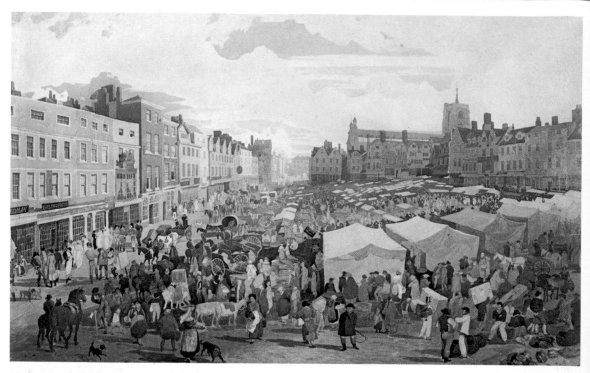

Mousehold Heath, Norwich (1810)
(no. 80)

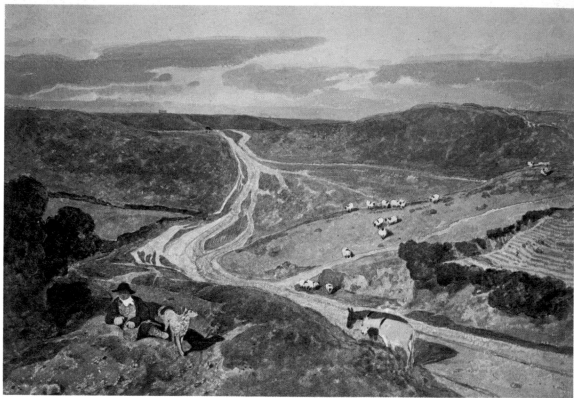

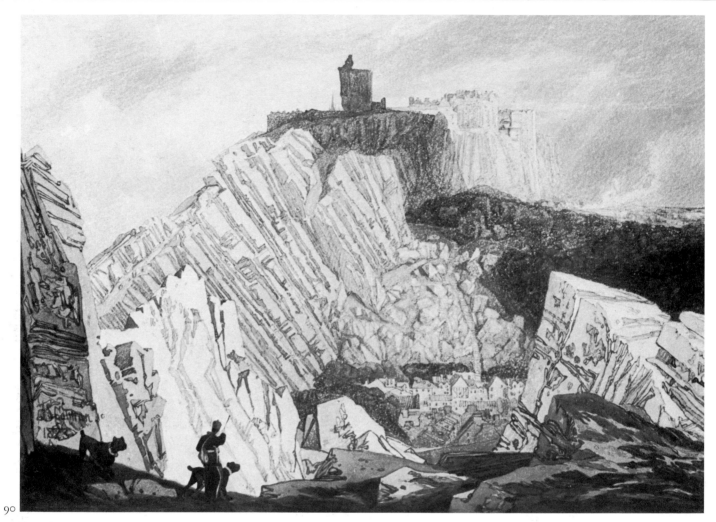

90

90 Domfront 1823

pencil, reed pen and watercolour with
extensive scraping on wove paper;
29.5 × 41.6 (11⅝ × 16⅜)
Signed and dated l.l. *J S Cotman 1823*

Prov: Mr and Mrs W. W. Spooner;
Spooner Bequest 1967.
Exh: Courtauld Galleries 1968 (82);
Harrogate 1968 (61) repr. p.11; Bath
1969 (18).
Ref: Troutman 1968 p.56; Rajnai &
Allthorpe 1975 p.67.
*Courtauld Institute Galleries, London
(Spooner Bequest)*

Between 20 and 26 August 1820, on his
last tour of Normandy, Cotman stayed
for an eventful week at Domfront. He
lodged in an inn that looked
'unpromising' but proved very
acceptable with 'a good bed, clean linen,
& excellent living' and remarkably
cheap at that; in the intervals of
torrential rain and spectacular storms he
took sketches of the church and 'Views
of Town and Rocks extremely grand';
during two of his days there he made
interesting excursions to the
neighbourhood where he noticed the
exciting evidence of wolves; and to
crown it all he spent the last night of his
stay under arrest.

The view in the drawing 'is that of
Domfront Castle and town seen from
the north-west, from the top of Tertre
Grisière, looking over the more than
200 feet deep Val des Rochers in which
the Varenne winds its way round the
castle. It is an impressive view full of
foreboding and menace, as if he knew –
as he could well have done – that the
Tertre Grisière was traditionally held to
have been the site of the gallows and
that this drawing fixed on paper what
must have been the last earthly image
perceived by those who were hanged
there.' (Rajnai & Allthorpe.) In fact in

his letter of 17 September Cotman made a reference to the well-known Domfront saying:

Domfront, Ville de malheur,
Arrivé à midi, pendu à une heure;
Pas seulement le temps de dîner!

The man with the two huge dogs is based on an encounter during his excursion to the Phare de Bonvouloir in the neighbourhood when he 'overtook a gentleman well clad in leather buskins & waistcoat, with two double barrel guns with bayonets to them, a short sword, & four large Dogs, between the bull & mastiff' which farmers of the region kept as protection against the wolves. (See Rajnai & Allthorpe for other versions and other Domfront subjects.)

91 Street scene at Alençon 1828
(repr. in colour)

pencil and watercolour; 43.2 × 58.4 (17 × 23)
Signed and dated l.r. *J. S. Cotman 1828*

Prov: Dawson Turner; presented by G. R. Burnett, 1908.
Exh: NSA 1828 (163); Norwich 1975 (L2); Arts Council 1981 (44).
Ref: Kitson 1937 pp.274–5 fig.122; Rienaecker 1953 pl.47 fig.91; Pidgley 1975 p.74 n.234, p.77; Rajnai & Allthorpe 1975 p.45.
By courtesy of Birmingham Museum and Art Gallery

Based on a sketch done in 1820 during his visit to Alençon on his third and last Normandy tour. This is a scene he 'encountered' when walking from his hotel towards the city centre on the only day he spent there sketching, 16 August. It shows the continuation of the Rue St Blaise, the Grande Rue, with the west end of the Church of Notre-Dame with its fine late Gothic porch (Cotman calls it 'bad') as the most memorable feature of the scene. He also sketched two aspects of the castle and three views on

the river. The other two versions of the *Street Scene* (Private Collections) are not necessariy by or entirely by Cotman. The Reeve Collection pen drawing of the same scene in the BM seems to be by William Crotch after Cotman.

The lively street scene recalls the excitement Cotman felt on entering Normandy. The sight of Dieppe Harbour made him exclaim, '. . . such colouring. Oh had I fortune and time beyond the limit of mortal man what might be done! ! ! – Nothing even as to colour can be seen in England like it.' However, his concentration on monochromes for a never-realised publication also delayed the working up of his pencil sketches in colour. Some did appear eventually, but not many of them can be considered as successful as the *Street scene at Alençon* in preserving the original elation that induced the artist to fix the particular scene in his sketchbook.

92 Mont St Michel 1829

pencil and watercolour on wove paper; 29.1 × 47.3 ($11\frac{7}{16} × 18\frac{9}{16}$)
Signed and dated l.r. *J. S. Cotman 1829*

Prov: J. N. Waite by 1860; Mase; with Boswell; with Agnew 1919–22; Private Collection, Manchester; with Agnew; Trustees of the John Wigham Bequest to the Walker Mechanics Institute 1925; presented by them 1942.
Exh: NSA 1829 (159) or NSA 1830 (35); Norwich 1860 (248); Norwich 1885 (323); NAC 1888 (193) repr.; BFAC 1888 (48) repr.; Great Yarmouth 1889 (105); Tate 1922 (126) lent by Agnew; Bristol 1953 (30); Arts Council 1959 (393); Bedford 1960 (50); Kendal 1973 (15); Norwich 1975 (L29).
Ref: Dickes 1905 p.338; Kitson 1937 pp.256–7; Davies 1942 pp.4,5, pl.10; Pidgley 1975 p.74, n.231.
Laing Art Gallery, Tyne and Wear County Council Museums

Cotman visited Mont St Michel in the

92

course of each of his three tours of Normandy. He found it 'most curious and awful' and gives a vivid description of the crossing of the sands to the Mount in September 1820: after joining a baker who was delivering loaves to the inhabitants of the island, 'on we jogged – through water and slippery mud till we came to a tolerable deep and broad

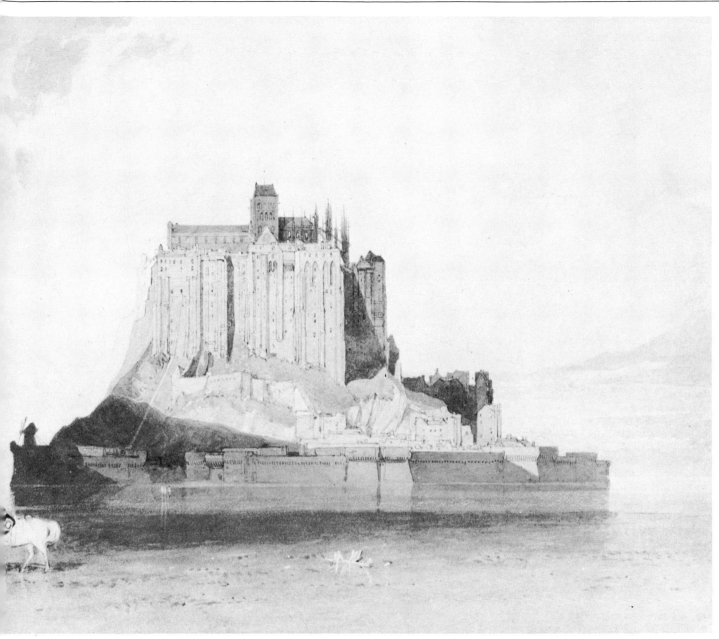

unequal stream in full view of the castle
... well here he dismounted and told me
to do the same ... he also told me to go
first ... Gracious God what were my
sensations to find I was on the brink of
destruction by being on one of those
tremendous quicksands – the very floor
trembles under me at the very thought
of it. – The land rose in the center above
the water, and all round shook like
custard meat.' (to DT and Mrs Cotman
23 September 1820). Two days earlier he
saw the Mount in a storm, when it
appeared to him a 'Terrific place, a place
for the Damned. A Hell more terrific
than poets, painters or Historians either
profane or sacred ever wrote upon or
conceived! ! !' He did a number of
drawings of the fortress and abbey and
apparently repeated the view at least
four times between 1818 and 1830, but
none of them seems to be an attempt at
the sublime, as if his verdict that 'no
description can equal the solitary
grandeur of the awe-striking Mt. St.
Michel' would have applied to pictorial
description as well.

123

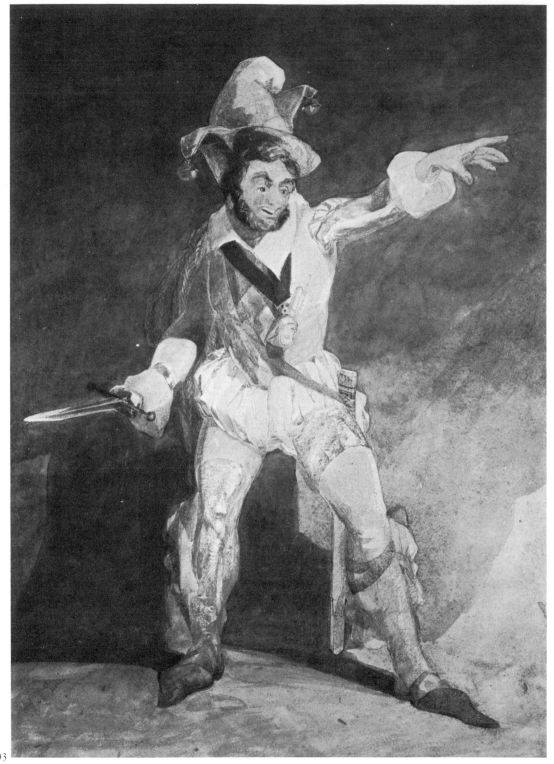

93

94

93 **The Jester** (1829)

pencil and watercolour on wove paper; 61.6 × 43.8 (24¼ × 17¼) (sight)

Prov: ?the artist's sale, Christie's 17–18 May 1843, first day, lot 154 *A fool, capitally coloured*, bt M. E. Cotman; by descent to J. J. Cotman; pledged by him as part of a large collection to William Steward, a pawnbroker at Yarmouth; the sale of this collection, Spelman, Norwich, 16 May 1861 lot 135 *The Jester*, bt Miller £3.5s.; ?the Revd James Bulwer; ?by descent to the Misses Bulwer. Exh: ?NSA 1829 (87 – '*Do'st thou call me fool, boy?' – Shakespeare*); Palser Gallery 1940 (22).
Private Collection

A unique piece in Cotman's oeuvre: a figure drawing on far the largest scale he ever attempted. There is a feasible suggestion that it represents Feste in *Twelfth Night*. However, if there is a Shakespeare connection at all, this watercolour, obviously intended for public show, might well be one of Cotman's contributions to the 1829 exhibition of the Norwich Society of Artists: no.87 was listed in the catalogue with a short quotation from *King Lear* Act 1 Scene 4 as its title: '*Do'st thou call me fool, boy?*' If this suggestion is correct, the title must have been given to the drawing as an afterthought – as a fitting expression to accompany and explain the figure's stance – because the drawing

is not an illustration of that scene: in the play it is Lear who speaks this line.

94 **Gunton Park** [late 1820s]

black chalk heightened with white on blue grey paper; 22.2 × 33.3 (8¹¹⁄₁₆ × 13⅛)
Inscribed l.c. and l.r.: *dead leaves . . . and dead . . .*

Prov: ?presented by the Misses Field 1922 as one of forty-one drawings in a volume bearing inscription: *Vol. I. Miles E. Cotman 8 Henrietta Street Brunswick Square and Kings Coll., Strand. The Visitors of the Ashmolean Museum, Oxford (The Misses Field)*

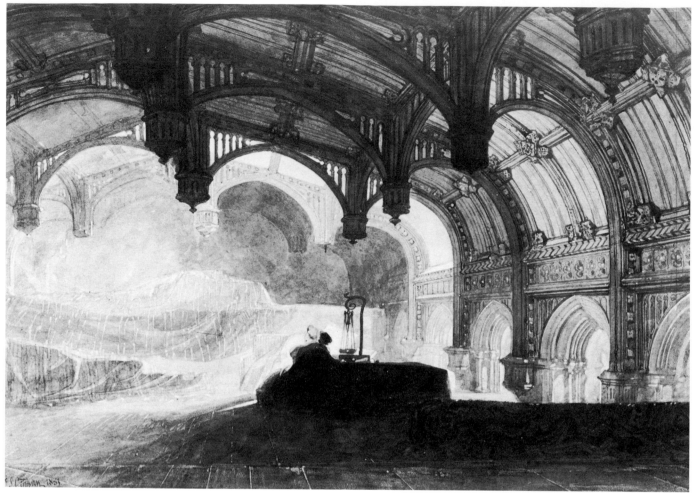

95

Cotman's brother-in-law John Hick, and his wife, Mrs Cotman's third and youngest sister, lived near Gunton. Apparently Cotman and his sons often stayed with them; certainly John Sell and Miles Edmund produced a number of drawings and watercolours which took the Park as their subjects.

95 **Interior of Crosby Hall 1831**

pencil, reed pen and watercolour on wove paper; 40 × 56.9 (15¾ × 22⅜)
Signed and dated l.r. *J S Cotman 1831*

Prov: ?Foster's sale 19 Dec. 1860 lot 27, bt Andrews £2.15s.; Christie's sale, 16 May 1862 lot 156, bt Graves; ?the Revd James Bulwer; John Redford Bulwer by 1888; purchased from Walker's Gallery 1927 £550.
Exh: OWCS 1831 (47); NAC 1888 (194); ?Agnew 1927(30).
Ref: Dickes 1905 p.370; Kitson 1937 p.294; Hardie vol.II 1967 p.91; Pidgley 1975 pp.197–8 n.99, and p.247 n.14.
Victoria and Albert Museum, London

A repetition, on a slightly enlarged scale, of the NCM watercolour dated 1830 and exhibited the same year (NSA no.40). The scene may have reminded Cotman of the Abbaye-aux-Dames at Caen. There a medieval nave, here a medieval Hall, had been cut in half by the insertion of a floor, creating a peculiar 'dwarfed' effect. (In both cases the floor was later removed.) The iridescent colours are something new and show his indebtedness to Turner.

The house with this Great Hall was built in 1466 by Sir John Crosby and was considered 'very large and beautiful and the highest at that time in London'. Around 1830 it belonged to a firm of packers (see Pidgley). Many years after Cotman painted it, the Hall was transferred from its original site in Bishopsgate to its present location in Cheyne Walk.

96 **The Shepherd on a Hill 1831**

watercolour on wove paper watermarked J WHATMAN 1830; 23 × 33.6 (9$\frac{1}{16}$ × 13$\frac{1}{4}$) Signed and dated l.l. *J S Cotman 1831*

Prov: C. E. Hughes by 1912; bt from Walker's Gallery by Henry Bell 1920; presented by Mrs Bell's sister, Miss Richardson, 1938.
Exh: Grafton Galleries 1911 (202); Paterson 1913 (61); Tate 1922 (47); RA 1934 (721); Agnew 1938 (166); British Council 1949–50 (25); Geneva & Zurich 1955–6 (28).
Ref: Finberg 1912 p.7 pl.IV; *Walker's Monthly* Feb. 1929 pl.I in colour; Lucas 1934 p.96; Kitson 1937 p.296; Hardie vol.II 1967 p.92.

Walker Art Gallery, Merseyside County Council, Liverpool

While Cotman did not exhibit many pieces in 1831, a good number of highly successful watercolours dated to this year survive, the present drawing among them. In composition and in mood it points towards the so-called 'paste' drawings, the long series of which had just started at about this date.

It was aquatinted in colour by M. M. Bucan in 1933.

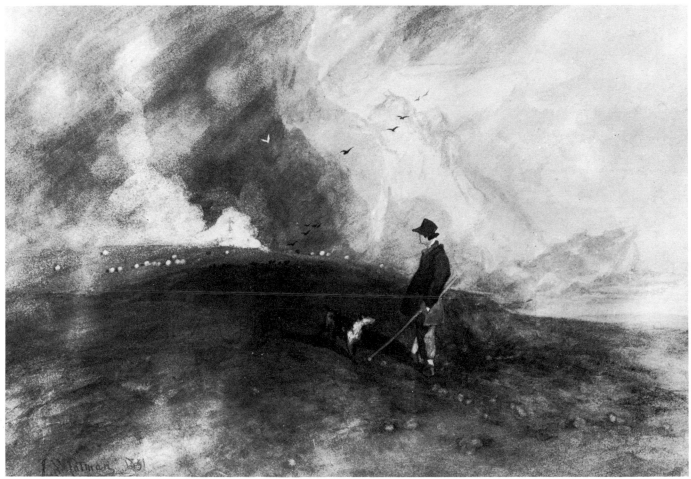

96

97 The Entrance of the Valley of Lauterbrunnen, from Interlaken 1831
(repr. in colour)

pencil and watercolour on wove paper; 32.4 × 47.3 (12¾ × 18⅝)
Backing board – since removed – was inscribed with title and artist's name.

Prov: Joseph Geldart; his daughter's sale 1930 (148); Sir James Macfarlane; by descent to the Misses Martha and Catherine Macfarlane; bt Dr T. Besterman from the Leger Galleries Jan. 1970.
Exh: Leger Galleries 1969 (26) repr. in colour; Munich 1979–80 (222).
Ref: Dickes 1905 p.349; Kitson 1937 p.296; Pidgley 1975 p.90 n.293.
Private Collection

There is no trace that this important watercolour was ever exhibited by Cotman, which seems to indicate that it was painted as a commission, presumably for Joseph Geldart, the Norwich artist, Cotman's pupil and friend of his sons. Pidgley suggests that its first owner, who was a great traveller as well as an amateur artist, rather than Harriott, as put forward by Kitson, could have provided the sketch for this watercolour. A rather similar composition, both in conception and execution, is at Bedford.

The Valley of Lauterbrunnen with its small rivers and waterfalls was already a tourist attraction in Cotman's time. Some of the sights were admired by Wordsworth and Byron and painted by Koch (see Munich catalogue).

98 Entrance to Gunton Park, Norfolk
(1822)

pencil, watercolour and bodycolour on wove paper; 43 × 31.9 (16¹⁵⁄₁₆ × 12⁷⁄₁₆)

Prov:?Foster's sale, 12 June 1867 lot 20, bt Graves £1.12s.6d; ?William Ascroft by 1874; with Vicars 1936; bequeathed by J. Leslie Wright 1954.
Exh: OWCS 1832 (150); ?London IE 1874 (316a); Palser Gallery 1940 (32); RA 1949 (247); Bourges 1970 (66)
By courtesy of Birmingham Museum and Art Gallery

For Cotman's connection with Gunton see no.94. Although Cotman's contribution to the Norwich and London exhibitions remained low, he seems to have had a very productive period in the years just before his removal to London. Most of the works produced at this period are luscious, showy pieces like the present drawing. See also nos. 97 and 99. In the light of these works it is peculiar that he was so overwhelmed by the Spanish drawings of Lewis and Roberts. He was certainly wrong when deprecating his own palette: 'My poor Red Blues & Yellows for which I have in Norwich been so much abused and broken hearted about, are faded fades, to what I there saw [at a conversazione with Lewis's drawings], Yes, and aye, Faded fades & trash – nonsense & stuff –.' And again – referring to Lewis's portfolios: 'his ske[t]ches are wonderful – These folios are open to my & my Son at all times!!!!!!!!!!!! – They are to us more than the Regalia of All England!!!! – An entire new light has burst upon me!' In fact, as far as heightened colour schemes are concerned, he had been working on the same lines for years. The 'light' had been on him for at least a decade. (See Pidgley 2nd chapter where Cotman letters of 8 January and 25 February 1834 are quoted.) A preparatory drawing is at Leeds.

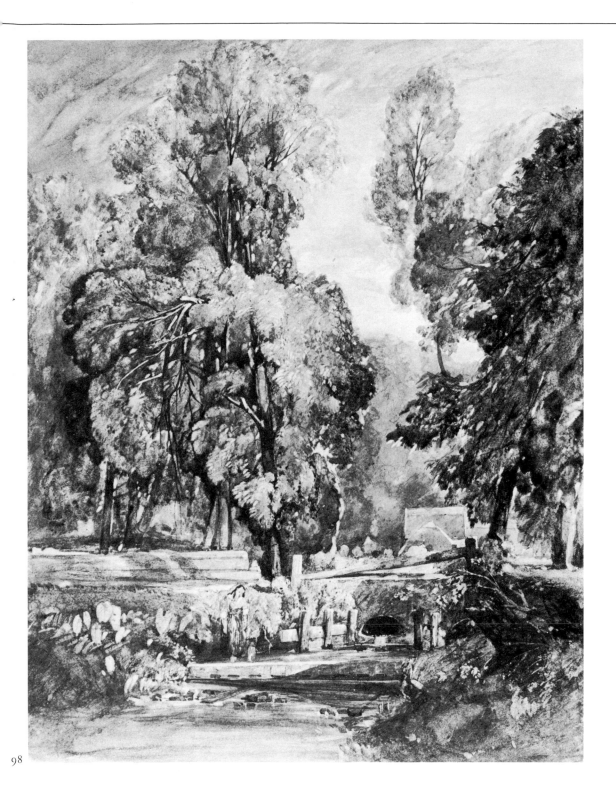

98

99 Italian Peasant at a Fountain in the Valley of Coriati 1832

pencil, watercolour and bodycolour on
wove paper; 40 × 29.2 ($15\frac{3}{4}$ × $11\frac{1}{2}$)
Signed and dated l.l. *J S Cotman 1832*

Prov: Sotheby's 19 March 1981 lot 109.
Exh: OWCS 1833 (304); NSA 1833 (77).
Ref: Pidgley 1975 p.84.
Stanhope Shelton

The significance of the title has escaped
explanation so far. As there does not
seem to be a River Coriati in Italy, the
late Alec Cotman suggested that the
name might be a corruption of Crati, the
Calabrian river on whose left bank once
stood the ancient world's most
luxurious city, Sybaris. However the
allusion of the tomb-like fountain is
classical only in spirit; in style it is
renaissance and in content it is Christian
(the cardinal's hat). The decorative
value of the latter motif was made good
use of by Cotman in another
watercolour of the same period, *A Study
of Armour etc.*, exhibited in Norwich in
1832 and now in NCM.
 The Sotheby's catalogue draws
attention to its being reminiscent both
in subject and mood of the genre of
paintings with the theme of 'Et in
Arcadia ego'. The peasant woman is of
the same breed as the women of Joshua
Cristall and must be derived from him.

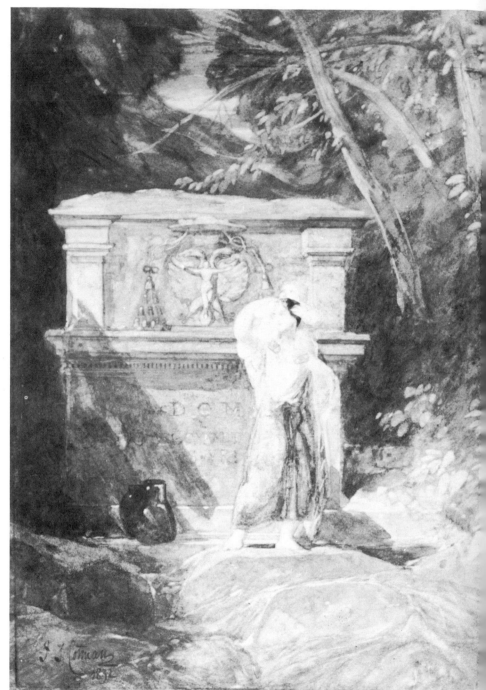

99

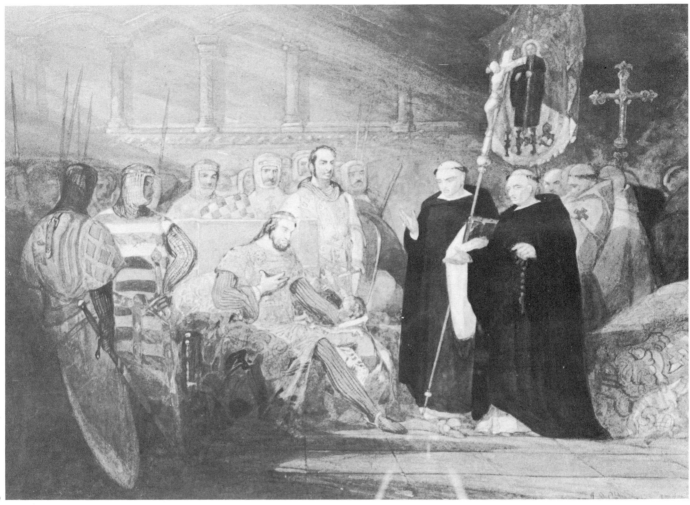

100

100 King John and Prince Henry at Swineshead Abbey, attended by the Earls of Salisbury, Oxford, Pembroke, Essex, and Warrenne; after their defeat and loss at crossing the Lynn Wash 1833

pencil and watercolour heightened with white; 33.5 × 49.8 (13$\frac{3}{16}$ × 19$\frac{5}{8}$)
Signed and dated l.r. *J. S. Cotman 1833*

Prov: Ann Cotman; given by her to her cousin F. G. Cotman; descended in the family until the 1940s; L. J. Gibson who presented it 1978.

Exh: OWCS 1833 (222); NSA 1833 (35) with *Swinested* and *Warwick* instead of *Swineshead* and *Warrenne* in the title; King's Lynn 1877 (233); Burnley 1980.
Ref: Binyon 1897 p.95; Kitson 1937 p.299; Clifford 1965 pp.65–6; Pidgley 1975 p.194.
Warrington Borough Council, Museum and Art Gallery

An imaginary scene from the life of King John a few days before he died on 19 October 1216. After the battle with the barons at King's Lynn he stopped at Swineshead Abbey, where he caught dysentery – rumours said he was poisoned by a monk – which led to his death at Newark a few days later. The child kneeling in front of him is his eldest son, the future Henry III. Not all those listed in the title were present at the Abbey; some of them had already abandoned the King's cause by then.

The composition is much influenced by George Cattermole's similar history pieces but the greater genuis of Cotman is apparent, especially in the delicious painterly details of the group of ecclesiastics.

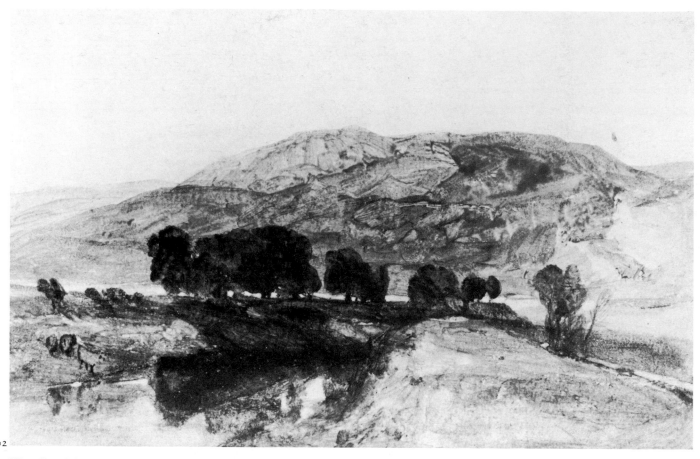

102

101 Woodland Glade [1830s]
(repr. in colour)

pencil and watercolour on wove paper; 18 × 24.3 ($7\frac{1}{16}$ × $9\frac{9}{16}$)

Prov: the late Sir Hickman Bacon.
Exh: Whitworth 1937 (30); Hull 1938 (51); Arts Council 1946 and 1948 (14); Norwich 1956 (25); Colnaghi 1970 (45) pl.XI.
Ref: Oppé 1923 p.xiv pl.XX as *Dark Trees*; Kitson 1937 p.349; Hawcroft 1962 p.29 pl.VII.
Private Collection

At the time when Cotman was producing his most luxuriantly colourful works he painted a series of almost monochrome landscape compositions in which a rich, blackish, velvety colour and a few modulated

tones played the leading parts. None of these landscapes seems to be anchored in topography. They can perhaps be regarded as Cotman's versions of the Cozensian 'blot' drawings: a few simple forms suggesting densely foliated tree-crowns, river banks, etc. are moved about on the paper to create an infinite variety of landscape images of an inherent similarity and of enticing charm.

102 A Rocky Landscape at Sunset [1830s]

watercolour on wove paper; 17.5 × 26.7 ($6\frac{7}{8}$ × $10\frac{9}{16}$)

Prov: bt from the artist by J. H. Maw; by descent to Mrs A. B. Wood, née Anna Mary Maw, his daughter; by descent to F. Derwent Wood, her son;

Mrs Derwent Wood sale, Christie's 25 June 1926 lot 105, bt Agnew; purchased from them 1926 £194. 5s.
Exh: Tate 1922 (46); Sudbury 1978 (26)..
Ref: Oppé 1923 p.xiv pl.XIX in colour; Kaines Smith 1926 p.148; Hardie vol.II 1967 p.92.
Victoria and Albert Museum, London

One of the late, highly alluring watercolours by Cotman spun from the basic constituents of a landscape and having no topographical content whatsoever. This drawing and its companions are always a feast for the eye but, as they are not direct responses to particular visual and emotional experiences but constructions from elements provided by the artist's memory-bank, there is a somewhat disconcerting sameness about them.

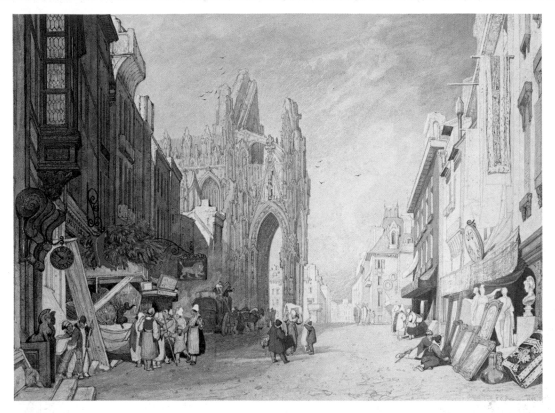

Street scene at Alençon 1828 (no. 91)

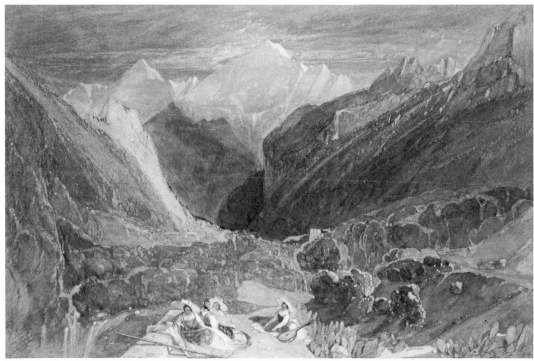

The Entrance of the Valley of Lauterbrunnen, from Interlaken 1831 (no. 97)

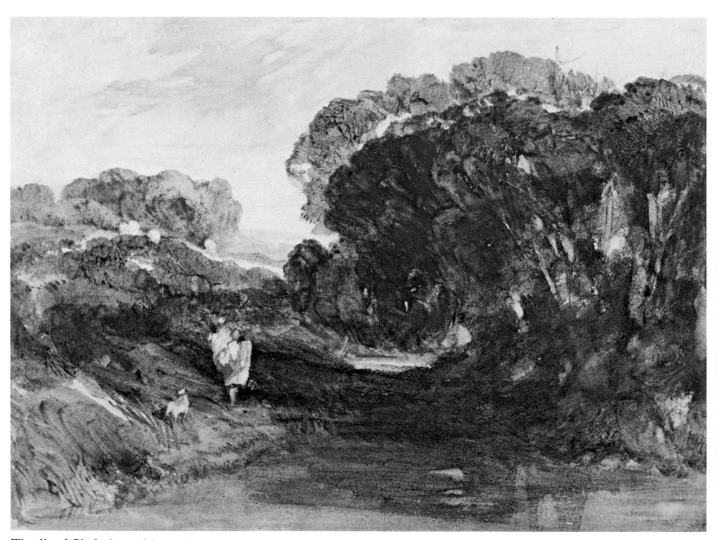

Woodland Glade [1830s] (no. 101)

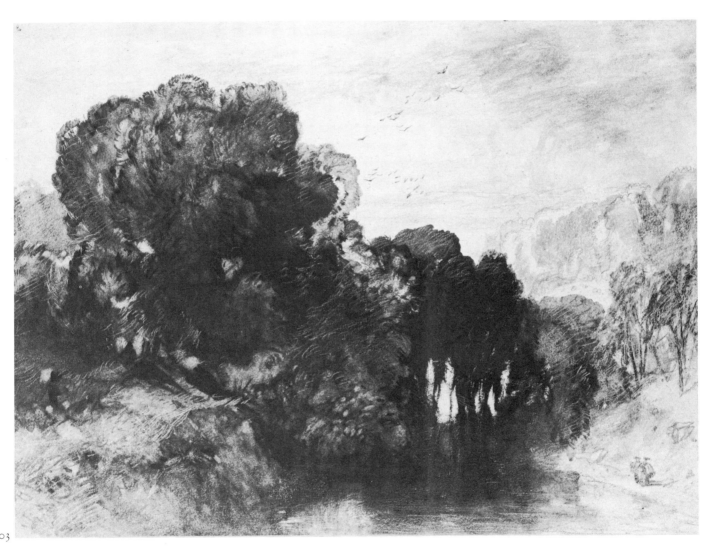

103

103 The Shadowed Stream [1830s]

pencil and brown and grey wash on
wove paper; 23 × 31.9 (9$\frac{1}{16}$ × 12$\frac{9}{16}$)
(sight)

Prov: J. Orfeur of Norwich; Miss Stark;
bt from her by James Reeve; purchased
from him with the rest of his collection
1902.

Exh: NAC 1888 (127) repr. in cat.; BFAC
1888 (110); Bedford 1960 (61).
Ref: *The Architect* 15 Feb. 1889 repr.;
Binyon 1897 p.64 repr. p.77; Reeve MS;
Binyon 1903 p.vi,xiii repr. C8; Dickes
1905 p.327; Reeve 1911 repr.; Kaines
Smith 1926 p.104; Bury 1937 repr. p.32;
Kitson 1937 p.349 pl.141; Rienaecker
1953 p.43; Clifford 1965 p.76; Hardie

vol.II 1967 p.92.
The Trustees of the British Museum

See comment on no.102. Kitson, who
was very appreciative of this phase of
Cotman's art, considered it 'the ultimate
outcome of his life-long mastery of
pattern-making, combined with a
technique which is entirely his own'.

104 **Knight on Horseback** [1830s]

pencil and watercolour with gum arabic;
40.9 × 24.7 ($16\frac{1}{8}$ × $9\frac{3}{4}$)
Inscribed on the banner
HANNAH THE FAIREST; also, on the
collar of the Cat Crest, PURR.

Prov: given by the artist to J. H. Maw's
daughter, Anna Mary, the 'Hannah' of
the inscription, later Mrs A. B. Wood,
the mother of the sculptor F. Derwent
Wood; by descent to F. Derwent Wood;
Mrs Derwent Wood's sale, Christie's 25
June 1926 lot 112 with another, bt
Agnew; bt from them by S. D. Kitson;
by descent to the Misses Kitson who
presented it 1973.
Exh: Tate 1922 (226).
Ref: Oppé 1923 p.xiv; Kitson 1937
p.348 pl.137.
*The Trustees of Cecil Higgins Art Gallery,
Bedford*

A cut-out (*papier coupé*) painted and
mounted on wooden panel for the small
daughter of one of Cotman's most active
patrons in the last decade of his life,
John Hornby Maw of Guildford, a
manufacturer of surgical instruments,
amateur artist and writer on
watercolour painting. Although it is
obviously a light-hearted *divertissement*,
one of the 'purely playful experiments in
the nursery of his friend', it is well in line
with Cotman's interest at this period in
historical subjects and costume pieces.
One can find in it everything that
Gibson, another patron, admired in his
pencil drawings: it is indeed 'nobly
square, bold characteristic and
expressive', much more so, in fact, than
most works of the 1830s, and without its
connection with the Maw family one
would tend to date it much earlier. The
cat of the crest and in the arms on the
shield is perhaps an amusing portrayal
of the black cat which the superstitious
Cotman kept for luck (see Pidgley 1975
pp.97,106 note 330).

104

136

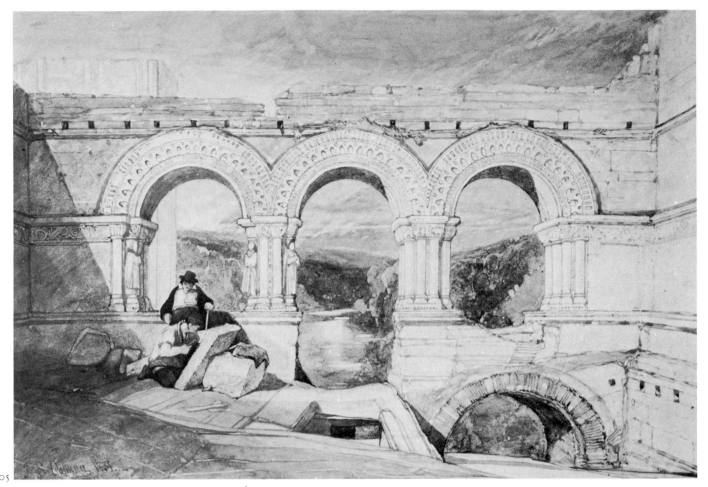

105

105 Hilly landscape with bridge, called Jumièges 1831

pencil, reed pen and watercolour,
wiping out in sky, on wove paper;
27.3 × 39.8 (10¾ × 15¹¹⁄₁₆)
Signed and dated l.l. *J. S Cotman 1831*

Prov: bequeathed by John Scott 1864.
Exh: Tate 1922 (134); Norwich 1975
(L40).
Ref: Dickes 1905 p.342; Rajnai &
Allthorpe 1975 p.86.
*The Trustees of the National Galleries of
Scotland*

The 'bridge' is composed of the three
entrance arches of the Chapter House of
St Georges-de-Boscherville, sketched by
Cotman on his second and last visit
there on 3 July 1818 in the company of
Mrs Dawson Turner and two of her
daughters. This watercolour shows with
clarity how Cotman's mind worked and
how he transmuted an earlier

experience. By taking the arches (of
which four versions exist) as a motif,
placing them on an elevated site as part
of a 'classical' ruin through which is
glimpsed a watery arcadian landscape,
Cotman has produced an attractive
architectural capriccio. Curiously the
arches have been reversed, which
suggests that they were traced from a
preparatory drawing such as the one in
pencil in the BM.

106

106 **Harlech Castle** [1830s]

pencil, watercolour and bodycolour on wove paper; 20.3 × 28.6 (8 × 11¼)

Prov: David Cox.
Exh: Bourges 1970 (64); Birmingham 1970 (5); Arts Council 1981 (38).
By courtesy of Birmingham Museum and Art Gallery

Cotman was a scrupulous topographer, but when he had finished with the subject in one or more true renderings he used these works as a storehouse of motifs to be manipulated in whatever way they served his purpose. In this drawing of the 1830s one can still recognise as a basis the two on-the-spot pencil sketches of 1800 in the NCM (Rajnai & Allthorpe 1975 nos.7 & 8), but some towers are now shorn off, walls are straightened out, a village is obliterated and a hillock blasted away to give place to a valley, resulting in a vague reminiscence of Harlech rather than the castle we know.

107 **At Whitlingham** [1830s]

pencil and watercolour on wove paper; 28.7 × 41.4 (11⁵⁄₁₆ × 16⁵⁄₁₆)

Prov: J. I. Mott of Barningham, Norfolk; his sale, Christie's 28 Feb. 1885 ?lot 122 *A Woody Landscape*, bt James Reeve; purchased from him with the rest of his collection 1902.
Exh: NAC 1888 (158).
Ref: Reeve MS.
The Trustees of the British Museum

Whitlingham, with its ruined church overlooking the Yare valley from a slight eminence just west of Norwich, was a great favourite with the artists of the Norwich School. However, Cotman never exhibited any work with this title, although one of the two watercolours of lot 198 in his posthumous sale, 17–18 May 1843, was a *View of Whitlingham*. Whether it is the site indicated by the title or not, Cotman seems to have taken a considerable liking to the composition: there is a summary sketch in black chalk

107

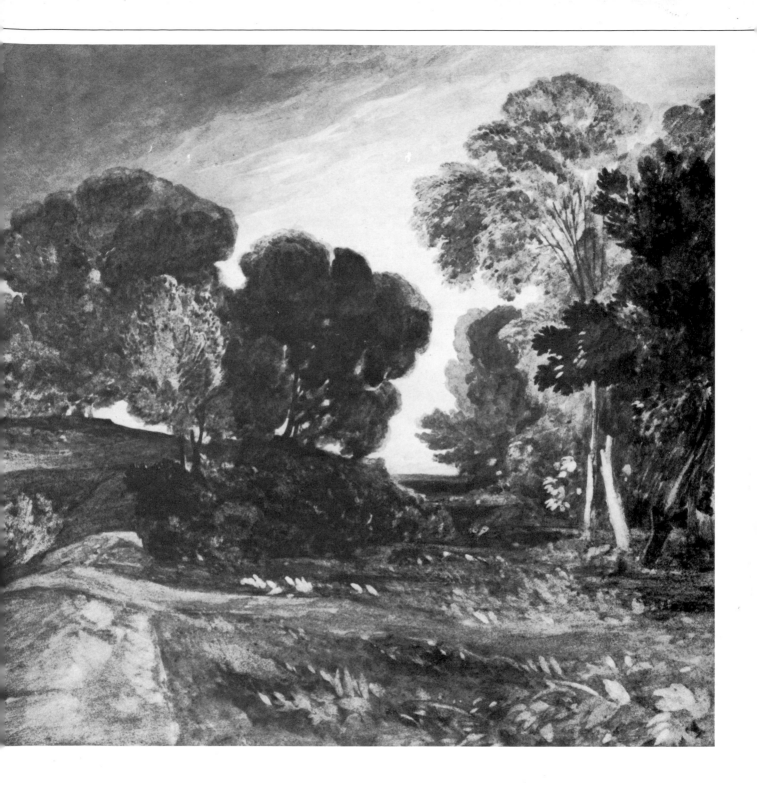

at the Ashmolean Museum, a water-colour version at Leeds and a version in oil in a private collection (see no.121). The larger chalk drawing of this scene in the Ashmolean looks more like the work of Joseph Geldart who became Cotman's pupil in 1829.

Michael Pidgley suggests that there was a belief at the time that the pictures of the Walpole Collection sold to Catherine in 1779 were imperilled in such a way during their transit, so the story was not entirely the artist's invention.

108 Lee shore, with the wreck of the Houghton pictures, books, &c., sold to the Empress Catherine of Russia (1838)

pencil and watercolour with bodycolour and gum arabic; 68×90.2 ($26\frac{3}{4} \times 35\frac{1}{2}$) (sight)

Prov: the artist's sale, Christie's, 17–18 May 1843 lot 160 bt Leggatt £4.15s; presented by Joseph Prior, March 1919.
Exh: OWCS 1838 (223)
Ref: Dickes 1905 pp.392–4; Kaines Smith 1926 pp.50–51; Kitson 1937 pp.343,344 fig. 134; Rienaecker 1953 p.28; Boase 1959 p.39; Boase JWCI 1959 pp.332–46, pl.33b; Clifford 1965 pp.66,67; Pidgley 1975 p.195–6 n.55.
Fitzwilliam Museum, Cambridge

In the last decade or more of Cotman's life, he and his eldest son, Miles Edmund, often collaborated in paintings which were sold under the father's name. This is a fully documented example of such collaboration: 'Miles & I have been working at a Sea shore,' writes Cotman on 7 April 1838, 'his part the larger of the two, Sea, Sky & Shipping, and I the foreground figures.' And on 24 April: 'What I done to Miles' Sea View, in words, will tell against me. He will not know his picture . . . "The Sea Shore", if I can get the catalogue altered will be christened "The Wreck of the Houghton pictures, Consigned to the Empress Catherine of Russia, including the gorgeous landscape of Rubens of the Wagoneer" – for such have I made it, by introducing pictures & things . . . in the foreground.' The title in fact was changed from one edition of the catalogue to the other.

109 A chapel in the Abbaye-aux-Dames at Caen 1839

pencil and reed pen and watercolour, heightened with white; 49.2×26.1 ($19\frac{3}{8} \times 14\frac{1}{4}$)
Signed and dated l.r. *J S Cotman 1839*

Prov: presented by W. F. R. Weldon 1928.
Exh: Norwich 1975 (L12).
Ref: Kitson 1937 p.346.
The Visitors of the Ashmolean Museum, Oxford (Weldon 1928)

During his three tours of Normandy, Cotman spent more time in Caen than in other towns (a few days short of two months spread over a number of visits) and the Abbaye-aux-Dames provided him with more subjects than any other site in Caen. He was already sketching it on 18 July, the day after his arrival there in 1817, but he seems to have done most of the work at the Abbaye in the same month of the following year. Spencer Smith 'has introduced me to Msr. Lechaude directeur of the Depot, or in English the House of Correction, Abbey St. Trinity [i.e. Abbaye-aux-Dames], from whence I am but just returned,' Cotman writes to DT on 27 July. 'This has opened to me a mine of rich work – of which the Etching after [?]Mayor Alexander, gives little or no idea.'
 This later watercolour is based on an earlier monochrome (Christie's, 3 August 1976 lot 36), but as the subject does not appear in the 1824 Cotman sale of Normandy drawings it is possible that both are derived from a print seen after the visits rather than from a sketch

108

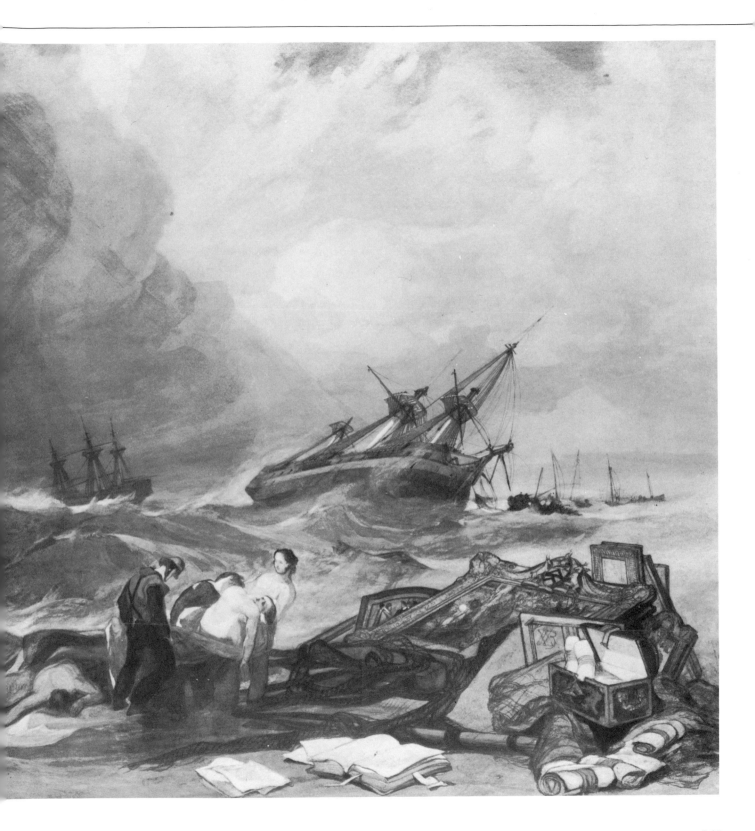

taken on the spot. The iridescent washes, for which Cotman owes a debt to Turner, first appear in his work in the early 1830s.

110 **A Lady of Alençon** (1839)

pencil and watercolour heightened with white on wove paper; 32 × 23.1 ($12\frac{5}{8} \times 9\frac{1}{8}$)

Prov: bt from the artist by Francis Gibson of Saffron Walden; by descent in the Fry family to present owner.
Exh: ?OWCS 1839 (152); Norwich 1922 (124); Tate 1922 (124); Aldeburgh 1950 (1).
Ref: Kitson 1937 pp. 223–4,345; Rajnai & Allthorpe 1975 p.46; Pidgley 1975 p.107 n.364.
Private Collection

According to Kitson it 'was elaborated from a rough pencil sketch . . . of a peasant girl stepping out of her cottage, made during Cotman's visit to Alençon in 1820'. Gibson reserved the drawing exhibited in the Old Water-Colour Society Exhibition but the artist started another for him. Cotman wrote of this on 21 August 1839: 'I hope [it] will be a much better drawing in every respect . . . I will send them both that you may make your own choice . . . That the Drawing may be identified as being executed expresly for you pray do me the favour to send me a Sketch of your Arms . . . and I will insert them in a Shield that is on the side of the Porch.' (in lender's coll.). He promised to deliver the drawing in about a month. Gibson probably adhered to his original choice as there is no coat-of-arms on the porch and no second version has yet come to light. The subtle, muted colours set this drawing apart from his other late figure compositions of a highly pitched palette.

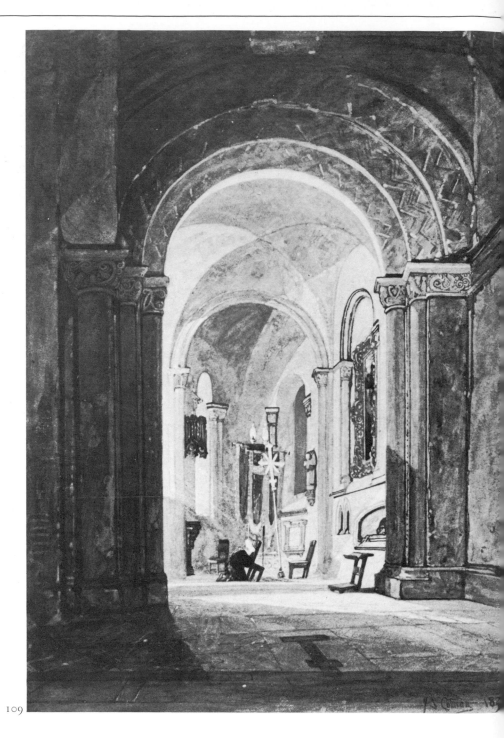

109

142

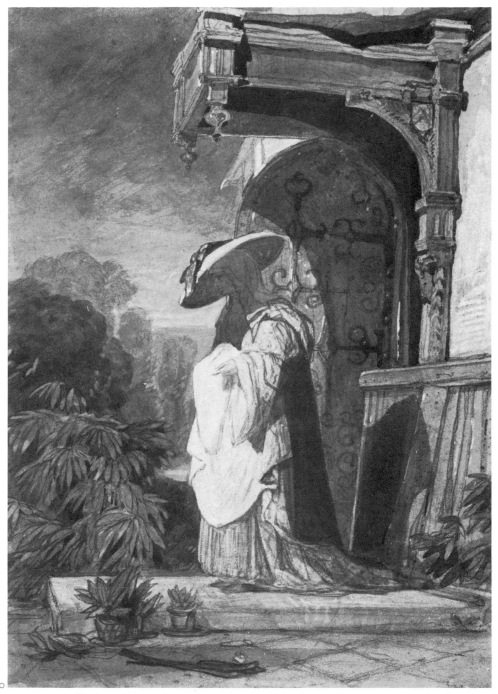

110

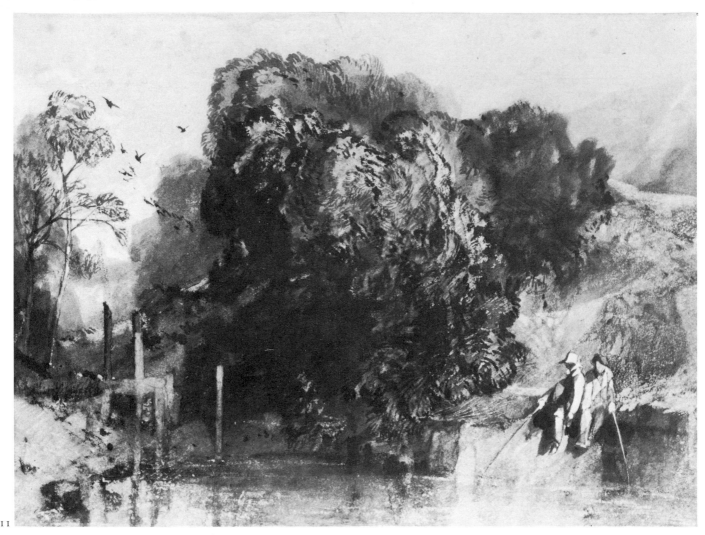

111

111 **Dewy Eve** [1839]

black chalk and grey wash with some watercolour and bodycolour on blue paper; 27.8 × 37.5 (10$\frac{15}{16}$ × 14$\frac{3}{4}$)

Prov: J. J. Cotman; bt from him by T. P. Downes, the artist; acquired from him by C. Clowes; bt from him by James Reeve; purchased from him with the rest of his collection 1902.

Exh: NAC 1888 (109) repr. in cat.; BFAC 1888 (112); Norwich 1956 (26); Whitworth 1961 (59).

Ref: *The Architect* 31 Oct. 1890 repr.; Binyon 1897 pp.63–4; Binyon 1903 pp.ix, xiii repr. C13; Dickes 1905 p.326 repr.; Finberg 1905 p.140; Reeve 1911 repr.; Cundall 1920 p.21; Kaines Smith 1926 p.103; Kitson 1937 p.341; Rienaecker 1953 pp.43,45; Holcomb 1978 p.16 pl.88.
The Trustees of the British Museum

Technically and in conception this is very close to nos.95–7. It is a study for, or more likely a watercolour version of,

the NCM oil which, according to Kitson's plausible suggestion, is the painting Cotman exhibited in Norwich in 1839 with the title *Henley-on-Thames: Boys Fishing* (125). Kitson regarded the *Dewy Eve* as 'one of the loveliest of Cotman's drawings in the Reeve Collection'. The title does not appear in Cotman's lifetime or in his sales: it must be a Victorian invention.

112 Blofield, The old Yarmouth Road to Norwich (1841–2)

black and white chalk on stone-grey paper; 36.8 × 54.1 (14½ × 21 5⁄16)
Inscribed and dated along lower edge
Blofield/The old Yarmouth Road to Norwich Nov. 1841 –

Prov: J. J. Cotman; bt from him by James Reeve 1864; purchased from him with the rest of his collection 1902.
Exh: NAC 1888 (134) repr. in cat.
Ref: Binyon 1903 repr. C30; Dickes 1905 p.402; Reeve 1911 repr.; Kitson 1937 fig. 150; Holcomb 1978 p.16 pl.95.
The Trustees of the British Museum

One of a group of drawings done in black and white chalk on grey paper from sketches made during October – November 1841, Cotman's last visit to his native county. 'The Principal of King's College has given me a holiday of a fortnight, but I shall stretch it to three weeks or nearly so, for Edmund can do my duty, (though he is really ill),' he wrote to Bulwer, 24 September 1841.

In fact he 'stretched' the holiday to about two months, constantly on the move in spite of the atrocious weather with its attendant floods.

The *Study at Blofield on the Old Yarmouth road to Norwich* lent by Arthur Batchelor to the Cotman Exhibition at the Tate Gallery in 1922 is presumably connected with this drawing.

112

113

114 Boy at Marbles (Henry Cotman)
(1808) (repr. in colour)

oil on canvas; 76.2 × 63.5 (30 × 25)

Prov: the sitter, Henry Cotman, John
Sell's youngest brother; descended in his
family through F. G. and Graham
Cotman to Alec and Kenneth Cotman
by 1947.
Exh: NSA 1808 (7); Norwich 1942 (5);
Arts Council 1947 (43); Kettering 1952
(46); Agnew 1958 (55); Whitworth 1961
(14); Norwich 1978 (1).
Ref: Kitson 1937 p.105 fig.42.
The Kenneth Cotman Family Collection

Although Cotman did not lack talent for
portrait painting, he engaged in this
activity only occasionally, most of the
time limiting himself to the medium of
pencil drawing. He never exhibited
portraits anywhere except in Norwich
and of the twenty-nine portraits which
he contributed, twenty-six were
included in the first three exhibitions
1807–1809. Only one sitter is identified
out of the twenty-six – Mr Freeman –
and the present picture and its
companion the *Beggar Boy*, also of Henry,
are perhaps more justifiably regarded as
genre pieces. They belong to his very
first achievements in the medium of oil
with which he started experimenting
two years before.

**113 From the garden of my father's house
at Thorpe, next Norwich** (1841–2)

black and white chalk on stone-grey
paper; 31.2 × 37.7 (12¼ × 14¹³⁄₁₆)

Prov: J. J. Cotman; bt from him by
James Reeve 1864; purchased from him
with the rest of his collection 1902.
Exh: NAC 1888 (128) repr. as heading of
the Memoir of Cotman in cat.; BFAC
1888 (127).

Ref: Reeve MS; Binyon 1903 p.xiii repr.
C43; Dickes 1905 p.403 repr.; Cundall
1920 p.23; Kaines Smith 1926 p.101;
Kitson 1937 pp.359, 362–3; Rienaecker
1953 pl. 56 fig. 106; Hawcroft *Burlington*
1962 p.70; Holcomb 1978 p.17 pl.102.
The Trustees of the British Museum

Like no.112, done in the winter of
1841–2 as a result of Cotman's last visit
to Norfolk the previous autumn. It is
one of two known preparatory
drawings towards the unfinished oil
dated 'Jany 18. 1842' in NCM, which
closely follows it both in composition
and in details with the major exception
of the fir trees: these are replaced by
poplars adopted from the other drawing
also in the BM. The view, aggrandised
beyond recognition, is from the small
terrace house of Cotman's father,
looking along the River Yare towards
the city, with Thorpe Hall nestling
among the trees.

Boy at Marbles (Henry Cotman) (1808) (no. 114)

Seashore with Boats [1808–10] (no. 118)

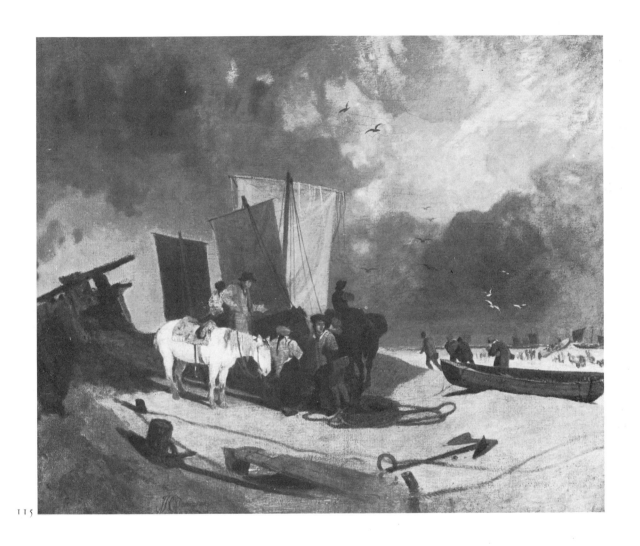

115

115 Yarmouth Beach with figures 1808

oil on canvas; 62.2 × 74.9 (24½ × 29½)
Signed and dated l.l. *J S Cotman 1808*

Prov: ?Cotman Sale, Spelman, Norwich,
10–12 Sept. 1834, 3rd day, lot 115, bt
John Norgate £3.6s.
Exh: Whitworth 1912 (316); Tate 1922
(130); *Country Life* Exh. London 1937
(366).
Ref: ?Kitson 1937 pp. ?114,115–6
(as *Cromer Beach,* he gives smaller
measurements and Sir Hickman Bacon
as the owner); *Burlington* Aug. 1954 repr.
p.265; Rajnai & Allthorpe 1979 p.72.
Private Collection

It has been plausibly suggested that this
painting, one of Cotman's most
impressive in this medium, might be
*Dealers waiting the coming in of the Herring
Boats, Yarmouth,* exhibited by him in
Norwich in 1808 (15). The scene is of
the same kind as Cotman's very first
painting in oil, about which he writes to
Dawson Turner, 15 October 1806, soon
after settling down in Norwich: 'Since I
have been home, I have been so much
engaged with painting, that every thing
else [se]ems to have give place to it. I
have now [fin]ished that I must call my
first picture, the Subject of it Shipping,
Sea Shore, & figures – but I have much
to learn [in] this great field of study to
become tolerably good – for more
[mu]st be done in this branch of Art
than in Water Colors or [no]thing is
done – .' The close similarity of the
white pony – if reversed – to the front
horse in the BM *Horses Drinking* (no. 49),
which can confidently be dated to 1806,
shows Cotman toying with a favourite
motif in more than one composition.
(See also no. 80.) He must have taken
special pride in this painting, apparently
the only oil he ever signed or dated.

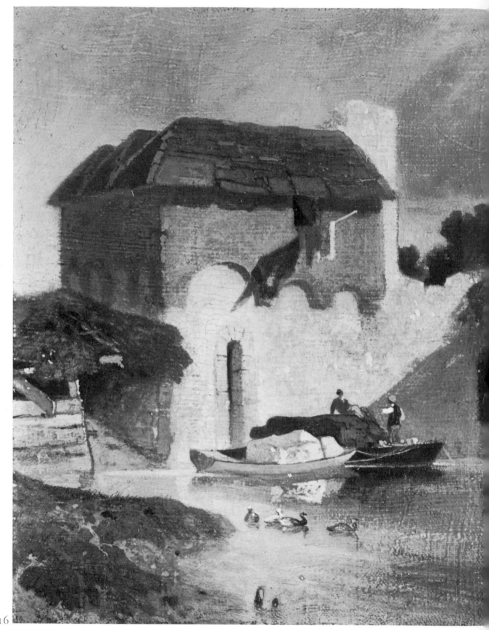

116

**116 Ferry House at Bristol, called
Building on a River** [1808–10]

oil on canvas; 35.9 × 30.8 (14⅛ × 12⅛)

Prov: George Holmes of Norwich;
W. B. Paterson of London by 1904;
presented by NACF 1905.
Exh: Tate 1922 (109); *Country Life* Exh.
London 1937 (366); Agnew 1958 (61).

Ref: Holmes 1904 p.79 repr. p. 78;
Kitson 1937 p.117.
*The Trustees of the National Galleries of
Scotland*

Cotman's first oil painting was
produced in the autumn of 1806 and in
the short period between then and when
he started on his etching projects,

several others followed. On stylistic evidence it is likely that the present painting belongs to this group. He turns back to his early sketches done in the West Country for the subject: a watercolour showing the same house and signed and dated 1802 on the reverse is inscribed *Bristol. Ferry* (see no.9).

117 **On the River Yare** [1808–10]

oil on panel; 42.5 × 33.6 ($16\frac{3}{4} \times 13\frac{1}{8}$)

Prov: with Shepherd's Gallery 1903; Christie's 2 March 1934 lot 18, bt in at 120 gns; Christie's 13 July 1934 lot 128, bt by the Leeds Art Collection Fund 120 gns; presented by them.
Exh: Shepherd's Gallery 1903 (121); Rotterdam 1955 (24); Agnew 1958 (58).
Ref: Annual Report of the Leeds Art Gallery for 1934–35; Kitson 1937 p.116 fig.53; Hendy 1942 p.38 fig.iv; Rienaecker 1953 pl. 30 fig. 59.
Leeds City Art Galleries

Like nos.114–6 and 118–9, this is also an early oil, much admired both by Oppé and Kitson. When the former saw it in the March 1934 sale he wrote to Kitson: '... very good, in the flat-patterned 1806–10 manner. Cost a lot of money. I forget how much. You should have had it!' Kitson considered it 'particularly attractive alike in design and execution'.
 A small preparatory drawing for it was exhibited at Eastwood Lodge, Norwich, in 1974.

118 **Seashore with Boats** [1808–10] (repr. in colour)

oil on millboard; 28.3 × 41 ($11\frac{1}{8} \times 16\frac{1}{8}$)

Prov: William Cooper, whose sister married the artist's second son, John Joseph; Norgate; Edwin Edwards; J. J. Heseltine by 1922; purchased 1935.
Exh: Tate 1922 (34); Agnew 1958 (70).
Ref: Kitson 1937 p.116; Rajnai & Allthorpe 1979 p.72.
The Trustees of the Tate Gallery

117

Possibly Cromer beach, with which Cotman became familiar – if he was not already so – during the period just before his marriage in 1809 to Anne Miles who lived only two miles away at Felbrigg. He exhibited two Cromer subjects in 1808, and one in each of the following two years. The abstract design, the intensity with which the image is stated and the elegance of execution make *Seashore with Boats* one of the outstanding pieces by Cotman in this medium.

119 Duncombe Park [1808–10]

oil on canvas; 40.6 × 28 (16 × 11)

Prov: T. Woolner; purchased from
Walker's Gallery 1921.
Exh: Tate 1922 (92).
Ref: *Connoisseur* Jan. 1923 repr. p.47;
Holcomb 1978 p.12 pl.41.
The Trustees of The Tate Gallery

Kitson cautiously identified this with
one of Cotman's 1824 exhibits, though
curiously not with no.146 *Trees in
Duncombe Park, Yorkshire* but with no. 15
*Trees at Kimberley – Clearing up after a
Storm at Mid-day*. Neither this
identification, nor the dating inherent in
it, seem convincing; characteristics such
as the dense colours and square trees fit
better with the group done in
1806–*c*.1810. However, the *Trees,
Duncombe Park, Yorkshire*, no.72 in the
1811 exhibition, was probably plate 5
for his *Miscellaneous Etchings* rather than
this oil.

120 Drop Gate [1820s]

oil on canvas; 34.9 × 26 (13¾ × 10¼)

Prov: the Revd J. M. Johnson; R. S.
Tait; Frederick Roe by 1896; presented
by Sir William Lancaster 1922.
Exh: RA 1896 (26); Tate 1922 (114);
Norwich 1925 (25)
Ref: Dickes 1905 p.316; PMT 1922 p.248
pl.11, fig C; Kaines Smith 1926 p.91;
Kitson 1937 p.271 fig. 120 as *Landscape,
with a man wading in a stream*; Rienaecker
1953 pl.44 fig. 87.
The Trustees of the Tate Gallery

This oil belongs to a group which – as
Kitson rightly observes – 'represents the
high-water mark of Cotman's individual
vision and technical skill in oil painting'.
Cotman's gift of making us read his
pictures as beautifully arranged flat
patterns – as well as representations –
which is so prominent in his early work,
manifests itself again in a muted form in

119

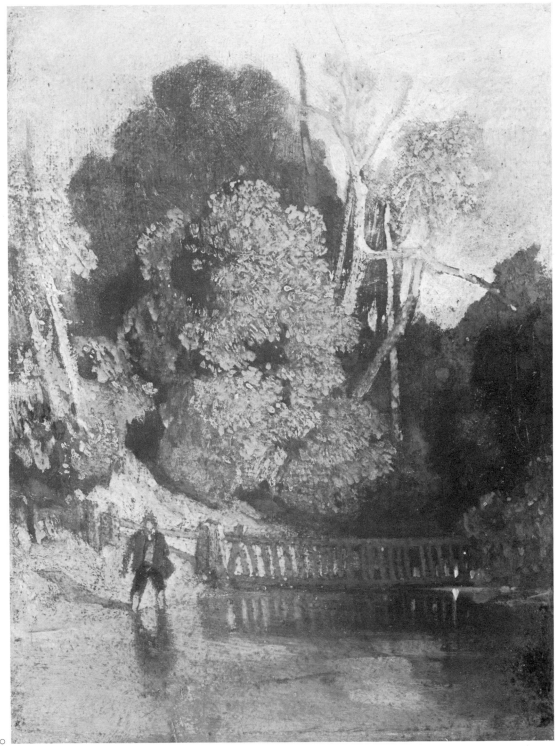

this oil. The watercolour of this
composition in NCM is a copy by
another hand (perhaps J. J. Cotman's).
The same seems to apply to the drawing,
numbered 1240, recorded by a
photograph in the Witt Library.

121 **A wooded landscape** [1830s]

oil on panel; 25.4 × 40.6 (10 × 16)

Exh: O. & P. Johnson, Norwich
School, 1965 (11).
Ref: ILN 8 May 1965 repr.
Private Collection

An oil version of the watercolour *At
Whitlingham*, in the British Museum (see
no. 107). It is one of the many instances
when Cotman gave expression with
equal success in both media to the very
same composition.

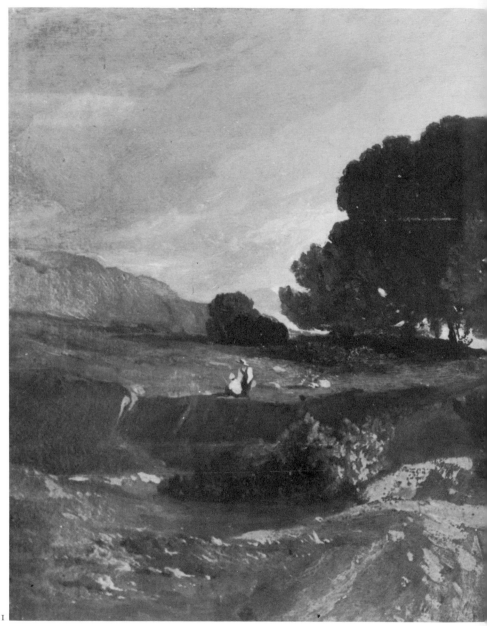

121

154

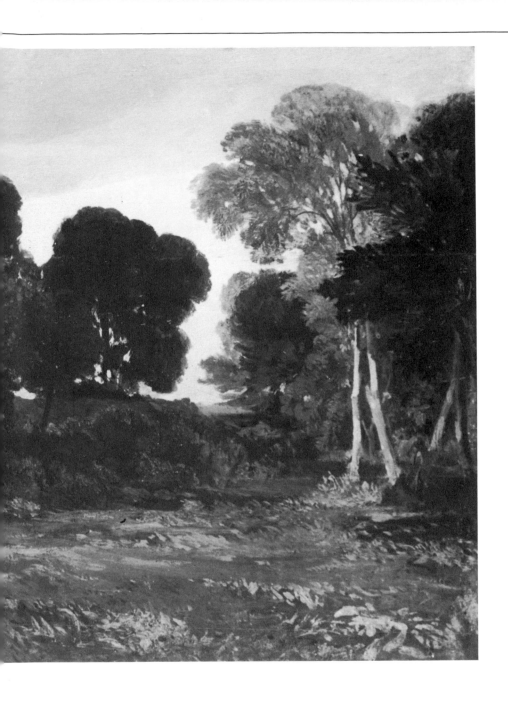

122 West Front of Byland Abbey: Yorks 1811

Etching; plate size 30.5 × 22.6 (12 × 8⅞)
Published Norwich 5 May 1811.

Plate 15 of *Miscellaneous Etchings* 1811 and plate XI of *Fourth Series* of Henry G. Bohn's omnibus edition 1838. (Popham 15)
Dr Michael Pidgley

This, the subject also of four watercolours (see Rajnai & Allthorpe 1975 pp48–9), seems to have been a favourite with Cotman. Byland was one of the sites he visited within the first week of his arrival at Brandsby in July 1803 and he returned to it at least twice more during the same summer, on both occasions in the company of some members of the Cholmeley family. Appropriately, the watercolour which is closest to the etching and is now in the NCM, entered the Cholmeleys' possession at one point (in fact – strange as it is – this is the only major work by Cotman which can be traced to this family, otherwise so important in his life). Kitson might be right in suggesting that it was perhaps a wedding present from Cotman to Francis Cholmeley, both of whom married in 1809, the approximate date of the watercolour.

123 The North West Tower, Yarmouth 1812

Etching; plate size 36.9 × 25.7 (14½ × 10⅛)
Signed and dated l.r. *Cotman f 181 2* [sic]

Plate 3 (but not numbered so) of *Architectural Antiquities of Norfolk* 1818, and plate XLVIII of *First Series* of Henry G. Bohn's omnibus edition, 1838. (Popham 132)
Dr Michael Pidgley

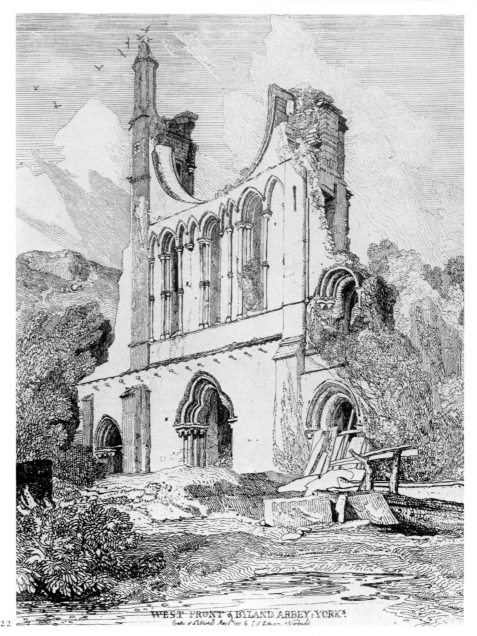

122
WEST FRONT of BYLAND ABBEY: YORKS
Etched & Published May 5th 1811 by J S Cotman, Norwich

Cotman's *Miscellaneous Etchings* of twenty-six plates published during 1810–11 were not yet finished when he embarked upon collecting material towards the sixty plates of his *Architectural Antiquities of Norfolk*, which was to be published in batches of six plates at quarterly intervals but which was in fact not completed until 1817. See no. 83 for the drawing on which Cotman based this etching. Its large reserved places are obviously influenced by his watercolour technique and the warm human element may well stem from personal experience in the circle of his own young family.

156

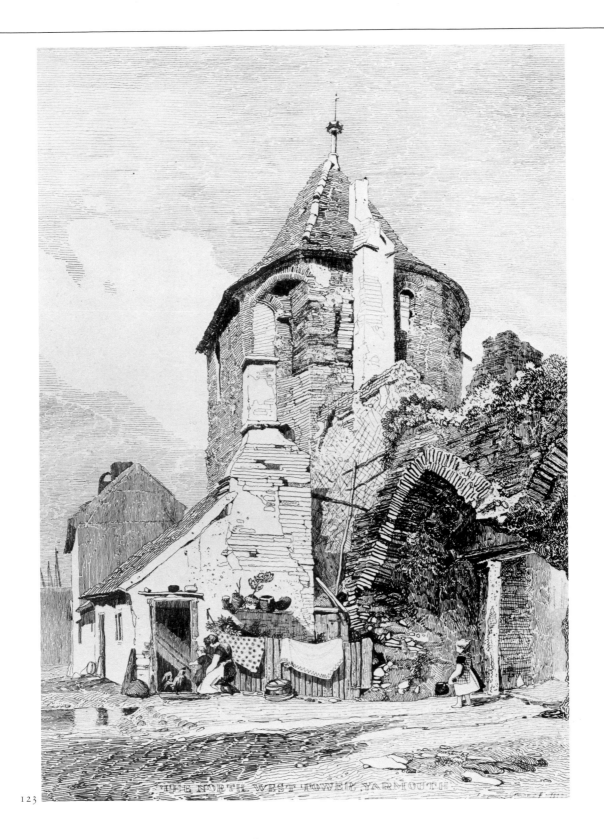

THE NORTH WEST TOWER YARMOUTH.

123

124

124 **Castle Rising Castle 1813**

etching; plate size 27.5 × 38 ($10\frac{13}{16}$ × 15) Dated l.l. *Yarmouth 1813* and dedicated to Richard Howard, the 'Proprietor of these noble remains'.

Plate xxv of *Architectural Antiquities of Norfolk* and plate xLv of *First Series* of Henry G. Bohn's omnibus edition, 1838. (Popham 155)
Dr Michael Pidgley

This is Cotman's most Piranesian etching based on a pencil drawing discussed in the entry for no.84. He was much impressed by the great Italian, and in his correspondence of 1811 and 1812 repeatedly refers to him, invariably in glowing terms. 'I decidedly follow Piranesi', Cotman writes on 10 February 1811, 'however far I may be behind him in every requisite' – and solicits Dawson Turner's help in trying to borrow a set from Hudson Gurney so that he 'can glean something from that vast mass of excellence'.

125 **Castle of Falaise, North View 1821**

Etching; plate size 28.1 × 38.2 ($11\frac{1}{16}$ × $15\frac{1}{16}$)
Published 1 October 1821.

Plate 90 in *Architectural Antiquities of Normandy* 1822. (Popham 287)
Dr Michael Pidgley

Cotman visited Falaise, the reputed birthplace of William the Conqueror, twice: on 6 September 1818, when he found it 'all haze, rain, smoke & dirt, like Leeds for blackness', and again in 1820, in much more favourable circumstances. This time it was 'grey-green with all the vigor of Spring', with groups of colourful figures, giving him a 'joyous' feeling. He seems to have sketched the present view at the time of the first visit, as the Whitworth Gallery's drawing, on which it is based, bears the date 'Sept. 16 1818' (the '16' is apparently a mistake, it should be '6').

125

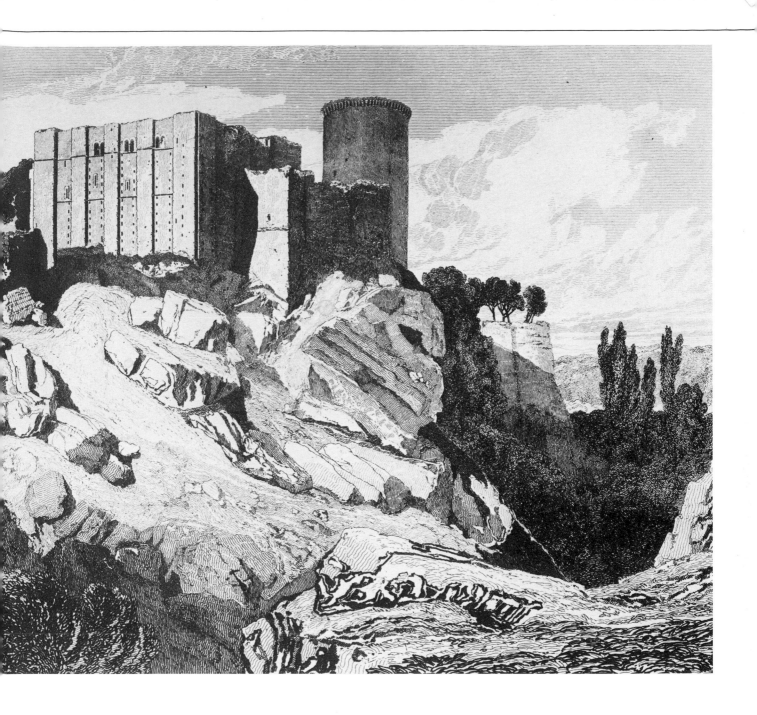

126

Millbank on the Thames

126 **Millbank on the Thames** [1810–21]

softground etching; plate size
16.4 × 25.4 ($6\frac{7}{16}$ × 10)
Signed l.c. *J S Cotman*. Inscribed with
title.

Plate 8 (Popham 303) of *Liber Studiorum*
published by Henry G. Bohn as an
independent volume as well as the final
part – the fifth series of etchings – of his

ambitious edition of Cotman's etched
work of English subjects, *Specimens of
Architectural Remains . . . 1838.*
Dr Michael Pidgley

It is supposed that the *Liber Studiorum*
was fashioned on Turner's work
similarly named, but it is more likely
that the title was the publisher's
invention for a group of etchings which

did not fit the architectural–topographical
categories in which the others could
easily be organised. It certainly contains
some of Cotman's best prints, in the –
for him, very happy – medium of
softground etching, which he mastered
as well as anybody, including Crome,
and which was the most sympathetic
technique to reproduce and multiply his
fine drawings in chalk.

Norwich Castle Museum: the Colman Bequest

The following pages contain a selection of the most important Cotman paintings from the Colman Bequest at the Norwich Castle Museum, one of the largest single collections of his works. They could not be lent for the Arts Council touring exhibition and so were not included in the catalogue. They are reproduced here, in colour, by courtesy of Norfolk Museums Service (Norwich Castle Museum) and are arranged chronologically.

Exhibitions

(in additions to those listed on p.31–5)

Norwich AU 1839. The First Exhibition of the Norfolk and Norwich Art Union, at their gallery, St Andrew's, Broad Street.
Norwich 1902. Norwich, St Andrew's Hall, *Art Loan Exhibition in Aid of the Funds of St George's Club for Working Girls.*
RSBA 1927. London, Suffolk Street, Royal Society of British Artists.
Olympia 1928. London, Olympia, *Daily Telegraph Exhibition of Antiques and Works of Art.*
Tokyo 1929. Tokyo, Teikoku Bijutsu, *European Painting.*
Norwich 1945. Norwich, Castle Museum, R.J. Colman lent 13 oils and 84 watercolours by John Sell Cotman prior to his bequest in 1946.
Arts Council, Norwich 1947. Norwich, Castle Museum, *Loan Exhibition of Water Colours by John Sell Cotman from the Colman Collection.*

References

(in addition to those listed on p.35–7)

Alston 1922. A.E. Alston, *J.S. Cotman's 'Abbatial House'* (information sheet) 1922.
Art Union, October 1939.
Batchelor 1922. Arthur Batchelor, 'J.S. Cotman Exhibition at the Tate', *Eastern Daily Press*, 30 August 1922.
Binyon 1942. Laurence Binyon, 'The Art of John Sell Cotman', *Burlington Magazine*, Cotman Number, July 1942.
Collins Baker & James 1933. Collins Baker and Montague R. James, *British Painting*, Medici Society, 1933.
Cundall 1936. H.M. Cundall, 'Cotman Collection at Crown Point, Experiment in Water Colour Conservation,' *Eastern Daily Press*, 18 September 1936.
EDP 1922. 'Local Exhibits at the Tate Gallery',

Eastern Daily Press, 13 April 1922.
EDP 1936. L.H.F., 'Cotman Collection at Crown Point, Experiment in Water Colour Conservation, An Historic Occasion',*Eastern Daily Press*, 18 September 1936.
EEN 1945. 'The Crown Point Cotmans', *Eastern Evening News*, 28 June 1945.
Fell 1936. Granville Fell, 'The John Sell Cotman Watercolours at Crown Point. Mr Russell J. Colman's Collection', *The Connoisseur*, November 1936.
Guide 1951. *Guide to Norwich Castle Museum*, Norfolk Museums Service 1951.
Guide (Colman) 1951. Norwich Castle Museum, *The Colman Collection of Norwich School Pictures*, Illustrated Guide 1951.
Hawcroft 1956. Francis Hawcroft, '19th century artists working abroad', *Country Life*, 15 November 1956.
K. North 1936. S. Kennedy North, *Report on the Treatment of watercolour drawings by John Sell Cotman and John Crome in the Colman Collection, Norwich, carried out between September 1934 and August 1936*, accompanied with photographs, October 1936. Privately printed for R.J. Colman.
Ketton-Cremer 1962. R.W. Ketton-Cremer, *Felbrigg*, Rupert Hart-Davis, London 1962.
Kitson 1936. Sydney D. Kitson, 'The Colman Collection of Works by the Norwich Painters', *Country Life*, 7 November 1936.
Kitson 1942. Sydney D. Kitson, 'The Norwich School of Painting, with special reference to the work of John Sell Cotman', *The Colman Collection Catalogue*, privately printed for R.J. Colman, Oxford University Press, 1942.
NC 1839. *Norfolk Chronicle*, 12 October 1839.
NM 1825. (OWCS Exhibition) *Norwich Mercury*, 30 April 1825.
NM 1888. 'Cotman's Watercolours at the Burlington Fine Arts Club', *Norwich Mercury*, 21 November 1888.
NM 1903. Norwich Castle Museum, 'Extensions of the Picture Gallery, Turner and Cotman', *Norwich Mercury*, 8 April 1903.
Oppé 1945. A.P. Oppé, 'The Colman Exhibition of Cotman at Norwich', *Burlington Magazine*, August 1945.
Oppé Burlington 1942. A.P. Oppé, 'Cotman and his Public', *Burlington Magazine*, Cotman Number, July 1942.
Rajnai 1978. Miklos Rajnai, *The Norwich School of Painters*, Norwich, Jarrold Art Series, 1978.
Stephenson 1951. Andrew Stephenson, 'The Colman Galleries', *The St Albans Ambassador*, August 1951.
Tate Cat. 1922. The Tate Gallery 1922 Exhibition Catalogue.
Times 1888. Art Exhibition (BFAC), *The Times*, 19 November 1888.
Warner 1951. Oliver Warner, 'On Cotman', *Apollo*, July 1951.
Wedmore NM 1888. Frederick Wedmore, 'Cotman Drawings at Norwich', *Norwich Mercury*, 4 August 1888.

127 The Mars, riding at Anchor off Cromer [1807]

pencil and watercolour, with birds scraped out, on laid paper; 30.8 × 22 (12 1/8 × 8 5/8)
Signed l.r. *J S Cotman*

Prov: bt from the Palser Gallery by Percy Moore Turner 1926; bt from him by R.J. Colman 1926; R.J. Colman Bequest 1946.
Exh: ?NSA 1808 (193); Tokyo 1929 (?); Norwich 1945 (no cat.); Arts Council, Norwich 1947 (8).
Ref: K. North 1936 p.19 no.18; Kitson 1937 pp.111,112,127,179 fig.48; Kitson 1942 p.xxvii; Stephenson 1951 p.12; Clifford 1965 pl.32a; Ketton-Cremer 1962 p.223; Rajnai & Allthorpe 1979 no.61 pl.40.

The Mars, not a whaling ship as Kitson thought, but a warship of seventy-four guns, was under the command of William Lukin of Felbrigg, brother of John who married Cotman and Ann Miles in 1809. It is recorded that 'on 31 July 1807, in squally weather, she anchored within sight of Cromer'. Cotman apparently altered the ship's position in relation to the shore: 'no ship of the line could conceivably have anchored so close inshore, and it is evident from the log that her position that night was some way east of Cromer', comments Ketton-Cremer. The towering cloud provides this dramatic composition with one of Cotman's most impressive skies.

128 Interior of Trentham Church, Staffordshire [1808]

pencil and watercolour on laid paper; 54.5 × 41 (21 7/16 × 16 1/8)
Signed l.l. *J.S.Cotman*

Prov: purchased from the Palser Gallery by the Revd G.W. Minns; bt from him by James Reeve 1890; bt from him by H.S. Theobald ?after 1903; bt from him by R.J. Colman 1910; R.J. Colman Bequest 1946.
Exh: RA 1892 (47); Norwich 1902 (220); Norwich 1903 (16); Whitworth 1912

(326); Tate 1922 (60); Norwich 1945 (no cat.); Arts Council, Norwich 1947 (4).
Ref: Binyon 1897 repr. p.63; Binyon 1903 p.x repr. in colour; Dickes 1905 p.270 repr.; Batchelor 1922; Cundall 1922 p.71 repr.; Cundall 1936; Kitson 1936 pl.2; K. North 1936 p.17 no.12; Kitson 1937 pp.97,98; Kitson 1942 p.xxxi; Warner 1951 p.28 fig.11; Stephenson 1951 p.12; Rienaecker 1953 pl.20 fig.35; Rajnai & Allthorpe 1979 no.67 pl.44.

Cotman visited Trentham (near Stoke-on-Trent), the seat of George, 2nd Marquess of Stafford (later 1st Duke of Sutherland), one of the great English collectors, in the summer of 1806. His invitation there was presumably engineered by the Marquess's sister, Lady Carlisle, whom Cotman met at Castle Howard, only a few miles from Brandsby. Although Cotman had great expectations of this visit, they were not fulfilled. The only recorded benefit to him was the purchase of a watercolour (*Croyland Abbey*, unidentified). So Mrs Cholmeley's words in her letter to Cotman on 14 July 1806 were particularly apt: 'Not but that I think & hope you may find yr. very pleasing invitation to Trentham not only agreeable but beneficial to you. How much so, time alone can prove for God knows, experience every day shows us how uncertain is Protection of any kind, and the Patronage of ye rich and powerful is very rarely so advantageous as it ought to be . . .'
 This large watercolour fits in well with the interior views of Norwich Cathedral done at about the same time (see nos.63–6 and 73). The impressive Jacobean chancel screen and the Moorish saddle cloth presented by the Emperor of Morocco to George III, and in turn by the King to the 1st Marquess of Stafford, obviously delighted Cotman who made them the focal features of the finely ordered clutter of the church interior.

129 Fish Swills, Rud

pencil and waterco
18.3 × 26.5 (7 3/16 × 1
Signed and dated 1

Prov: bt from the P
Percy Moore Turn
seven other Cotma
R.J. Colman 1926;
1946.
Exh: ?NSA 1809 (16
(no cat.).
Ref: K. North 1936
1937 p.196; Kitson
1945 p.196 as *Gear*
& Allthorpe 1979

Still lifes are rare in Cotman's career. Th
preparatory drawin
with colour notes w
watercolour faithfu
for the rudder, whic
grey. 'The still life g
bundles of cloth, bu
little dog – has been
landscape setting, th
the lighter sky servi
the brilliant patch w
front.' (Rajnai & Al
 Oppé regarded th
coarse 'in brushwor
the apparent 'coarse
choice of a paper wit
was a deliberate atte
extend the scope of

130 Byland Abbey, Yo

pencil and watercol
arabic on wove pap
(20 1/2 × 17 1/8)

Prov: ?Francis Chol
Hugh C. Fairfax Chol
Agnew by S. Kenned
R.J.Colman 1938; R.J
Exh: W.B. Paterson
Tate 1922 (210); Agn
Norwich 1945 (no ca
Norwich 1947 (37)-
Ref: Oppé 1923 p.xi
Kitson 1937 pp.122,
p.196; Lemaître 1955
& Allthorpe 1979 n

Norwich Castle Museum: the Colman Bequest

The following pages contain a selection of the most important Cotman paintings from the Colman Bequest at the Norwich Castle Museum, one of the largest single collections of his works. They could not be lent for the Arts Council touring exhibition and so were not included in the catalogue. They are reproduced here, in colour, by courtesy of Norfolk Museums Service (Norwich Castle Museum) and are arranged chronologically.

Exhibitions

(in additions to those listed on p.31–5)

Norwich AU 1839. The First Exhibition of the Norfolk and Norwich Art Union, at their gallery, St Andrew's, Broad Street.
Norwich 1902. Norwich, St Andrew's Hall, *Art Loan Exhibition in Aid of the Funds of St George's Club for Working Girls.*
RSBA 1927. London, Suffolk Street, Royal Society of British Artists.
Olympia 1928. London, Olympia, *Daily Telegraph Exhibition of Antiques and Works of Art.*
Tokyo 1929. Tokyo, Teikoku Bijutsu, *European Painting.*
Norwich 1945. Norwich, Castle Museum, R.J. Colman lent 13 oils and 84 watercolours by John Sell Cotman prior to his bequest in 1946.
Arts Council, Norwich 1947. Norwich, Castle Museum, *Loan Exhibition of Water Colours by John Sell Cotman from the Colman Collection.*

References

(in addition to those listed on p.35–7)

Alston 1922. A.E. Alston, *J.S. Cotman's 'Abbatial House'* (information sheet) 1922.
Art Union, October 1939.
Batchelor 1922. Arthur Batchelor, 'J.S. Cotman Exhibition at the Tate', *Eastern Daily Press,* 30 August 1922.
Binyon 1942. Laurence Binyon, 'The Art of John Sell Cotman', *Burlington Magazine,* Cotman Number, July 1942.
Collins Baker & James 1933. Collins Baker and Montague R. James, *British Painting,* Medici Society, 1933.
Cundall 1936. H.M. Cundall, 'Cotman Collection at Crown Point, Experiment in Water Colour Conservation,' *Eastern Daily Press,* 18 September 1936.
EDP 1922. 'Local Exhibits at the Tate Gallery', *Eastern Daily Press,* 13 April 1922.
EDP 1936. L.H.F., 'Cotman Collection at Crown Point, Experiment in Water Colour Conservation, An Historic Occasion', *Eastern Daily Press,* 18 September 1936.
EEN 1945. 'The Crown Point Cotmans', *Eastern Evening News,* 28 June 1945.
Fell 1936. Granville Fell, 'The John Sell Cotman Watercolours at Crown Point. Mr Russell J. Colman's Collection', *The Connoisseur,* November 1936.
Guide 1951. *Guide to Norwich Castle Museum,* Norfolk Museums Service 1951.
Guide (Colman) 1951. Norwich Castle Museum, *The Colman Collection of Norwich School Pictures,* Illustrated Guide 1951.
Hawcroft 1956. Francis Hawcroft, '19th century artists working abroad', *Country Life,* 15 November 1956.
K. North 1936. S. Kennedy North, *Report on the Treatment of watercolour drawings by John Sell Cotman and John Crome in the Colman Collection, Norwich, carried out between September 1934 and August 1936,* accompanied with photographs, October 1936. Privately printed for R.J. Colman.
Ketton-Cremer 1962. R.W. Ketton-Cremer, *Felbrigg,* Rupert Hart-Davis, London 1962.
Kitson 1936. Sydney D. Kitson, 'The Colman Collection of Works by the Norwich Painters', *Country Life,* 7 November 1936.
Kitson 1942. Sydney D. Kitson, 'The Norwich School of Painting, with special reference to the work of John Sell Cotman', *The Colman Collection Catalogue,* privately printed for R.J. Colman, Oxford University Press, 1942.
NC 1839. *Norfolk Chronicle,* 12 October 1839.
NM 1825. (OWCS Exhibition) *Norwich Mercury,* 30 April 1825.
NM 1888. 'Cotman's Watercolours at the Burlington Fine Arts Club', *Norwich Mercury,* 21 November 1888.
NM 1903. Norwich Castle Museum, 'Extensions of the Picture Gallery, Turner and Cotman', *Norwich Mercury,* 8 April 1903.
Oppé 1945. A.P. Oppé, 'The Colman Exhibition of Cotman at Norwich', *Burlington Magazine,* August 1945.
Oppé Burlington 1942. A.P. Oppé, 'Cotman and his Public', *Burlington Magazine,* Cotman Number, July 1942.
Rajnai 1978. Miklos Rajnai, *The Norwich School of Painters,* Norwich, Jarrold Art Series, 1978.
Stephenson 1951. Andrew Stephenson, 'The Colman Galleries', *The St Albans Ambassador,* August 1951.
Tate Cat. 1922. The Tate Gallery 1922 Exhibition Catalogue.
Times 1888. Art Exhibition (BFAC), *The Times,* 19 November 1888.
Warner 1951. Oliver Warner, 'On Cotman', *Apollo,* July 1951.
Wedmore NM 1888. Frederick Wedmore, 'Cotman Drawings at Norwich', *Norwich Mercury,* 4 August 1888.

127 The Mars, riding at Anchor off Cromer [1807]

pencil and watercolour, with birds scraped out, on laid paper; 30.8 × 22 (12⅛ × 8⅝)
Signed l.r. *J S Cotman*

Prov: bt from the Palser Gallery by Percy Moore Turner 1926; bt from him by R.J. Colman 1926; R.J. Colman Bequest 1946.
Exh: ?NSA 1808 (193); Tokyo 1929 (?); Norwich 1945 (no cat.); Arts Council, Norwich 1947 (8).
Ref: K. North 1936 p.19 no.18; Kitson 1937 pp.111,112,127,179 fig.48; Kitson 1942 p.xxvii; Stephenson 1951 p.12; Clifford 1965 pl.32a; Ketton-Cremer 1962 p.223; Rajnai & Allthorpe 1979 no.61 pl.40.

The Mars, not a whaling ship as Kitson thought, but a warship of seventy-four guns, was under the command of William Lukin of Felbrigg, brother of John who married Cotman and Ann Miles in 1809. It is recorded that 'on 31 July 1807, in squally weather, she anchored within sight of Cromer'. Cotman apparently altered the ship's position in relation to the shore: 'no ship of the line could conceivably have anchored so close inshore, and it is evident from the log that her position that night was some way east of Cromer', comments Ketton-Cremer. The towering cloud provides this dramatic composition with one of Cotman's most impressive skies.

128 Interior of Trentham Church, Staffordshire [1808]

pencil and watercolour on laid paper; 54.5 × 41 (21⁷⁄₁₆ × 16⅛)
Signed l.l. *J.S.Cotman*

Prov: purchased from the Palser Gallery by the Revd G.W. Minns; bt from him by James Reeve 1890; bt from him by H.S. Theobald ?after 1903; bt from him by R.J. Colman 1910; R.J. Colman Bequest 1946.
Exh: RA 1892 (47); Norwich 1902 (220); Norwich 1903 (16); Whitworth 1912 (326); Tate 1922 (60); Norwich 1945 (no cat.); Arts Council, Norwich 1947 (4).
Ref: Binyon 1897 repr. p.63; Binyon 1903 p.x repr. in colour; Dickes 1905 p.270 repr.; Batchelor 1922; Cundall 1922 p.71 repr.; Cundall 1936; Kitson 1936 pl.2; K. North 1936 p.17 no.12; Kitson 1937 pp.97,98; Kitson 1942 p.xxxi; Warner 1951 p.28 fig.11; Stephenson 1951 p.12; Rienaecker 1953 pl.20 fig.35; Rajnai & Allthorpe 1979 no.67 pl.44.

Cotman visited Trentham (near Stoke-on-Trent), the seat of George, 2nd Marquess of Stafford (later 1st Duke of Sutherland), one of the great English collectors, in the summer of 1806. His invitation there was presumably engineered by the Marquess's sister, Lady Carlisle, whom Cotman met at Castle Howard, only a few miles from Brandsby. Although Cotman had great expectations of this visit, they were not fulfilled. The only recorded benefit to him was the purchase of a watercolour (*Croyland Abbey*, unidentified). So Mrs Cholmeley's words in her letter to Cotman on 14 July 1806 were particularly apt: 'Not but that I think & hope you may find yr. very pleasing invitation to Trentham not only agreeable but beneficial to you. How much so, time alone can prove for God knows, experience every day shows us how uncertain is Protection of any kind, and the Patronage of ye rich and powerful is very rarely so advantageous as it ought to be . . .'

This large watercolour fits in well with the interior views of Norwich Cathedral done at about the same time (see nos.63–6 and 73). The impressive Jacobean chancel screen and the Moorish saddle cloth presented by the Emperor of Morocco to George III, and in turn by the King to the 1st Marquess of Stafford, obviously delighted Cotman who made them the focal features of the finely ordered clutter of the church interior.

129 Fish Swills, Rudder, etc. 1809

pencil and watercolour on wove paper; 18.3 × 26.5 (7³⁄₁₆ × 10⁷⁄₁₆)
Signed and dated l.r. *J S Cotman/09*

Prov: bt from the Palser Gallery by Percy Moore Turner; bt from him, with seven other Cotman watercolours, by R.J. Colman 1926; R.J. Colman Bequest 1946.
Exh: ?NSA 1809 (169); Norwich 1945 (no cat.).
Ref: K. North 1936 p.20 no.30; Kitson 1937 p.196; Kitson 1942 p.xxvii; Oppé 1945 p.196 as *Gear of Fishing Boat*; Rajnai & Allthorpe 1979 no.82 pl.52.

Still lifes are rare in the first decade of Cotman's career. This one has a preparatory drawing in pencil inscribed with colour notes which the watercolour faithfully follows except for the rudder, which is pink instead of grey. 'The still life group – baskets, bundles of cloth, bucket and an odd little dog – has been placed in a token landscape setting, the dark blue hill and the lighter sky serving as a backdrop for the brilliant patchwork of shapes in front.' (Rajnai & Allthorpe).

Oppé regarded this watercolour as coarse 'in brushwork and handling', but the apparent 'coarseness', as well as the choice of a paper with canvas-like texture, was a deliberate attempt by Cotman to extend the scope of his medium.

130 Byland Abbey, Yorkshire [1809]

pencil and watercolour with some gum arabic on wove paper; 52.1 × 43.5 (20½ × 17⅛)

Prov: ?Francis Cholmeley; by descent to Hugh C. Fairfax Cholmeley by 1922; bt from Agnew by S. Kennedy North on behalf of R.J. Colman 1938; R.J. Colman Bequest 1946.
Exh: W.B. Paterson's Gallery 1913 (13); Tate 1922 (210); Agnew 1938 (117); Norwich 1945 (no cat.); Arts Council, Norwich 1947 (37).
Ref: Oppé 1923 p.xi; Kitson 1930 p.10; Kitson 1937 pp.122,123,144; Oppé 1945 p.196; Lemaître 1955 p.271 n.1; Rajnai & Allthorpe 1979 no.85 pl.55.

The Mars, riding at Anchor off Cromer [1807] (no. 127)

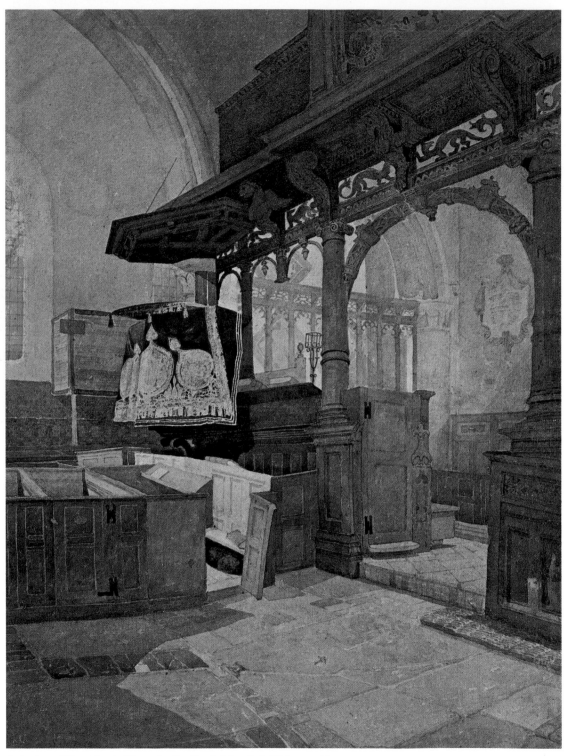

Interior of Trentham Church, Staffordshire [1808] (no. 128)

Fish Swills, Rudder, etc. 1809 (no. 129)

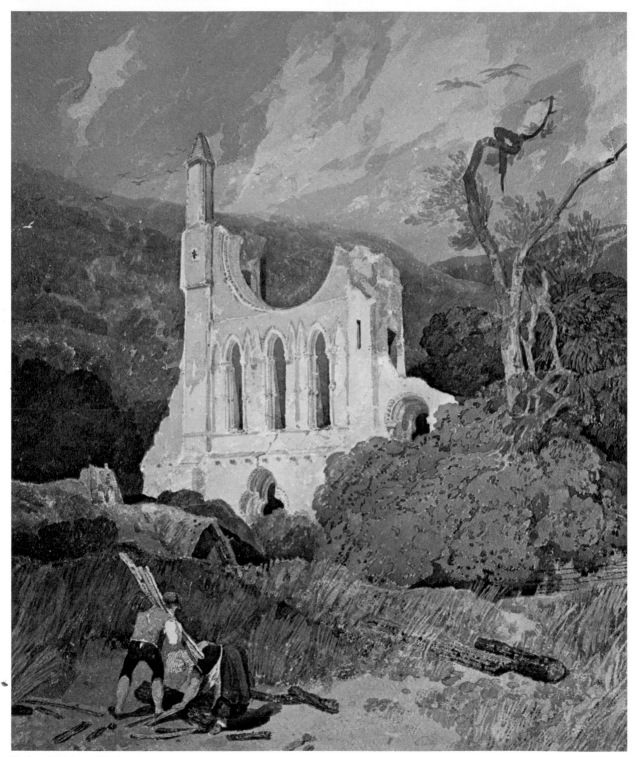

Byland Abbey, Yorkshire [1809] (no. 130)

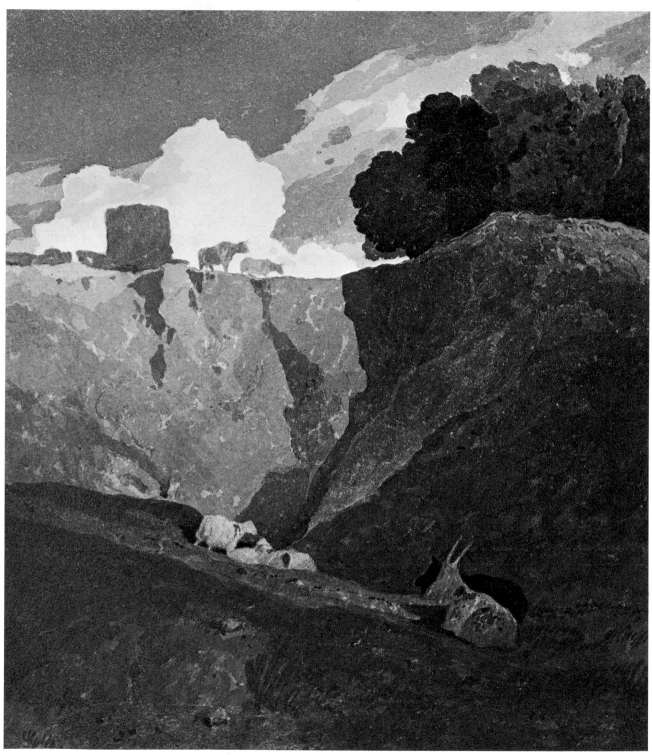

The Marl Pit [1809–10] (no. 131)

Yarmouth Beach [mid 1810s]
(no. 132)

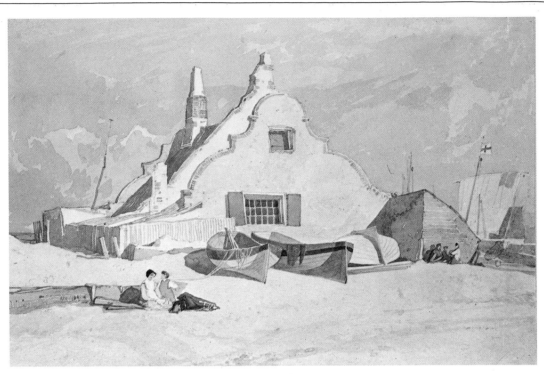

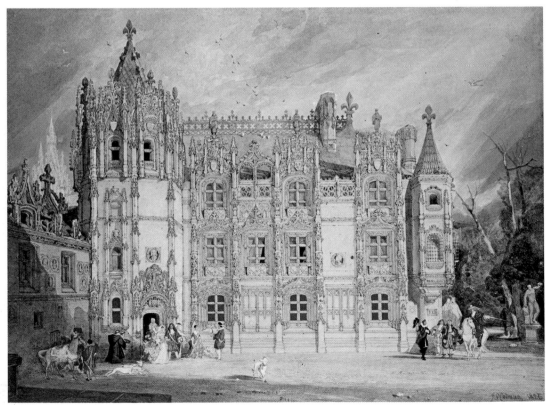

**Abbatial House
of the Abbey of St Ouen
at Rouen 1825**
(no. 133)

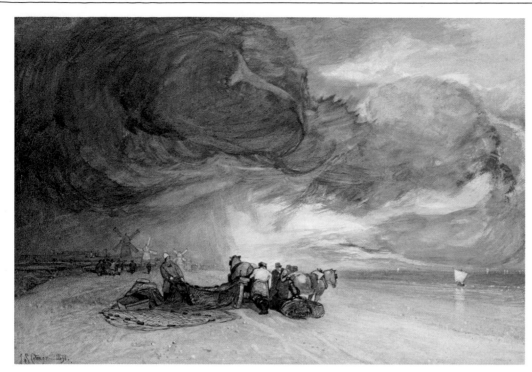

Storm on Yarmouth Beach 1831
(no. 134)

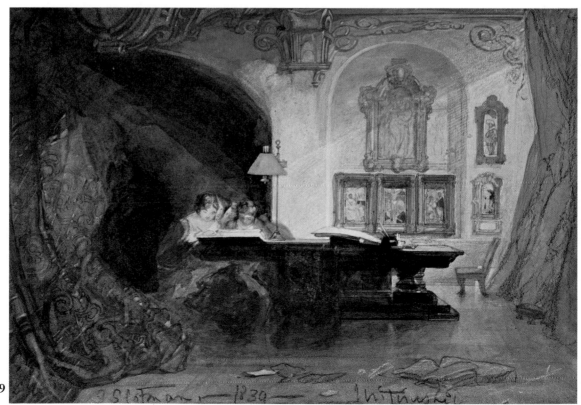

The Green Lamp 1839
(no. 135)

Silver Birches [1820s] (no. 136)

See no.122 for Cotman's visits to Byland and the Cholmeley connection with this watercolour, which is the latest of the four Cotman devoted to this subject. With its robust monumentality it stands out as one of his greatest achievements. Oppé called it 'the most sensational and overpowering of all Cotman's known work' and drew attention to the motif of the flying birds above the dead tree with curiously jagged outlines, which he took as indisputable proof of Oriental influence. As it happens, Cotman did own a collection of Chinese drawings, so his awareness of and interest in the art of the Far East is documented. However, in this particular instance it might be equally, if not more, appropriate to point to Salvator Rosa as a possible influence.

131 The Marl Pit [1809–10]

pencil and watercolour with some gum arabic on wove paper; 29.5 × 25.8 (11⅝ × 10⅛)

Prov: bt from the Palser Gallery by Percy Moore Turner 1926; bt from him by R.J. Colman 1926; R.J. Colman Bequest 1946.
Exh: Brussels 1929 (40); Norwich 1945 (no cat.); Arts Council, Norwich 1947 (15).
Ref: Kitson 1930 pl.1. in colour; Fell 1936 repr. p.263; K. North 1936 p.21 no.33; Kitson 1937 p.122; Kitson 1942 p.xxvii; EEN 1945; Guide 1951 p.8; Guide (Colman) 1951 p.6 pl.10; Lemaître 1955 p.280; Clifford 1965 pp.33,69 pl.326; Hardie vol.II 1967 p.84; Rajnai & Allthorpe 1979 no.101 pl.67 repr. in colour on cover.

The scene is unidentified. The most likely location is Whitlingham on the south bank of the River Yare, just outside Norwich to the south-east. There were several gravel and marl pits there, and the region, with its landmark of a ruined church on an eminence silhouetted against the sky, provided subjects for many of the Norwich School artists. However, the location is of little consequence here. 'This

composition, an unusually fat upright shape, is such a powerful interplay of diagonal planes, of flat areas of intensive colour and of light and shade with transitions of reflected light, that the physical reality of the motifs becomes of secondary importance.' (Rajnai & Allthorpe.) The two goats in the foreground are based on a pencil sketch at Leeds and they also occur in a drawing of Moreton Hall of c.1808.

132 Yarmouth Beach [mid 1810s]

pencil and watercolour on wove paper; 21.6 × 32.6 (8½ × 12¹³⁄₁₆)

Prov: William Cooper; bt from him by J.J. Colman; by descent to R.J. Colman 1898; R.J. Colman Bequest 1946.
Exh: Norwich 1903 (23); ?Whitworth 1912 (333).
Ref: K. North 1936 p.20 no.29.

Apart from pencil sketches intended to be etched, and monochromes for the engravers of Excursions in Norfolk and for his Normandy project, both often dated, there are few works by Cotman that can be firmly placed in his Yarmouth period. The subject and the pale colours of Yarmouth Beach suggest a tentative dating to those years. It has no drawing copy number, but a version, possibly a pencil drawing, must have served as such, since one of the drawings by S.C. Edwards, Cotman's pupil at King's College, is of this subject and is inscribed '3rd Drawing with Mr. Cotman March 2nd 1835'. The pencil drawing from the Bulwer Collection, no.51 in the Walker's Gallery Cotman Exhibition of 1926, called Old Gabled House on the South Dunes, Yarmouth, appears to be of this subject.

133 Abbatial House of the Abbey of St Ouen at Rouen 1825

pencil, pen and brown ink, watercolour and bodycolour with scraping out on wove paper; 42.3 × 57.3 (16⅝ × 22⁹⁄₁₆)
Signed and dated l.r. J S Cotman 1825 (the last digit is uncertain)

Prov: ?J. Webster 1825; T. Humphrey Ward; bt from him by J.J. Colman by 1888; his bequest to R.J. Colman 1898; R.J. Colman Bequest 1946.
Exh: ?OWCS 1825 (105); NAC 1888 (164); BFAC 1888 (61); RA 1892 (102); Norwich 1903 (53); Whitworth 1912 (330); Tate 1922 (144); Arts Council, Norwich 1947 (21).
Ref: ?NM 1825; Wedmore NM 1888; Times 1888; NM 1888; Wedmore 1888 repr. p.399; Binyon 1897 p.78; Dickes 1905 p.339 repr.; NM 1903; Tate Cat. 1922 p.5; EDP 1922; Alston 1922; K. North 1936 p.25 no.73; EDP 1936; Kitson 1937 p.257 fig. 131; Oppé, Burlington 1942 p.169; Guide (Colman) 1951 p.6; Rienaecker 1953 pl.41 figs.80&81; Hawcroft 1956 p.1123 (reference to the subject); Clifford 1965 p.56 pl.36a; Pidgley 1975 p.64 n.220, pp.73–4; Rajnai & Allthorpe 1975 no.36 pl.1.

Cotman visited Rouen twice, in 1817 and in 1818, spending a short fortnight there on each occasion. However, he never saw the Abbatial House, which nonetheless seems to be the one he calls 'the best subject I ever touched upon' The house 'was sold by the State on January 4th, 1816; the materials were to be removed by the purchasers before the following September, and the occupiers were to quit before the 1st of March. The walls were so strong that it was found necessary for their speedy demolition to excavate the foundations and disintegrate the lower courses by fire. (Bulletin de la Commission des Antiquités de la Seine Inférieure, t.xi, p.389 &c.). Part of the site is now covered by municipal offices, and the rest forms part of the open "Place de l'Hotel de Ville"'. (Alston.) Cotman must have based his drawing on the engraving of the house in J.F. Pommeraye's Histoire de l'Abbaye de St Ouen 1662, a copy of which was in the library of Dawson Turner, Cotman's patron.

Cotman painted the subject three more times (in reverse) and the rather involved and hopelessly entangled story of the versions is related in Rajnai &

Allthorpe 1975. While his 1824 version was much praised by the Norwich critic, his 1831 exhibit at the Old Water-Colour Society was slated by one reviewer as 'the greatest outrage taste has suffered for some time, and that is saying a bold thing'. So even his deliberate attempt to join the mainstream of artistic fashion, of painting in highly pitched colours, failed to bring critical acclaim.

134 Storm on Yarmouth Beach 1831

watercolour, pen and ink with some scraping out on wove paper; 36.6 × 53.6 (14 $\frac{7}{16}$ × 21 $\frac{1}{8}$)
Signed and dated l.l. *J S Cotman 1831*

Prov: George Holmes; his sale, Christie's 27 April 1903 lot 1, bt Boswell & Son Ltd on behalf of R.J. Colman 245 gns; R.J. Colman Bequest 1946.
Exh: Norwich BMA 1874 (152); NAC 1888 (167) repr.; Norwich 1894 (70); Norwich 1902 (222); Whitworth 1912 (334); Tate 1922 (132); Norwich, Arts Council 1947 (29).
Ref: Binyon 1903 pl.C30; Dickes 1905 pp.372,388 repr.opp.p.372; K. North 1936 p.28 no.95; Kitson 1937 pp.296,301 fig.127; Kitson 1942 p.xxxii; Williams 1952 p.165; Lemaître 1955 p.194; Clifford 1965 p.58,63,69 pl.38 fig.a; Hardie vol.II 1967 p.92.

This is one of Cotman's most striking compositions of the 1830s, with probably the most violent juxtaposition of blue and golden yellow among all his many late works built on these two colours. Important as it is, strangely enough it does not seem to have been exhibited by Cotman, so one can only wonder what would have been the comments of the critic who regarded a version of the *Abbatial House*, painted in the same year, as an 'outrage' (see no.133). The immense change that occurred between Cotman's early and late works can be seen by comparing the masterfully designed stormy sky of *The Mars off Cromer* (no.127) with the skilful theatricality of the sky in this watercolour.

135 The Green Lamp 1839

pencil, chalk, watercolour and bodycolour with some gum arabic on wove paper; the green shade of the lamp is a cut-out pasted on; 33.1 × 47.6 (13 × 18 $\frac{3}{4}$)
Signed, dated and inscribed in black chalk along lower edge: *J S Cotman – 1839 – . . .* [sometimes read as 'Unfinished'].

Prov: given by the artist to Dr Firth; by descent to his daughter, Miss Firth; bt from her by Leggatt Bros.; bt from them by Percy Moore Turner; bt from him by R.J. Colman 1928; R.J. Colman Bequest 1946.
Exh: ?Norwich AU 1839 (267) as *Drawing Master*; NAC 1888 (165) as *Interior (Unfinished)*; BFAC 1888 (68) as in NAC exh.; Norwich, Arts Council 1947 (35).
Ref: NC 1839; *Art Union* Oct. 1839 p.151; K. North 1936 p.31 no.111; Kitson 1937 pp.346-7; Rienaecker 1953 pl.55 fig.105; Lemaître 1955 p.298 n.1, p.302; Hardie vol.II 1967 p.91 pl.78; Pidgley 1975 p.165 n.24, p.241 ns.147 & 148; Rajnai 1978 repr. in colour.

Kitson surmised that this watercolour was painted and sent to Norwich to impress the Norvicensians with the sumptuousness of Cotman's London residence, 'his front and back drawing-room in Bloomsbury, transmuted into the semblance of a reception room in a royal palace'. Be that as it may, neither this suggestion, nor a further one that it is Cotman, his wife and his daughter who sit around the table, can be substantiated. Nonetheless, it is a fact that the 'green lamp in this picture was the one Cotman worked by in the evenings. He sketched it in a letter to Turner (28 November 1834), and called it his "Lamp of Aladdin" because it worked wonders for him'. (Pidgley.) Its representation by a piece of green paper pasted in position did not find favour with the *Art Union* critic, who otherwise admired 'this splendid production'. He thought it 'somewhat derogatory to Art for a painter such as Mr. Cotman, to continue these practices'.

136 Silver Birches [1820]

oil on canvas; 76.2 × 62.7 (30 × 24 $\frac{3}{4}$)

Prov: acquired from the artist by Dawson Turner 1827; given by him to his daughter Harriet on her marriage to the Revd John Gunn; by descent to Eliza, John Gunn's second wife; acquired from her by W.A. Coates; bt by Percy Moore Turner 1927; bt from him by R.J. Colman 1935; R.J. Colman Bequest 1946.
Exh: W.B. Paterson's Gallery 1913 (3); RSBA 1927 (61); Olympia 1928 (X9).
Ref: Binyon 1897 p.91; Dickes 1905 pp.321,346,380-1 as *A Composition of Trees*; Collins Baker & James 1933 pl.XCIII; Kitson 1937 pp.271,272,293, fig.118; Binyon 1942 pp.159,163 pl.111 fig.B; Oppé 1942 p.165; Kitson 1942 pp.xxix, xxxi; Oppé 1945 p.199 pl.I; Rienaecker 1953 p.44 pl.43 fig.83; Lemaître 1955 p.284; Hawcroft *Burlington* 1962 p.70; Pidgley 1975 p.44; Hemingway 1979 p.73.

Binyon called this a masterpiece, 'one of Cotman's finest and most fortunate works'. The location of the scene is not known, since Dickes' suggestion that it is 'founded upon the view from the window of his new house' on St Martin at Palace Plain can hardly be taken seriously. Its lack of topographical interest makes it a curious purchase for Dawson Turner. 'Kitson even went so far as to interpret the purchase . . . as an "act of benevolence",' writes Pidgley, 'and whether or not one agrees with him, the very fact that both oils [it and its companion] were given away by Turner . . . as wedding presents . . . does suggest that he lacked any deep appreciation of, or genuine feeling for, some of Cotman's most intimate paintings.' Works like *Silver Birches*, of which there is a watercolour version in NCM, provide the melancholy proof that Cotman was capable of the same heights of achievement in his small oeuvre in oil as he was in watercolour.